EARTH TO SKY

EARTH TO SKY MICHAEL NICHOLS

AMONG AFRICA'S ELEPHANTS, A SPECIES IN CRISIS

aperture

Somewhere the Sky touches the Earth, and the name
of that place is the End.

—Proverb of the Kamba tribe,
quoted in Peter Matthiessen, The Tree Where Man Was Born, *1972*

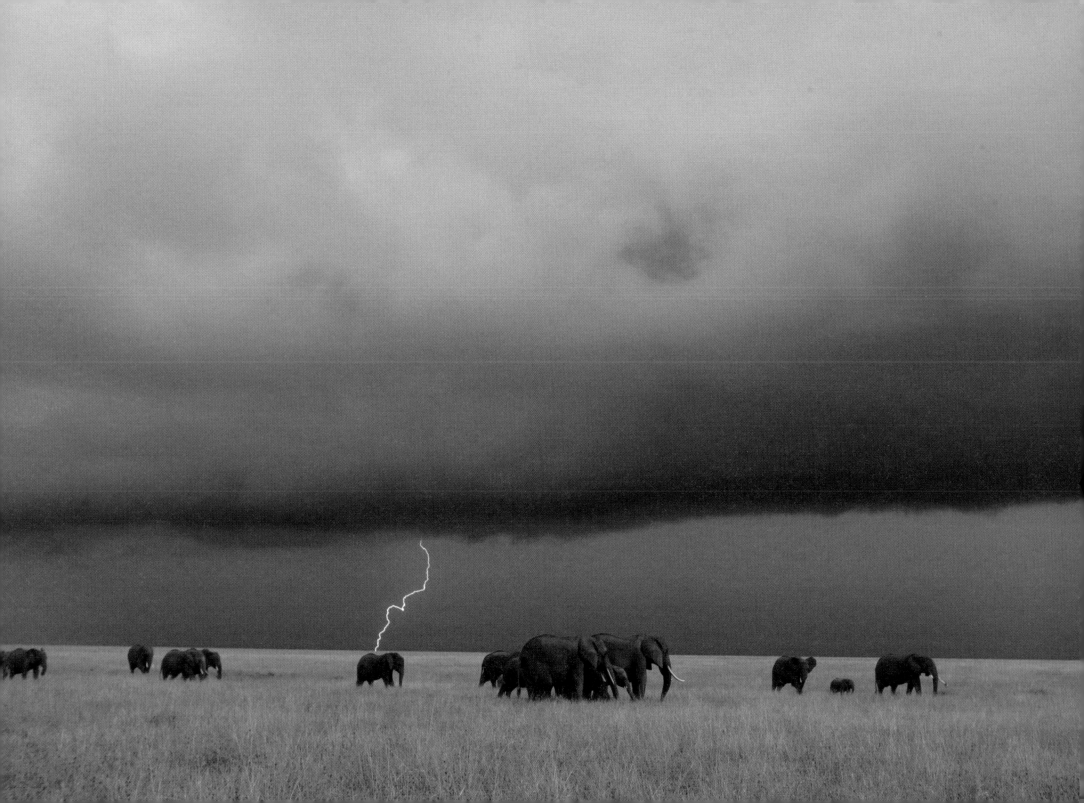

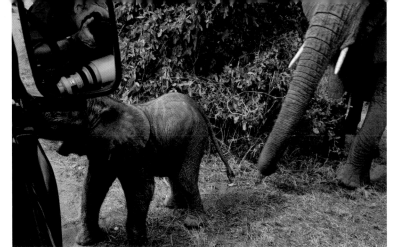
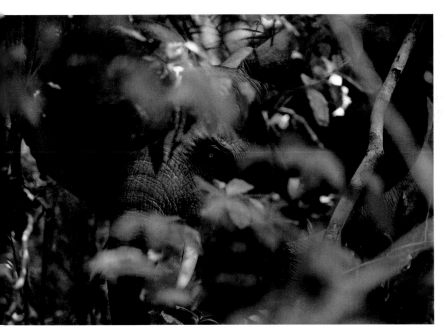
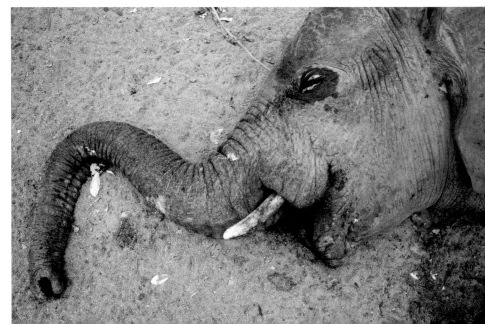

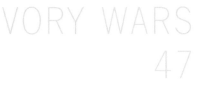

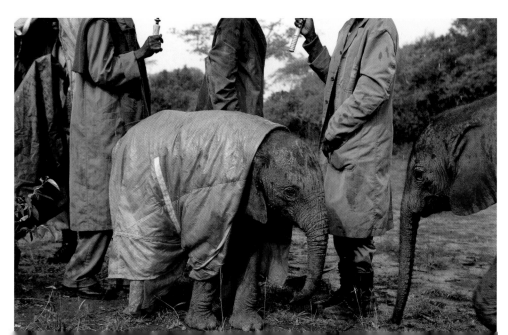

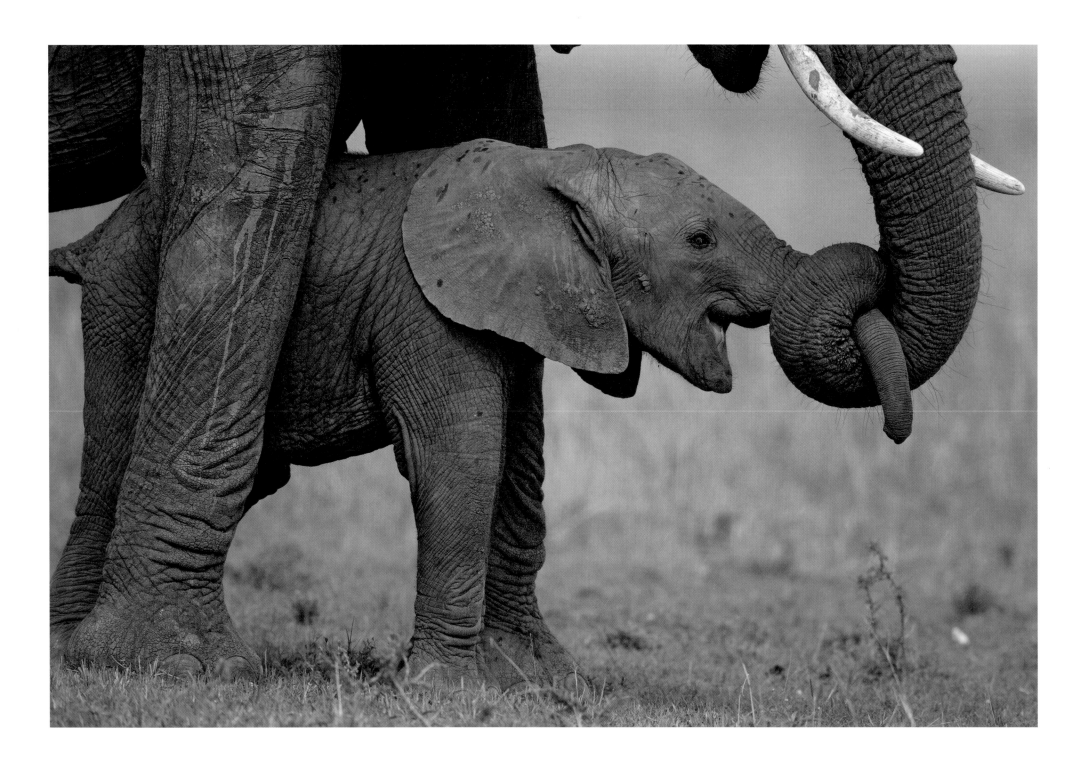

PREFACE

Earth to Sky is a collection of images of African elephants, made over the course of more than twenty years, from 1992 to the present. My journey with these incredible animals began with an introduction—through my friend and longtime collaborator, conservationist and biologist J. Michael Fay—to frightened forest elephants in the Central African Republic, Congo, and Gabon, animals that are under constant threat from poachers driven by a lust for ivory. Later I would encounter herds of elephants in Chad that have been decimated due to outright massacres. But also, with Iain Douglas-Hamilton, founder of the conservation group Save the Elephants and a foremost authority on the African elephant, I had the opportunity to spend time among well-protected, happy herds in Samburu, Kenya. And at the David Sheldrick Wildlife Trust orphan project at Kenya's Tsavo National Park, I saw that even the most traumatized elephants can be rescued and healed, and can learn that not all humans are to be feared.

In all these cases, the experience of watching elephant families from dawn to dusk—and sometimes by moonlight—showed me that these are the most caring and sentient creatures on earth. Yet they suffer so horribly at the hand of man. My hope is that the images in this book will reveal the astonishing intelligence and sympathetic nature of these animals, and will add up to an undeniable plea to stop the ivory trade and focus on resolving the central question: How can we help Africans share the land with elephants?

The title *Earth to Sky* is an homage to the work and beliefs of French novelist Romain Gary. In his 1956 book *Les Racines du ciel* (published in English as *Roots of Heaven* in 1958), and later in his 1967 *Life* magazine essay "Dear Elephant, Sir," Gary eloquently expressed the fundamental truth that the earth needs elephants, and that their presence provides a spiritual essence that defies any human-centric dogma.

The quotes in the following pages come from Gary and other writers, as well as biologists, zoologists, conservationists, and activists. Their words do so much to help convey the urgent message we are trying to put forth with the photographs.

—Michael "Nick" Nichols, Serengeti, fall 2012

IN THE FOREST

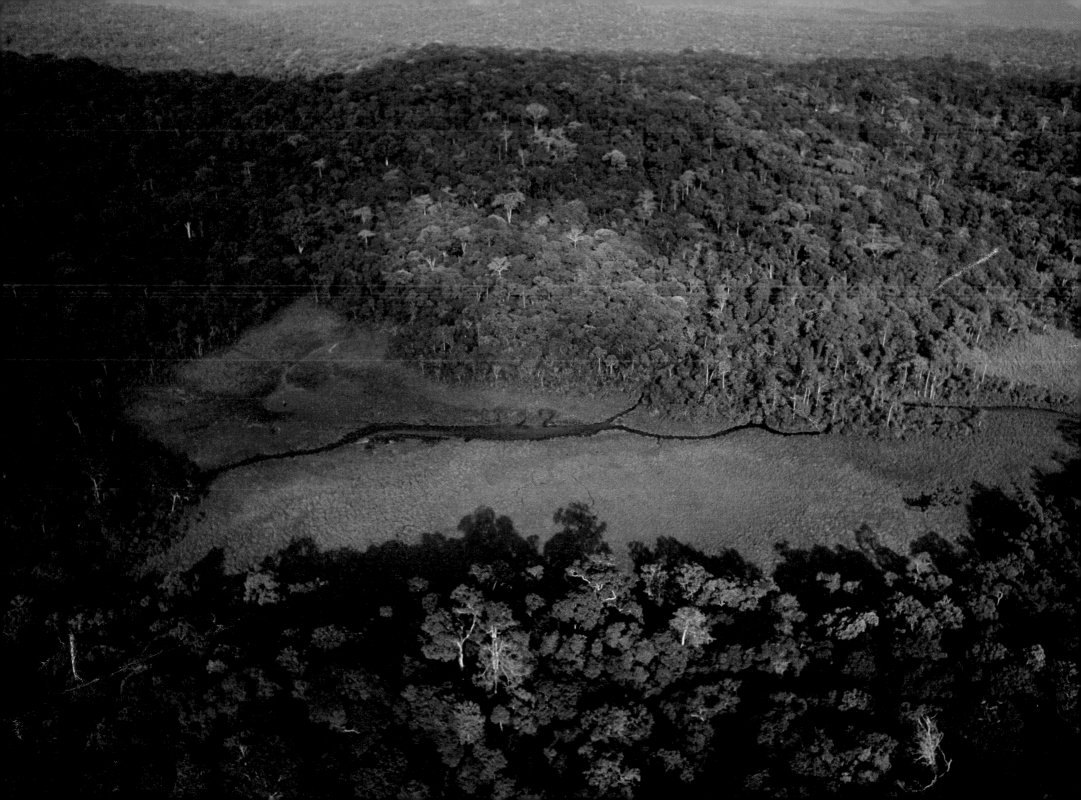

MY INTRODUCTION TO ELEPHANTS

—for that matter, to true wildness—took place in the early 1990s, when I went to photograph lowland gorillas in the Central African Republic with scientist and conservationist J. Michael Fay. In Mike I found a kindred spirit, and our collaboration—we have come to call it a "conspiracy of conservation"—continues to this day.

Mike had just finished his doctoral fieldwork on gorillas. These animals, like forest elephants, are under siege by hunters throughout their habitat, so the hint and scent of man means either run away or attack. Tracking the gorillas was not easy; we rarely saw them, and when we did they were fearful, so it was only for moments at a time.

For relief, Mike took me to one of the wonders of this world: the Dzanga Bai—a *bai* is a clearing where animals gather. It was here that I had my first experience photographing the *Loxodonta cyclotis* subspecies of elephants. Biologist Andrea Turkalo was just beginning a vigil that is still ongoing: every afternoon, she sits on an elevated platform at the bai and records the animals' activities; today she has identified more than five thousand elephants that have crossed her spotting scope.

Over the following years, Mike and I created many essays for *National Geographic* that helped bring the Congo Basin forests to the attention of the world. A climax to our work took place in 1999–2000. It began when Mike made a discovery while en route from his Sangha River basecamp to Libreville, Gabon, in 1996, circumventing the tumult of civil war in Congo-Brazzaville. In a small, single-engine Cessna, he flew for four and a half hours over completely undisturbed forest before reaching the Atlantic coast—and he realized that here was a rare

opportunity to explore, and maybe to save, a large swath of wilderness before it was too late. An obsessive hiker and data collector, Mike made the decision to survey this virtually uninhabited 1,200-mile corridor of Africa by foot—a project he called the Megatransect. As his partner and the photographer of the undertaking, I documented the fifteen-month journey in black-and-white and color images. This endeavor captured the world's imagination in three *National Geographic* articles and a 2001 television documentary.

The central characters of the Megatransect were the forest elephants and the highway trails they created; Mike's carefully penciled log of their activities and routes confirmed what we suspected: elephants and their ecosystems are much stronger when far from the presence of man—or if the land is well protected.

The payoff of our work, and the work of many others with like minds, was the creation of thirteen national parks in Gabon, two in Congo, and one in the Central African Republic. It was not just because of the Megatransect that these parks were established, but it is certain that the pictures and media attention helped. Today the boundaries of these parks are intact—no logging or mineral exploitation is taking place in them—but they continue to face great challenges from poachers and lack of government and NGO action. Much honest work is still to be done to establish truly lasting sanctuaries.

The images in this chapter were made in the Central African Republic, Congo, and Gabon between 1991 and 2005, principally in the national parks of Dzanga-Sangha, Ndoki, Odzala, Ivindo, and Petit Loango on the Atlantic coast.

PREVIOUS PAGE: Conservationist J. Michael "Mike" Fay discovered Gabon's Langoué Bai during the Megatransect, when giant elephant trails led him to the animals' hidden gathering site. OPPOSITE: Surprised when Mike Fay and I approached, this young elephant charged us. THIS PAGE: I met Mike in 1991, after he finished his research on lowland gorillas.

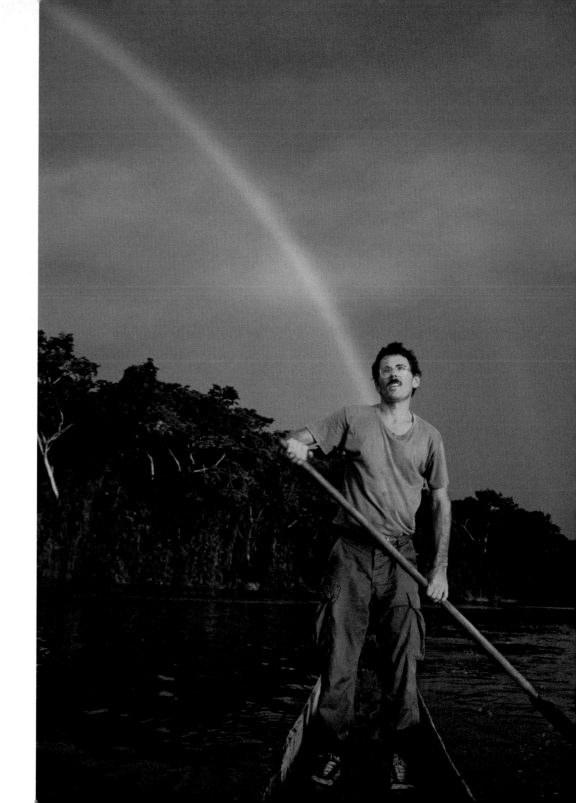

You don't see a whole elephant in the forest. What you do see is just a glimpse

of hide or tusk or trunk through the trees. And if you want to get this glimpse without

disturbing him you must do your glimpsing from down the wind.

—*Carl E. Akeley*, In Brightest Africa, *1923*

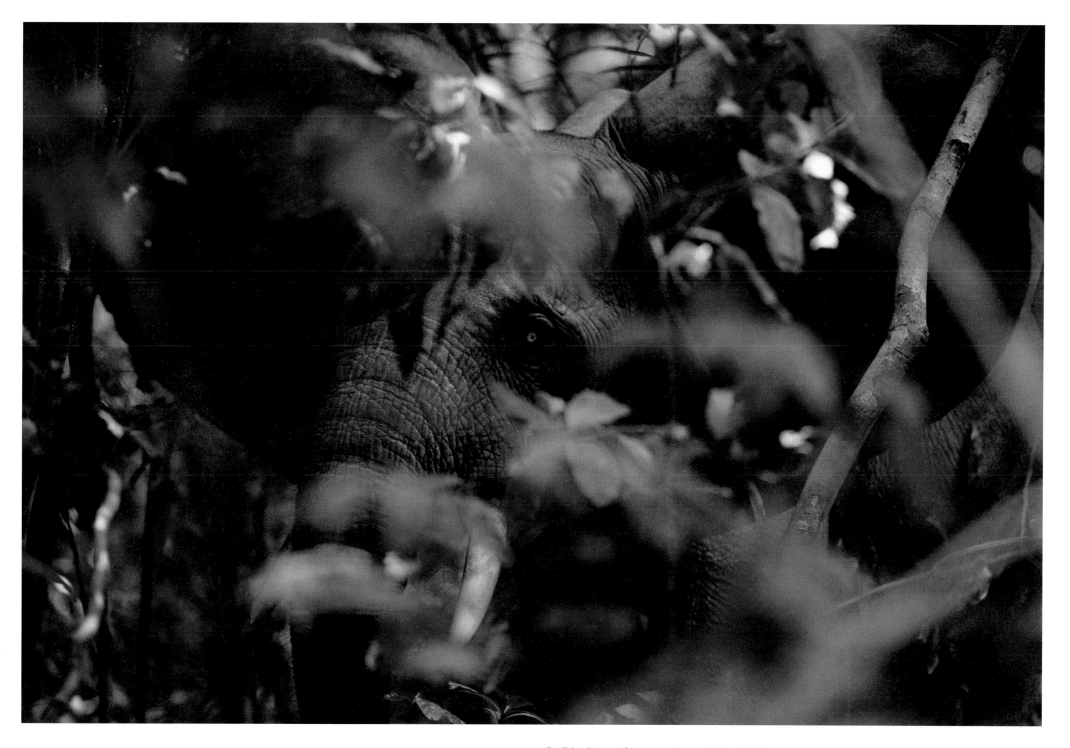

Realizing it was safe, young males recolonized the forest around this basecamp in Bomassa, Congo-Brazzaville. 17

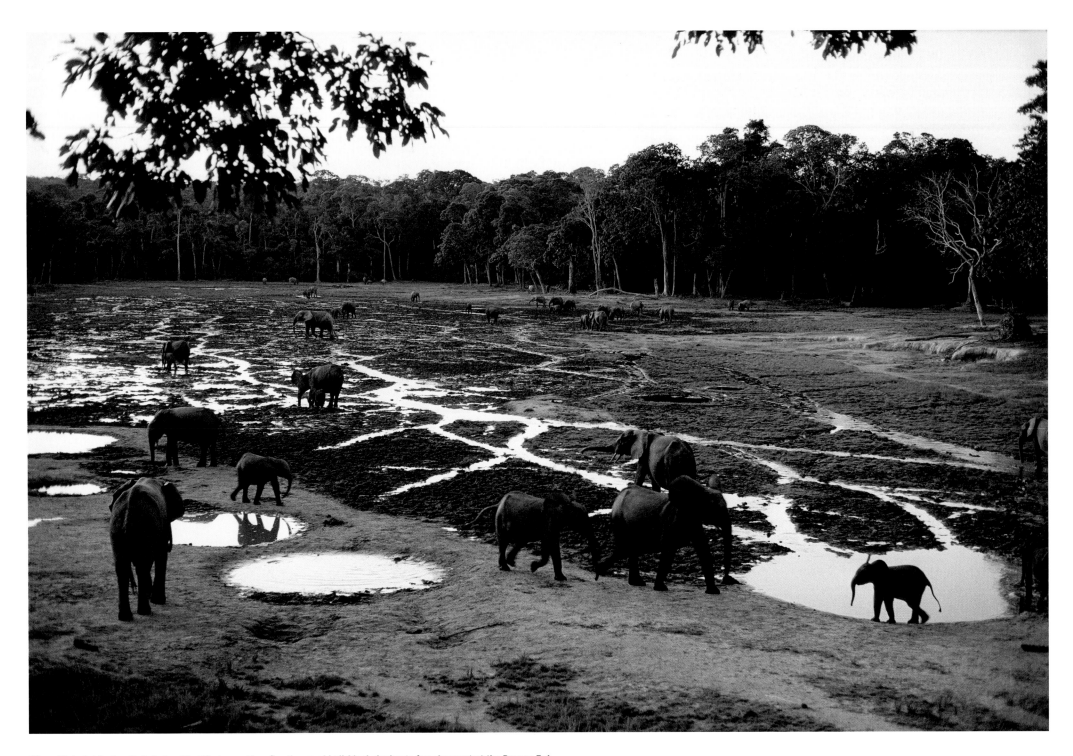

Biologist Andrea Turkalo has identified more than five thousand individual elephants from her post at the Dzanga Bai.

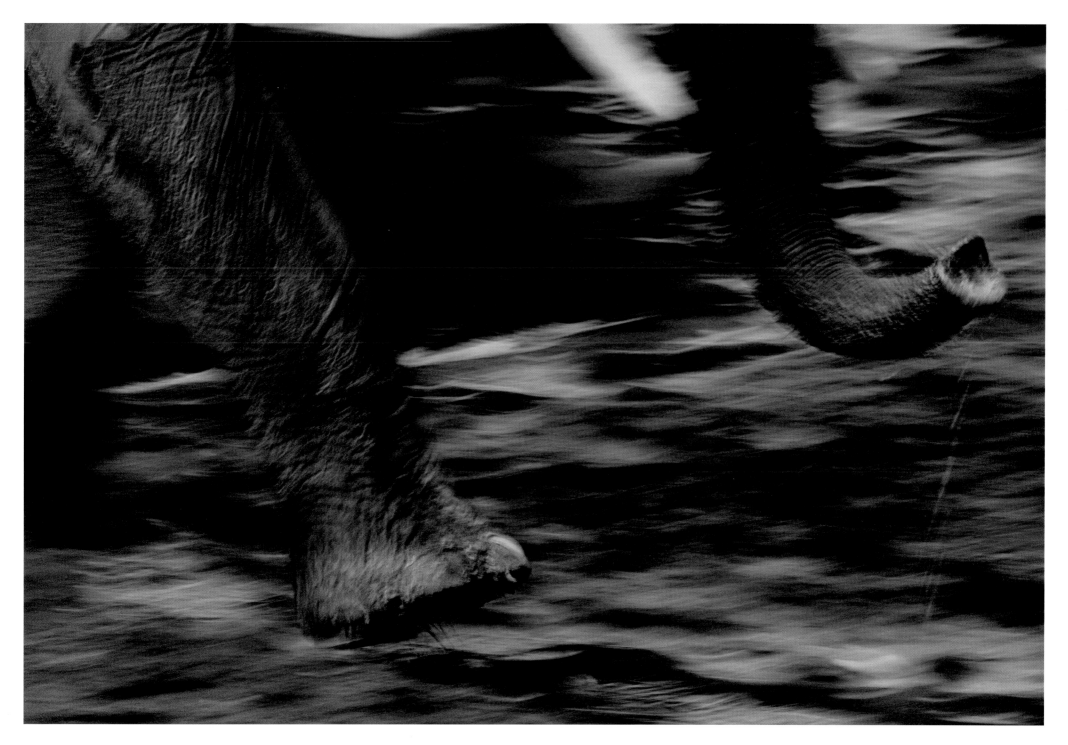

Elephants are drawn to the bai to dig for minerals and to socialize; it functions as a kind of elephant town square.

Of all African animals, the elephant is the most difficult for man to live with, yet its passing—if this must come—seems the most tragic of all. I can watch elephants (and elephants alone) for hours at a time, for sooner or later the elephant will do something very strange such as mow grass with its toenails or draw the tusks from the rotted carcass of another elephant and carry them off into the bush. There is mystery behind that masked gray visage, an ancient life force, delicate and mighty, awesome and enchanted, commanding the silence ordinarily reserved for mountain peaks, great fires, and the sea.

—*Peter Matthiessen,* The Tree Where Man Was Born, *1972*

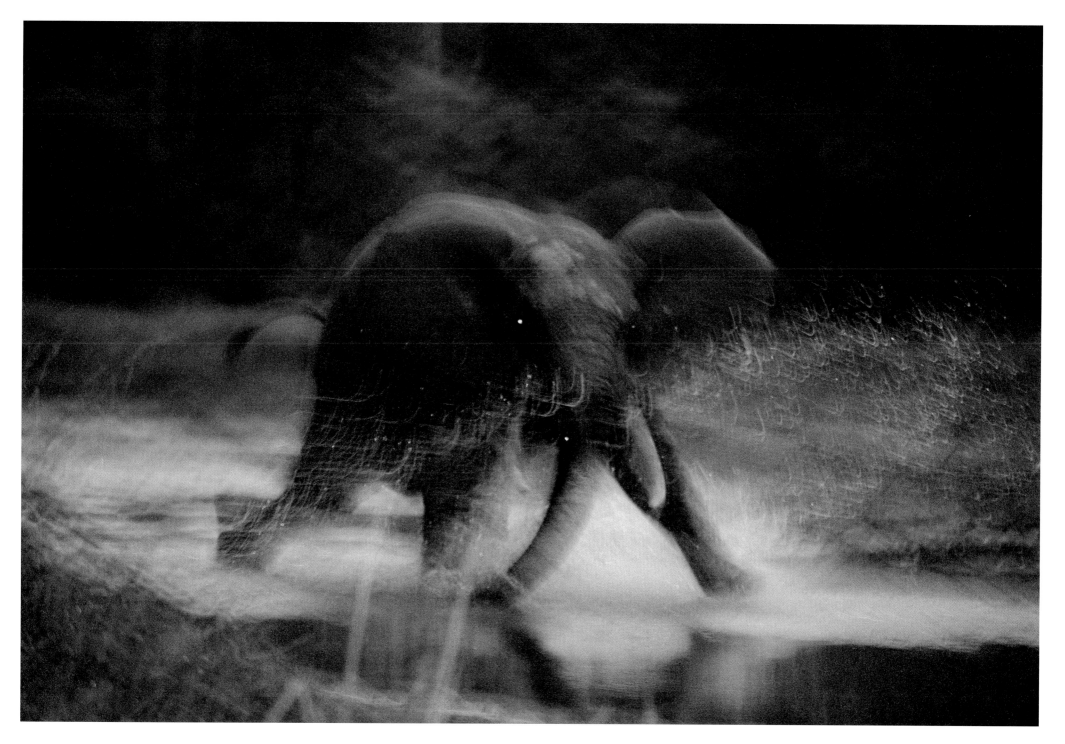

After charging at my scent, this elephant was putting on the brakes when I made this image; we both then turned and ran off.

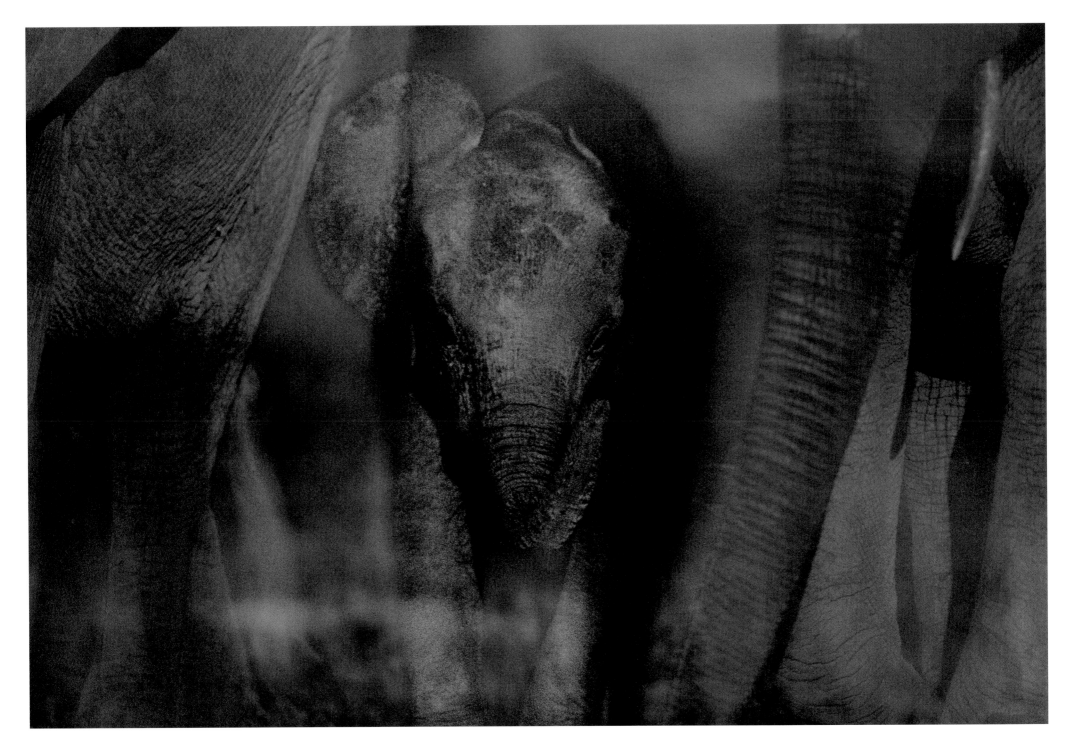

22 When newborns are introduced at the Dzanga Bai, they are protected under the bodies of their immediate family.

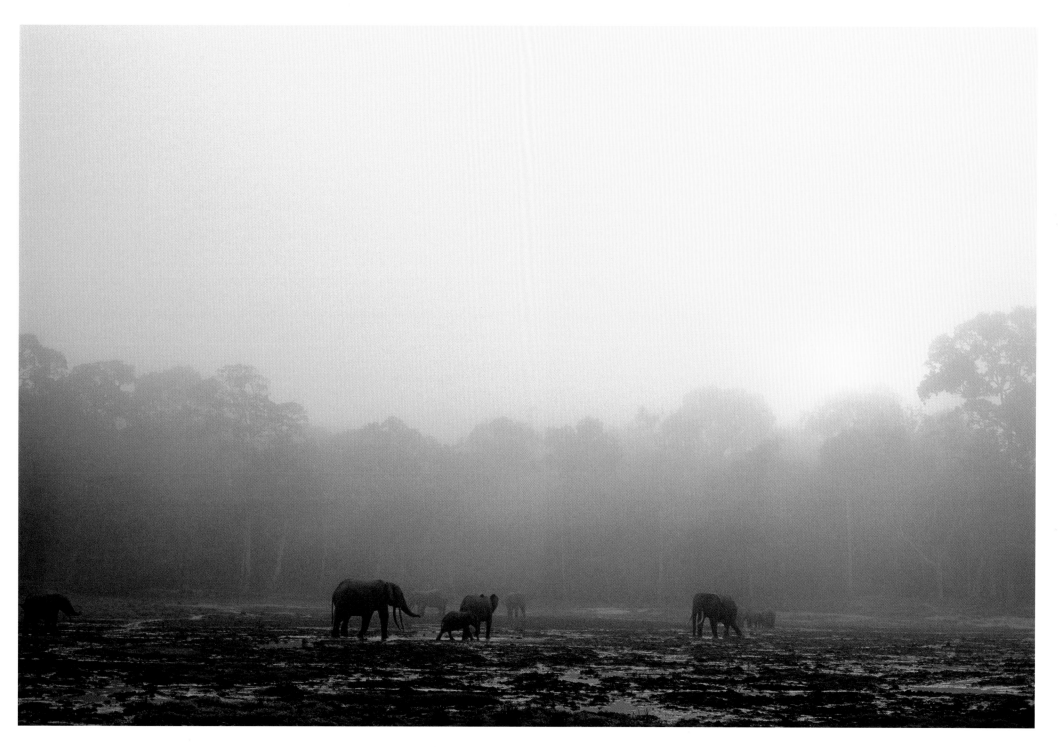

Andrea Turkalo has noted that if an elephant is killed within a hundred miles of the bai she can sense a change in the other elephants' behavior.

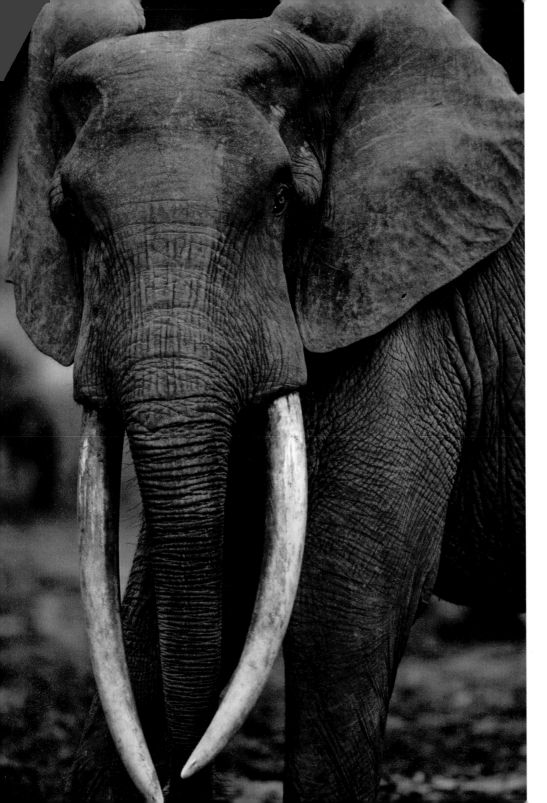

Just as I crossed the ant-hill, the elephant was momentarily hidden, and a most terrifying deep growl reverberated in my ears. It was the bull. There seemed to be such implacable hostility in the noise that I was convinced he was after my blood and I fled helter-skelter back to the car. When I turned to look round, the elephant was peacefully munching a palm frond, evidently without a care in the world and totally oblivious of my existence. I felt an idiot. It was the first time that I had heard an elephant rumble. Later I realized that this was simply a contact call by which elephants keep in touch with one another while they are feeding or on the move.

—*Iain Douglas-Hamilton,* Among the Elephants, *1975*

Loxodonta cyclotis has straight tusks of pinkish ivory; the coloration is probably from the clay the animals eat as a dietary supplement.

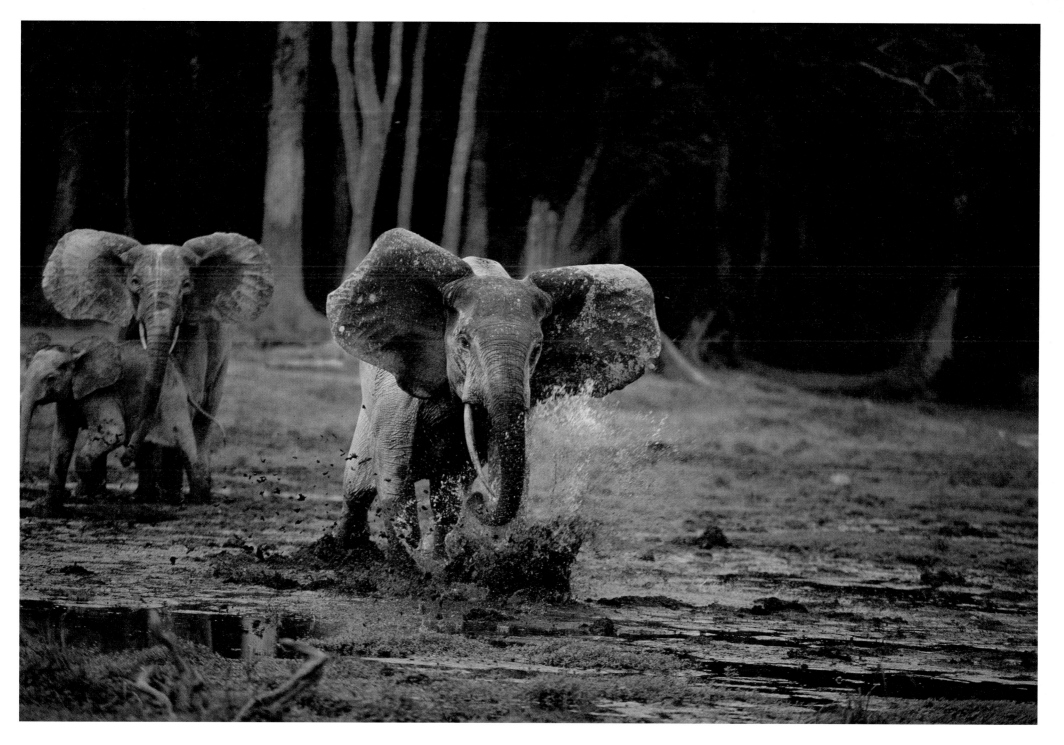

When Mike Fay and I stood at the edge of the clearing to observe, our scent attracted many spirited charges. 25

Indeed, elephant mysteries are still being discovered. It has now been learned that this animal can transmit low-frequency alarms and other elephantine messages across miles of wilderness, and increasingly it is credited with the apprehension of death that we had heretofore reserved to our own species. Except fire and man, these great animals have more impact on habitat than any force in Africa, and the prosperity of many other creatures may depend on them. This is as true in the forest as on the savanna. The very survival of the bongo, okapi, and lowland gorilla, which browse on the new growth in elephant-made gaps in the canopy, may depend upon the survival of the forest elephant.

—*Peter Matthiessen,* African Silences, *1990*

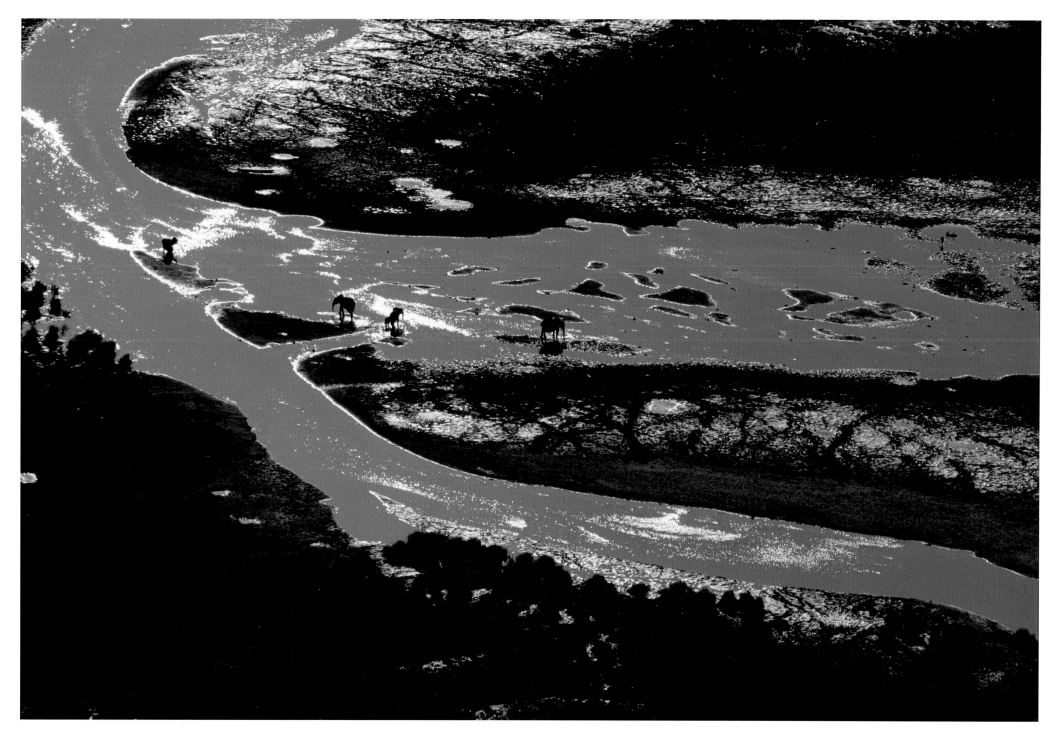

Odzala National Park in Congo-Brazzaville is a safe haven for thousands of forest elephants. 27

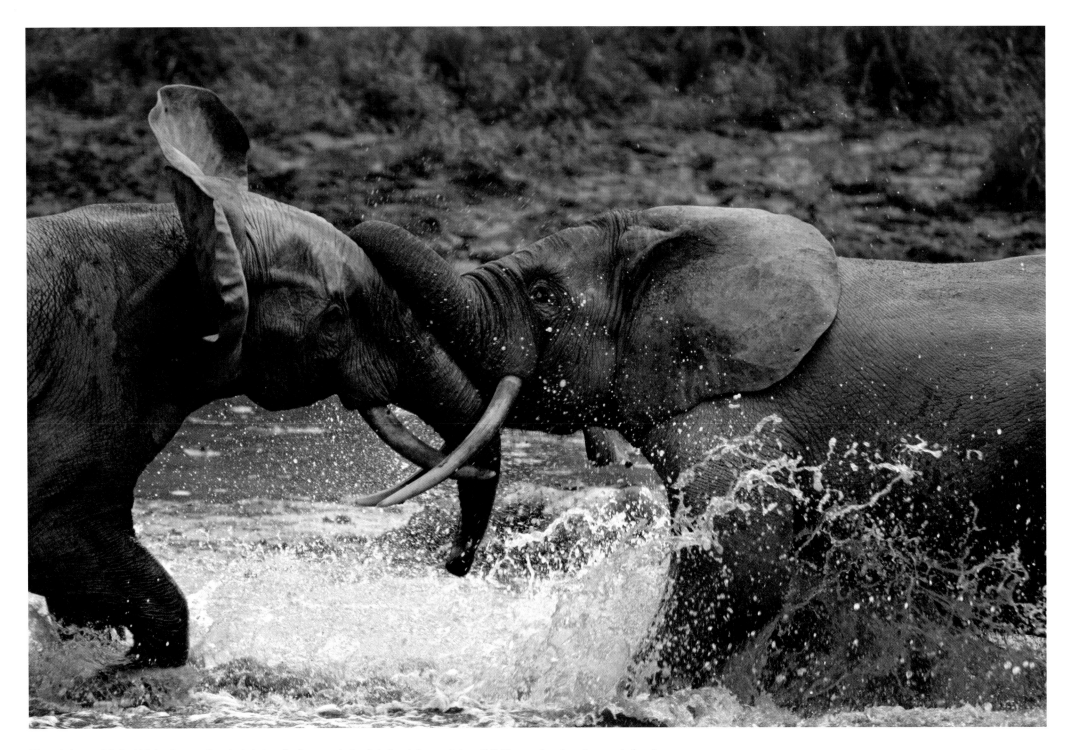

28 At Langoué Bai, which has been well protected since its discovery, bulls of similar stature and size will fight over minerals and access to females.

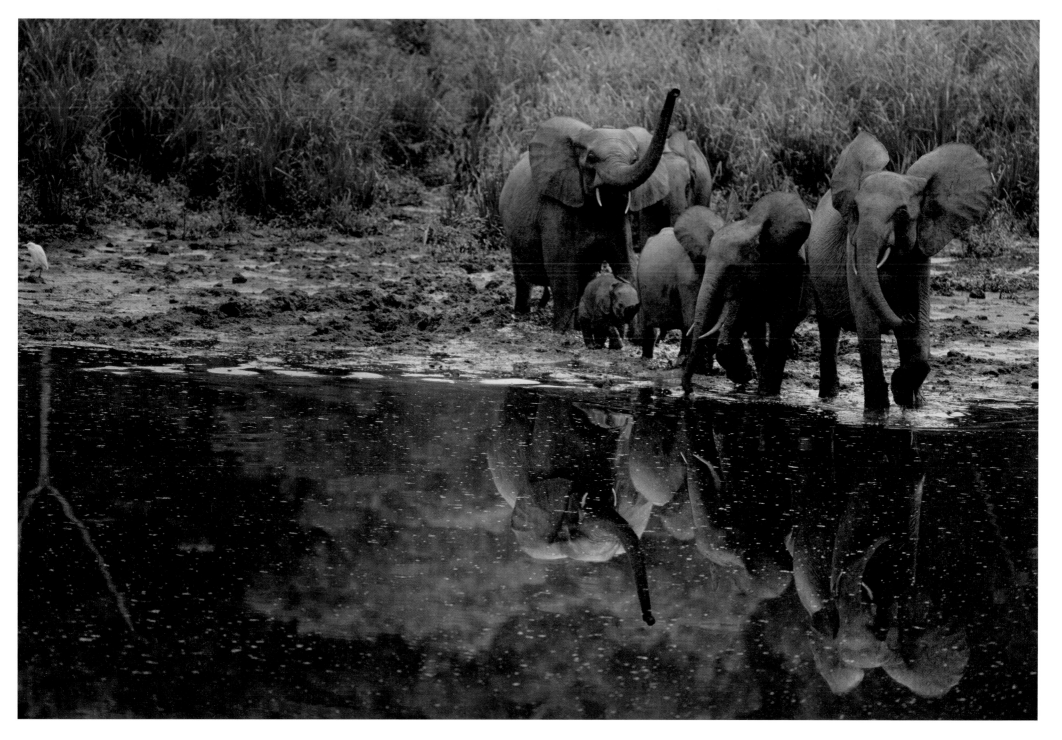

Elephants come from far and wide to dig much-needed minerals at bais. Forest elephants travel in family groups, not herds.

Each day we drifted further up the lagoon. Wherever we had touched the earth, the elephants caught our scent and vanished. Their reaction cast the only shadow on an otherwise idyllic interlude, and brought back the sadness we always felt when animals showed such fear of man.

—*Iain Douglas-Hamilton,* Battle for the Elephants, *1992*

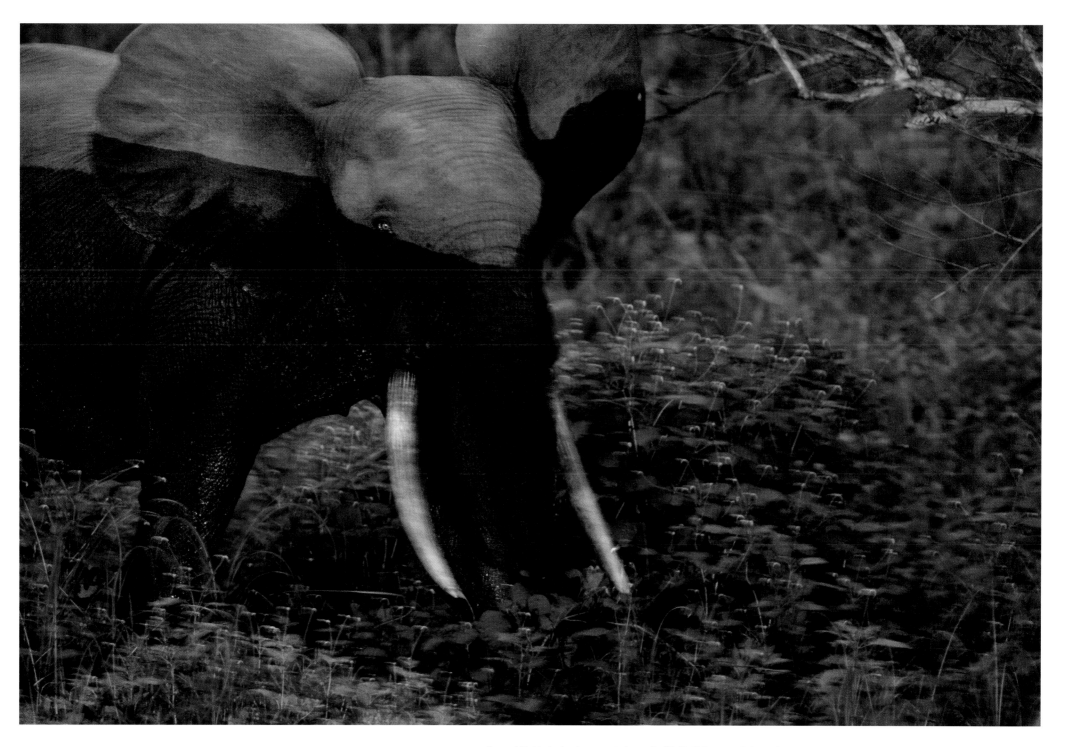

Several timid elephants were photographed in Petit Loango, Gabon, along a papyrus swamp, as they crossed the Ichura River.

The breath of the forest hung thick and moist in the windless air, heavy with the smell of decaying vegetation. Here the elephant was king, the path-maker, moving soundlessly on cushioned feet over an antique auburn carpet of soft, damp leaves. Huge trees arched overhead, filtering the dappled light which fell on his quilted hide. With his outstretched trunk he could pluck nuts from the ozouga tree, and fruit from the douka and mikoumina trees twenty feet above the ground, and draw water from rivers as he ambled on his way.

—*Iain Douglas-Hamilton,* Battle for the Elephants, *1992*

Many of these images of forest elephants resulted from patience and hiding; I was often photographing from hastily built tree platforms.

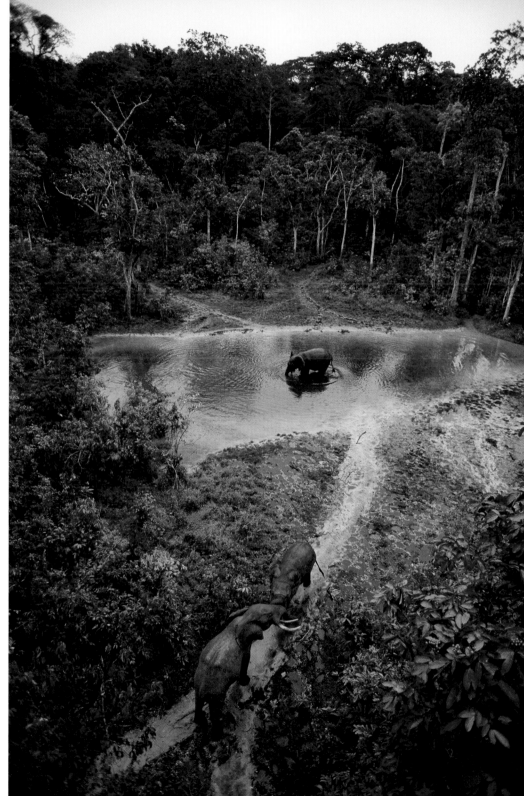

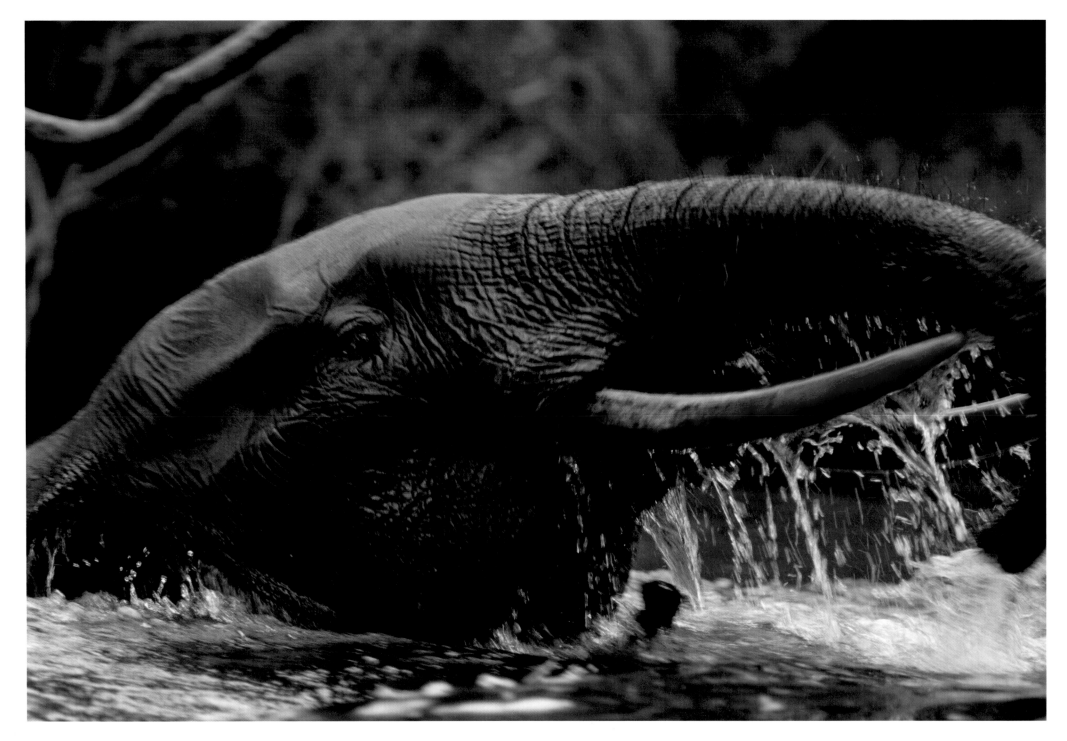

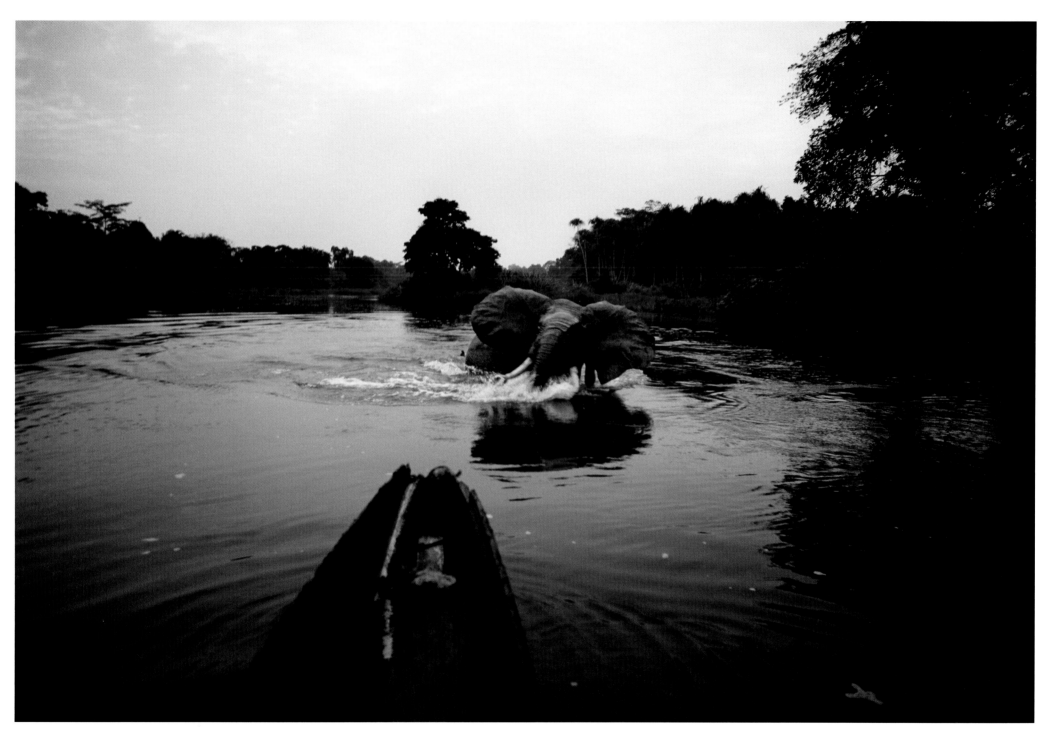

I would also float down rivers in small pirogues at dusk or dawn, hoping to find elephants crossing or grazing. 35

We went to go look at 2 male elephants. Bebe had gone to check out that sound after we crossed the first Djidji creek & I was checking out the map. He still has that kid in him that makes him willingly go after the odd elephants—not gorillas yet. We crossed back over the Djidji and we found 2 males: 12 + 10 yrs old hanging out together lazily feeding along in the thick veg, stripping a sapling of its leaves once in a while or pulling a vine down. It is amazing how flat their ears get on their bodies when they slip through the veg. Nothing to get hung up —no baggage, all the food you need is in the forest. These guys were typical young plumpsters with tusks 4 kg apiece + 2.5 kg apiece. The skin was blocky & the tusks rather robust, eyes yellow & ears small.

—*J. Michael Fay, Megatransect notebook 29, August 6, 2000*

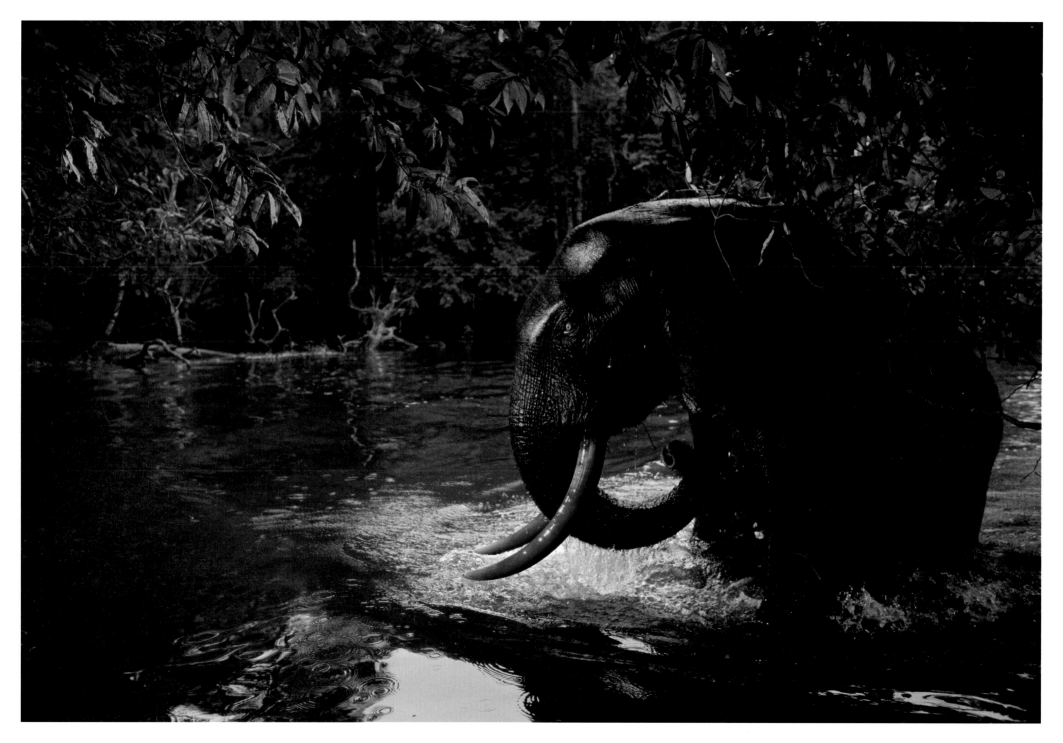

Some of my favorite images were taken by the elephants themselves, as they broke the invisible beams of carefully placed camera traps. 37

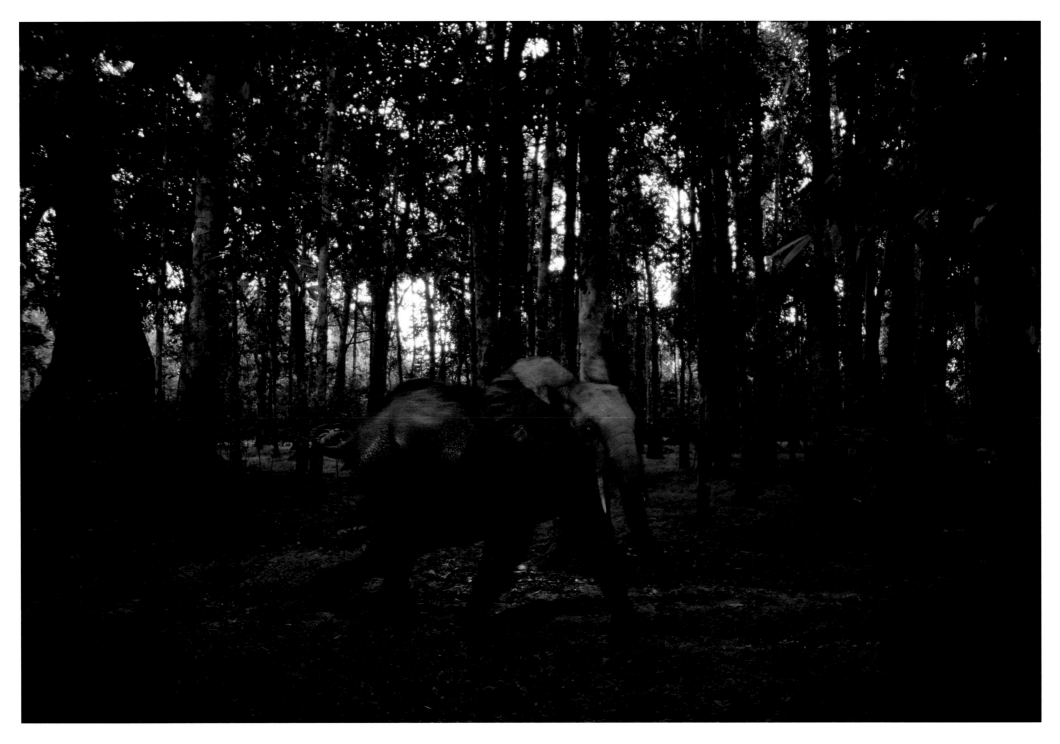

Camera traps are unmanned, benign "spies" into a hidden world; without doing any harm to the animals, they yield images that would otherwise be impossible to obtain.

Elephants may not have a graveyard but they seem to have some concept
of death. It is probably the single strangest thing about them. Unlike other
animals, elephants recognize one of their own carcasses or skeletons. Although
they pay no attention to the remains of other species, they always react to the
body of a dead elephant. . . . When they come upon an elephant carcass they
stop and become quiet and yet tense in a different way from anything I have
seen in other situations. First they reach their trunks toward the body to smell
it, and then they approach slowly and cautiously and begin to touch the bones,
sometimes lifting them and turning them with their feet and trunks. They
seem particularly interested in the head and tusks. They run their trunk tips
along the tusks and lower jaw and feel in all the crevices and hollows of the
skull. I would guess they are trying to recognize the individual.

—*Cynthia Moss,* Elephant Memories: Thirteen Years in the Life of an Elephant Family, *1988*

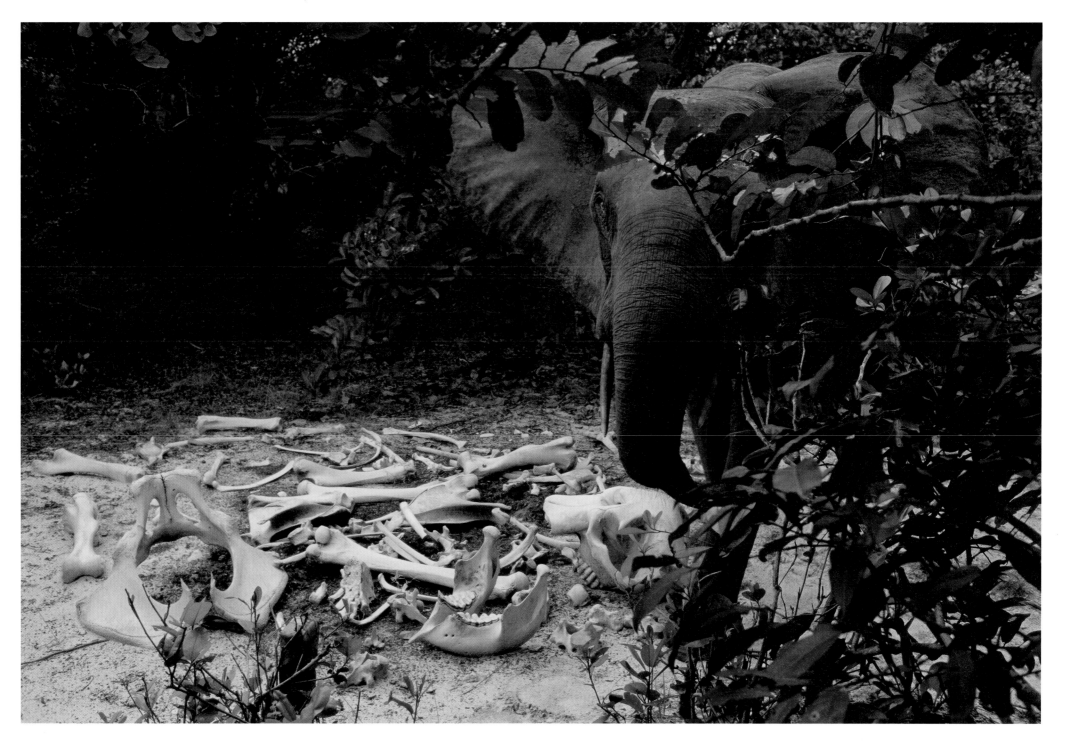

I set up a camera trap near these elephant bones, just to see if anyone would visit. 41

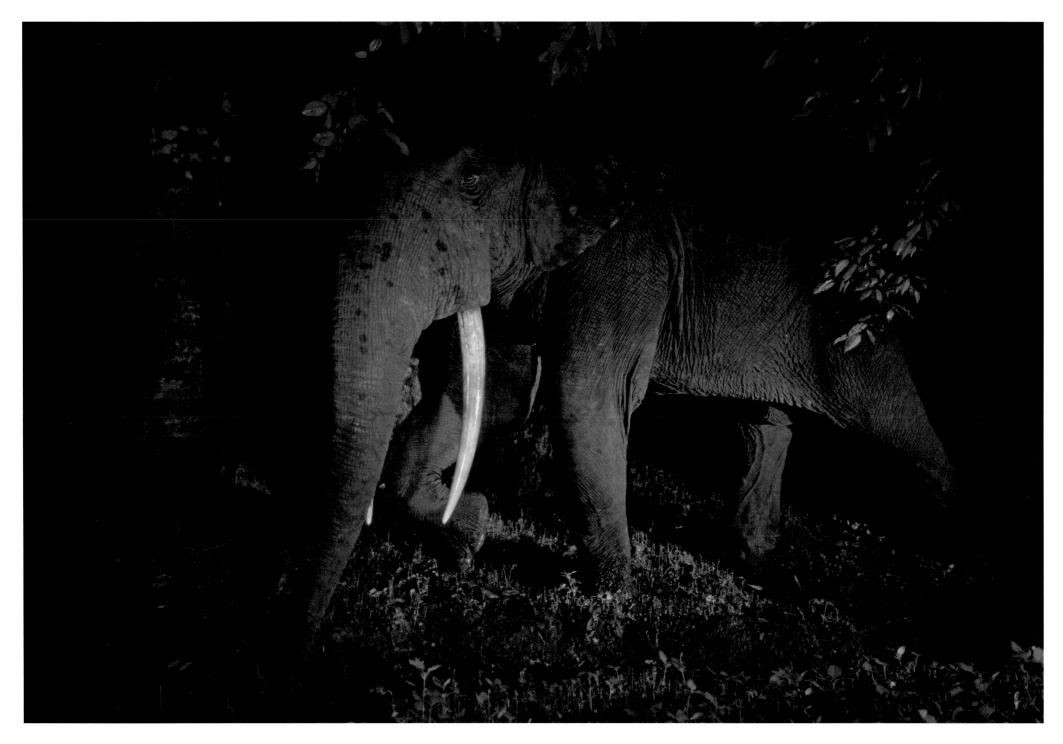

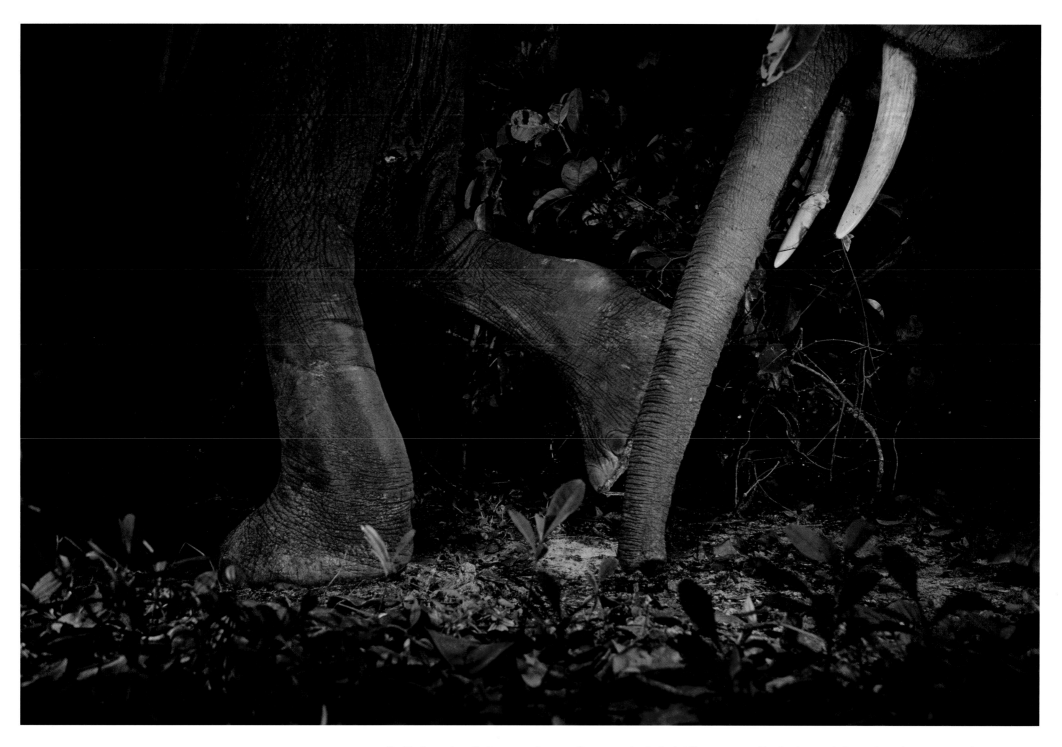

There are those, of course, who say you are useless, that you destroy crops

in a land where starvation is rampant, that mankind has enough problems

taking care of itself, without being expected to burden itself with elephants.

They are saying, in fact, that you are a luxury, that we can no longer afford

you. . . . If the world can no longer afford the luxury of natural beauty, then

it will soon be overcome and destroyed by its own ugliness.

—Romain Gary, "Dear Elephant, Sir," Life *magazine, December 22, 1967*

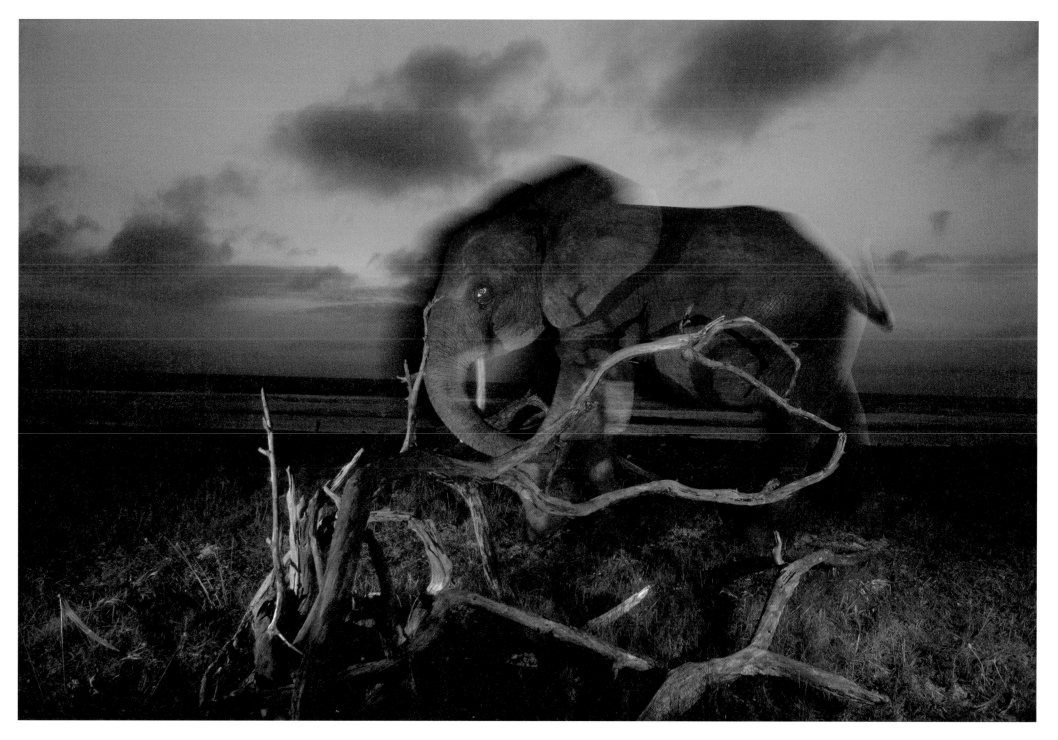

On this evening, I remember thinking: "If an elephant walks through my camera trap with this sunset, it will be a miracle." 45

IVORY WARS

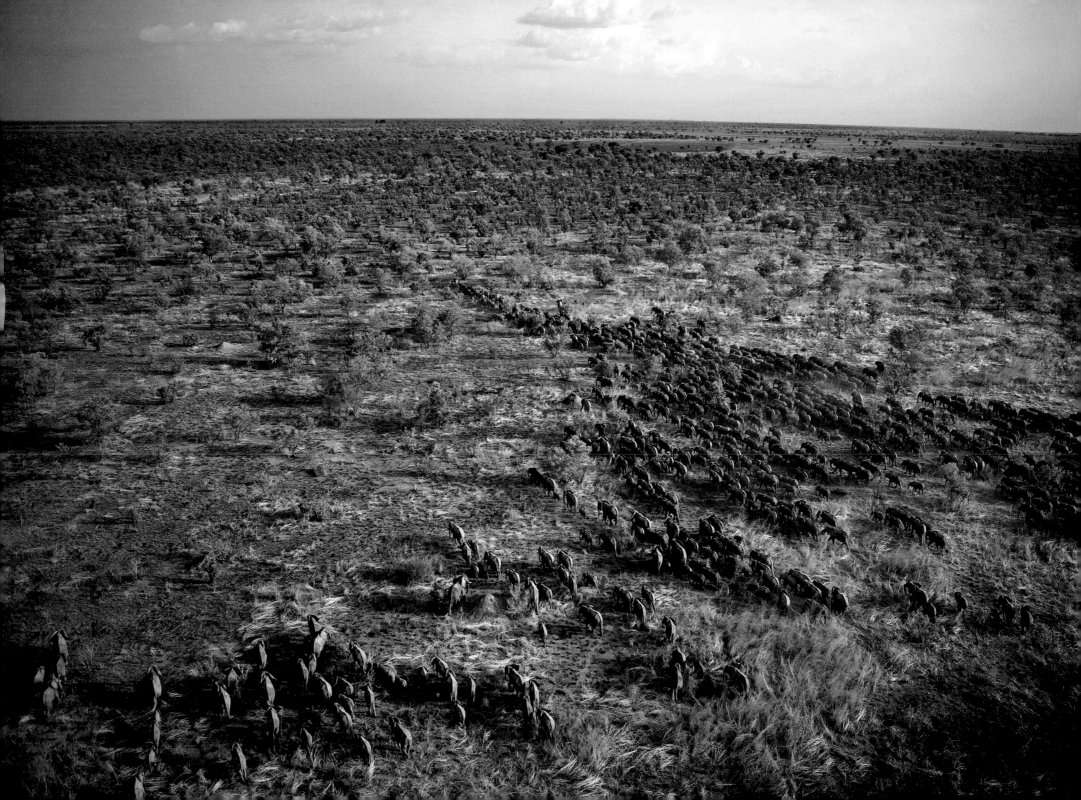

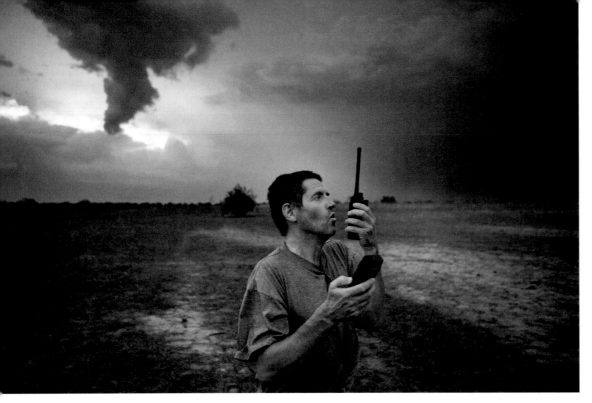

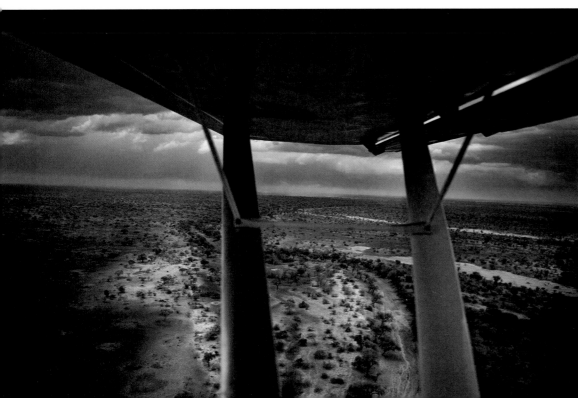

THE PROMISE OF THOUSANDS

of elephants bought me to Chad in 2006 to work with Mike Fay again. But it turned out to be a dark promise. We came to document one of the world's little-known ecosystems, an area ferociously protected by the African Parks Network and by Luis Arranz, at the time an administrator with the Zakouma National Park. The elephants there, we heard, had made a great recovery, and we were filled with optimism at showing this to the world.

But in fact, we stumbled into the early stages of a full-scale slaughter that continues to this day and is spreading through Africa's remaining elephant populations. And, all for ivory—once known as "white gold"—for which poachers will do almost anything. A single large tusk sold on the local black market can bring six thousand dollars; that's enough to support an unskilled worker for ten years in some African countries. The market for ivory, centered largely in China, had begun to trail off after the 1989 ivory ban, but has been reignited by growing Chinese wealth and is kept active with China's resource investments all over Africa. Elephants from lesser-known sanctuaries like Zakouma, and from the Sahel, along with the forest elephants of Gabon and Congo, have been decimated with barely any media noise to the world. The value of ivory is now so high that the butchery has spread to the more visible populations of savannah elephants in eastern and southern Africa. Every year at least twenty-five thousand elephants are killed for their tusks.

Ivory simply must be devalued. Those who buy it and use it and carve it must be shamed. Elephants are perceptive, conscious, and responsive animals; they cannot be terrorized and massacred by a

world that calls itself civilized. We have to forget about the absurd indulgence of ivory—a useless status symbol—and put our focus and resources into the far more complex problem of how elephants and humans can share land in an overtaxed continent.

After photographing at Zakouma, I was able to spend time with happy, well-protected elephants in Kenya, those being studied at Iain Douglas-Hamilton's Save the Elephants. There I saw again and again with amazement how loving they are, their uncanny gifts of communication, their ways of collaborating with the environment— things we are only beginning to comprehend. Humans tend to harbor an arrogant belief that we can manage nature. We come up with ways to cull and control populations, without giving a thought to what remains. Elephants, like almost all animals, must be raised by mothers and live in a balanced environment. We cannot manipulate this balance without profound understanding and care.

The life of the elephant is worth so much—both as a vital element in the ecosystem and as an intelligent presence on this planet. We cannot allow these animals to be exterminated for the sake of human greed.

The "Ivory Wars" images were made in March–June 2006, in and around Zakouma National Park, Sarh, Chad, where Mike Fay and I were hosted by Luis Arranz and the African Parks Network.

PREVIOUS PAGE: A clan of eight hundred elephants is led by a single wise matriarch out of the relative safety of Zakouma, in search of fresh food. They are free to roam in and out of the park. **OPPOSITE, TOP AND BOTTOM:** While I was shooting from a tiny Ultralight plane, Luis Arranz, who was piloting, saw a storm coming. We lost the race home and were torn out of the sky, but Luis got us down to the ground in one piece. **THIS PAGE, TOP:** There are issues with the sharing of precious water with the nomads who roam near the park. Mike Fay undertook tense interviews with several religious leaders of their tribes. **THIS PAGE, BOTTOM:** Mike placed this notebook on the bloody bullet holes in a bull killed within earshot of his patrol.

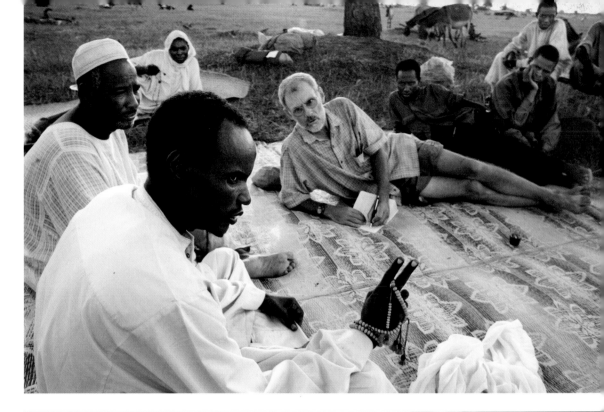

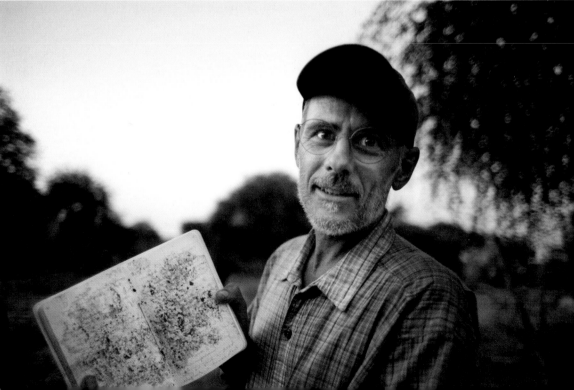

The word *ivory* disassociates it in our minds from the idea of an elephant. One tends to lump it with jade, teak, ebony, amber, even gold and silver, but there is a major difference: The other materials did not come from an animal; an ivory tusk is a modified incisor tooth. When one holds a beautiful ivory bracelet or delicate carving in one's hand, it takes a certain leap of understanding to realize that that piece of ivory came from an elephant who once walked around using its tusk for feeding, digging, poking, playing and fighting, and furthermore that the elephant had to be dead in order for that piece of ivory to be sitting in one's hand. I would venture to guess that only a tiny percentage of people who buy ivory ever make that leap. Even if they did they would probably buy ivory anyway in the all-too-common belief that there are plenty of elephants in the world, possibly too many, and in any case they are here for the use of man.

—*Cynthia Moss,* Elephant Memories: Thirteen Years in the Life of an Elephant Family, *1988*

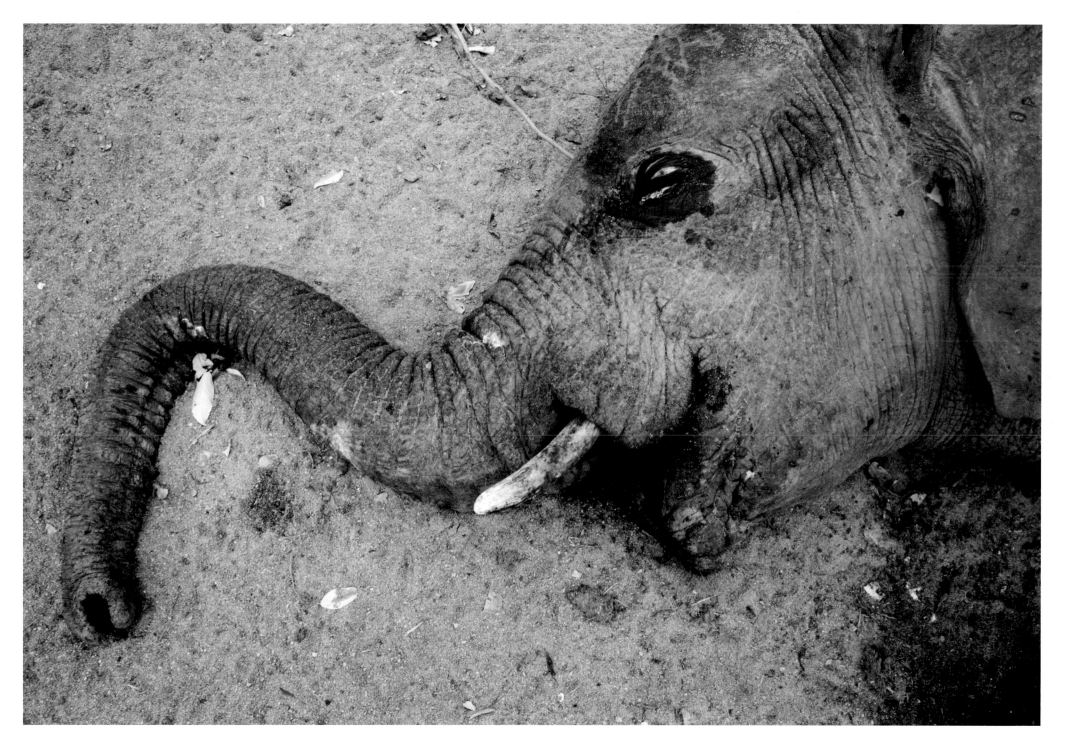

This young elephant, with tiny tusks, was killed in the park next to our camp. 53

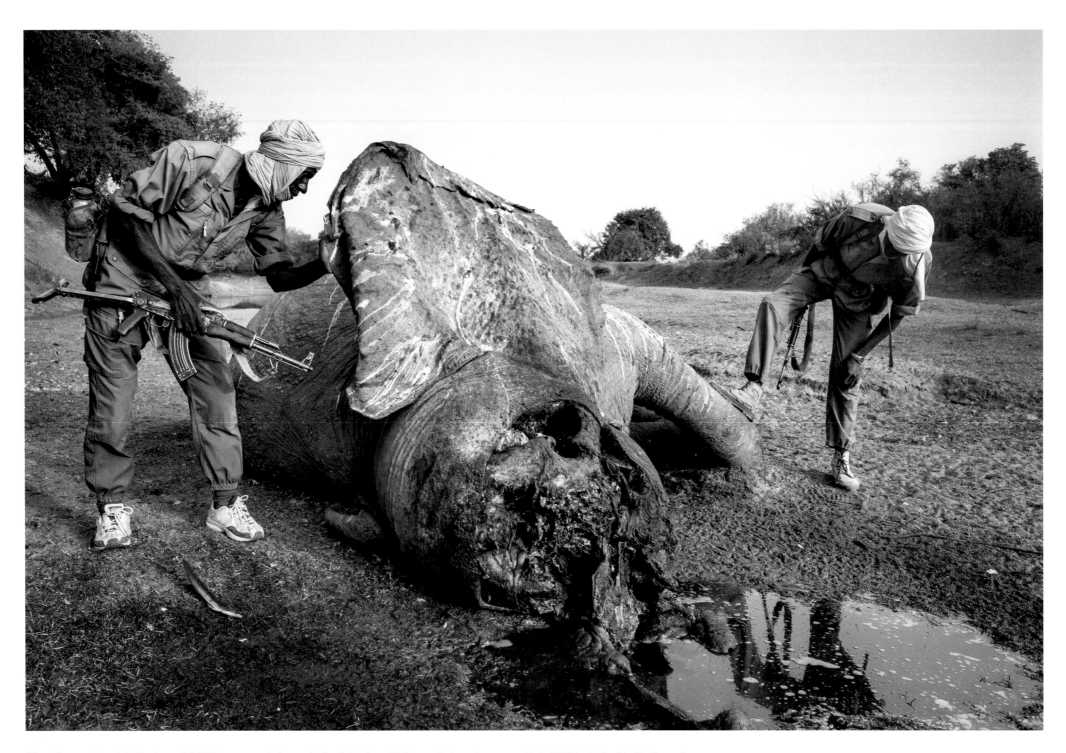

54 A coup attempt in Chad's capital, N'Djamena, created enough of a distraction at Zakouma that poachers were able to kill this elephant inside the park.

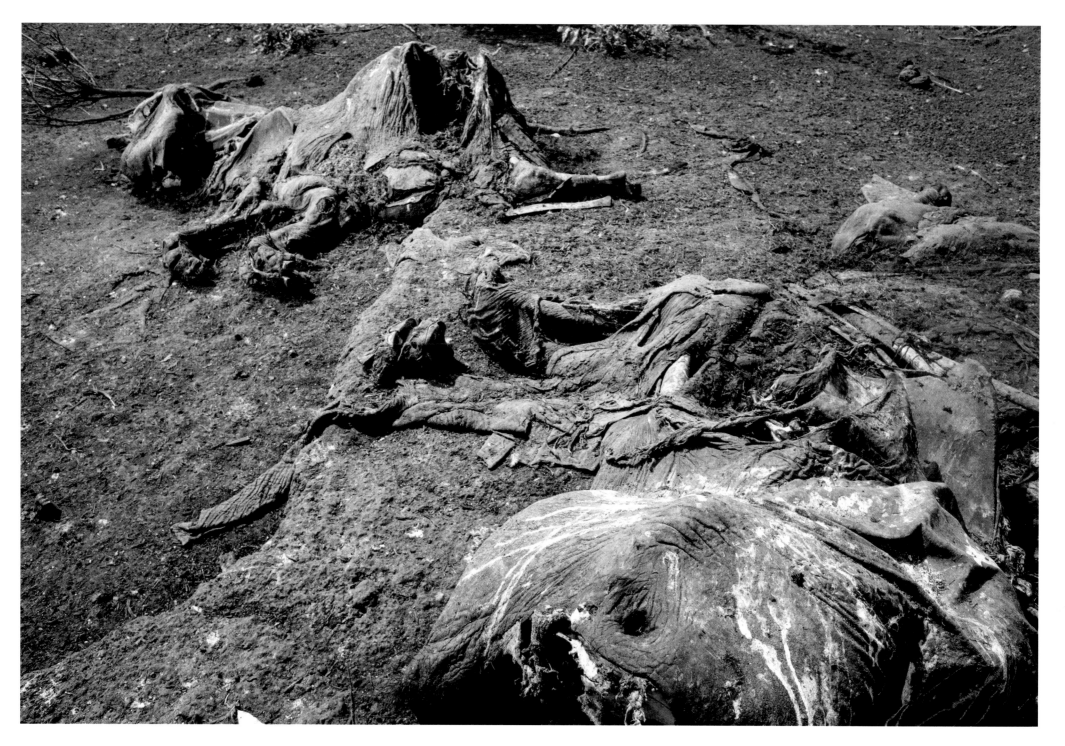

Three days after the massacre of twenty elephants, including this mother and her young, villagers had taken the meat and vultures had had their way with the carcasses.

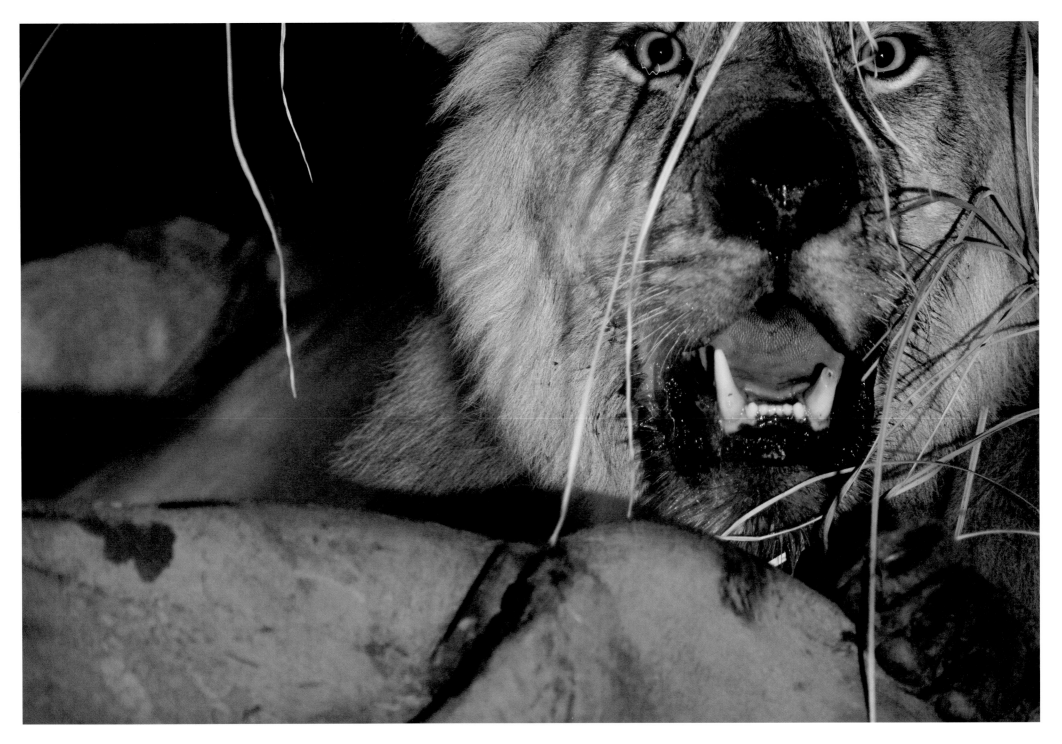

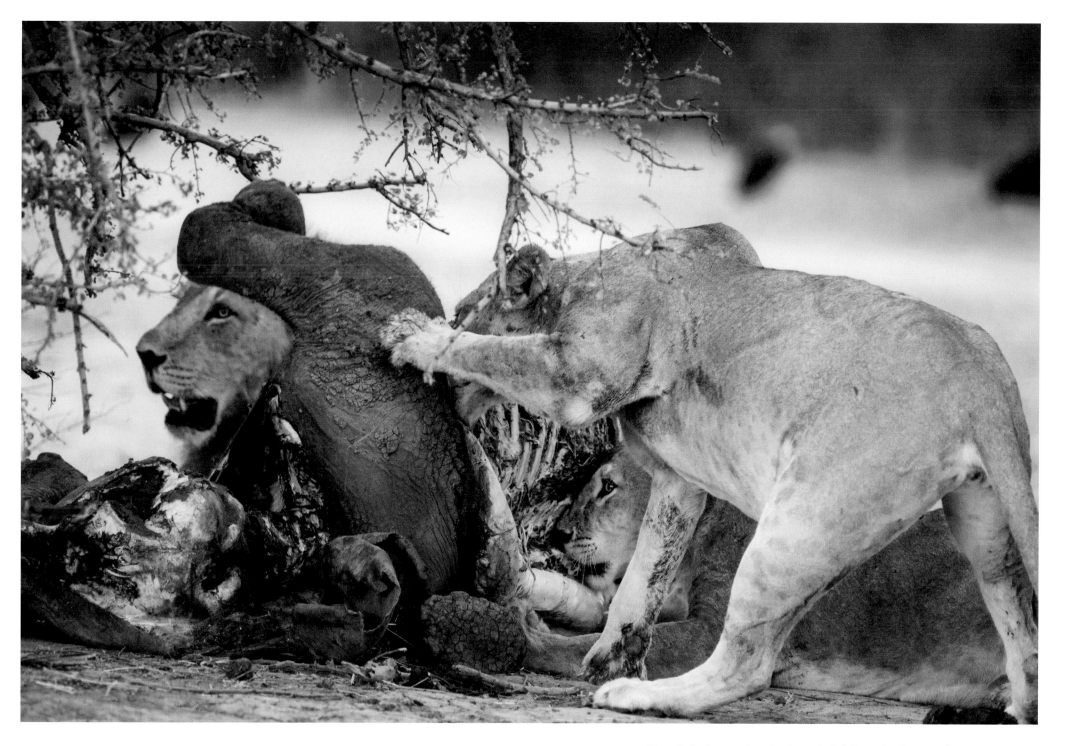

Many elephants are orphaned and unprotected; lions take advantage of the easy prey.

In January 2012 a hundred raiders on horseback charged out of Chad into Cameroon's Bouba Ndjidah National Park, slaughtering hundreds of elephants—entire families—in one of the worst concentrated killings since a global ivory ban went into effect in 1989. Carrying AK-47s and rocket-propelled grenades, they dispatched the elephants with a military precision reminiscent of a 2006 butchering outside Chad's Zakouma National Park. And then some stopped to pray to Allah. Seen from the ground, each of the bloated elephants is a monument to human greed. . . . From the air too the scattered bodies present a senseless crime scene— you can see which animals fled, which mothers tried to protect their young, how one terrified herd of 50 went down together, the latest of the tens of thousands of elephants killed across Africa each year. Seen from higher still, from the vantage of history, this killing field is not new at all. It is timeless, and it is now.

—*Bryan Christy,* "Ivory Worship," National Geographic *magazine, October 2012*

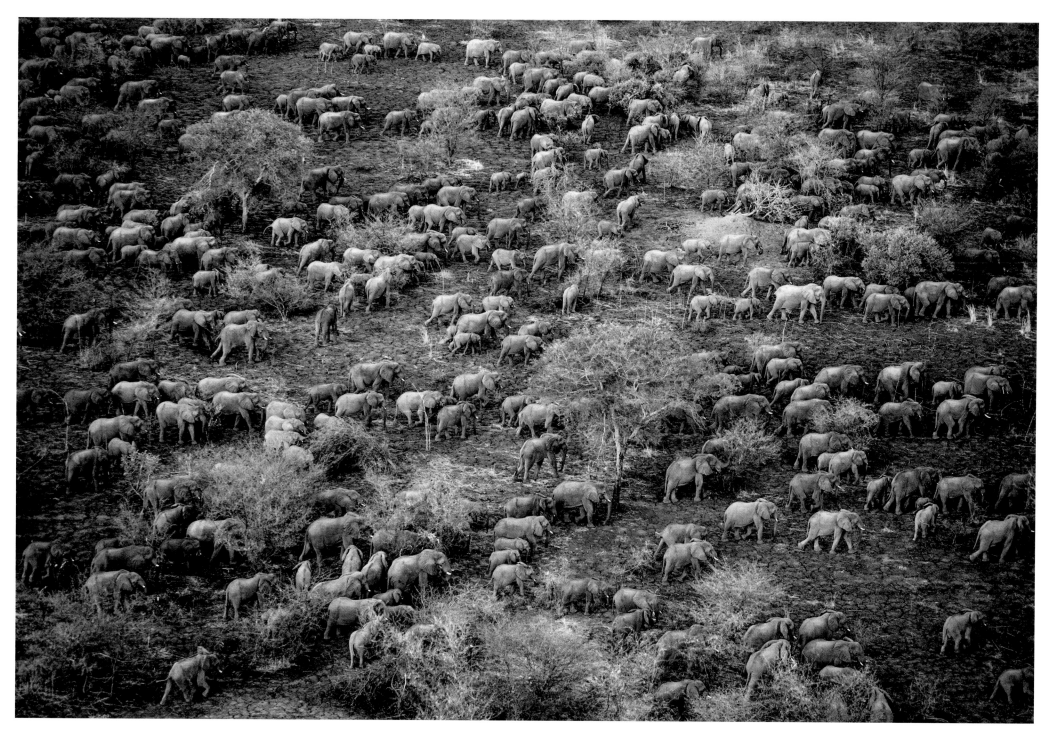

One night when a herd of eight hundred elephants left the park to look for fresh food, twenty were gunned down in an ambush.

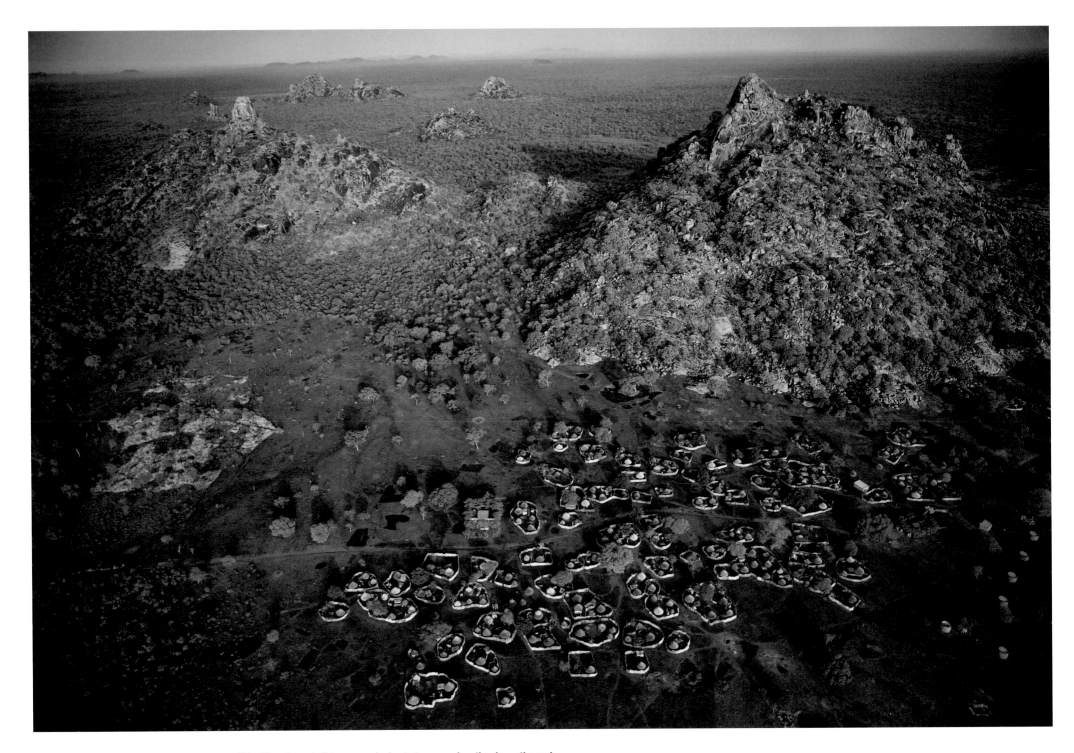

60 The area around Zakouma is very remote. This village is part of the range elephants traverse when they leave the park.

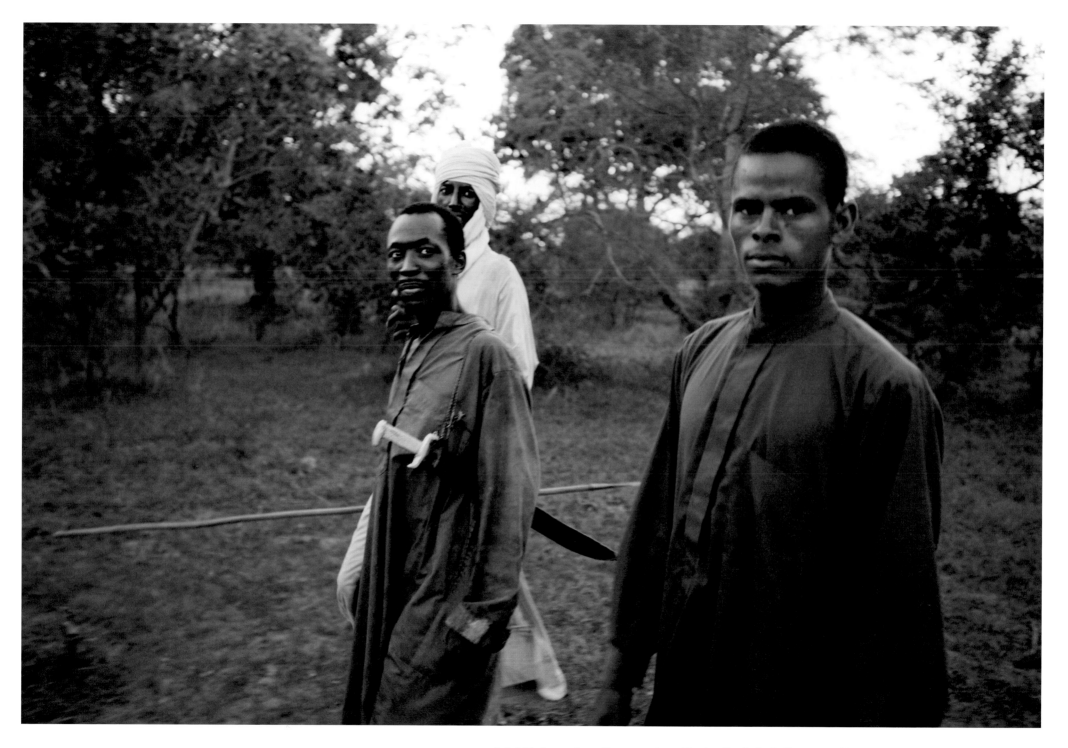

Animist Arab nomads use the same water and land as the elephants. These men told us they did not kill elephants for ivory. 61

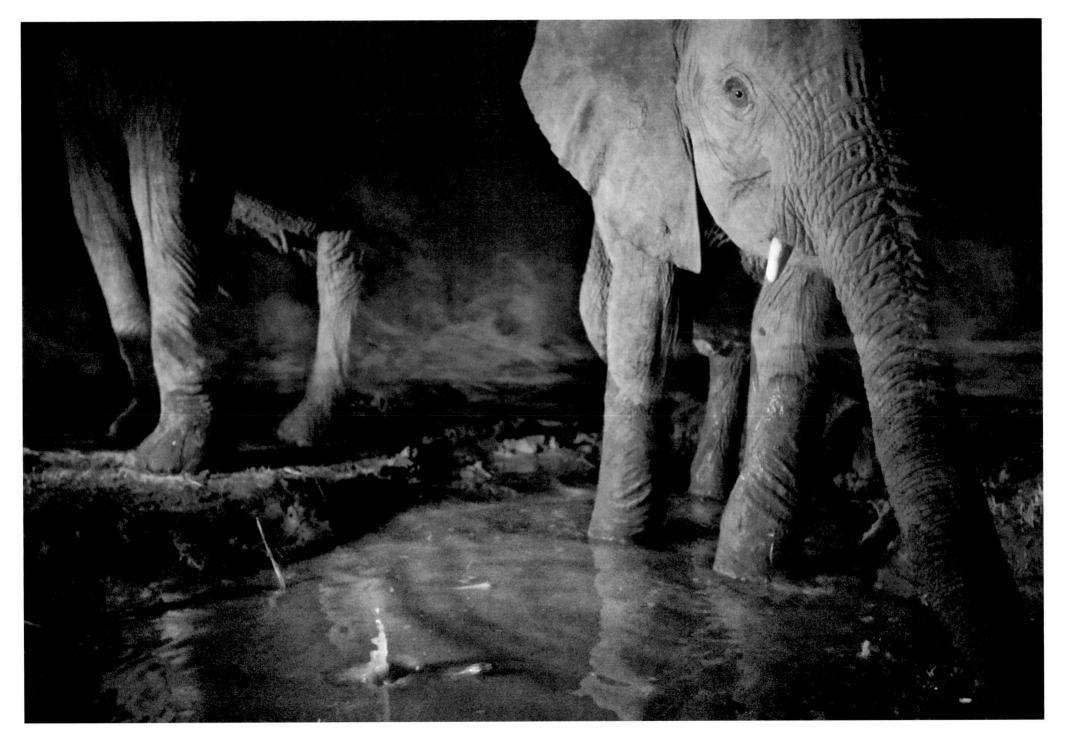

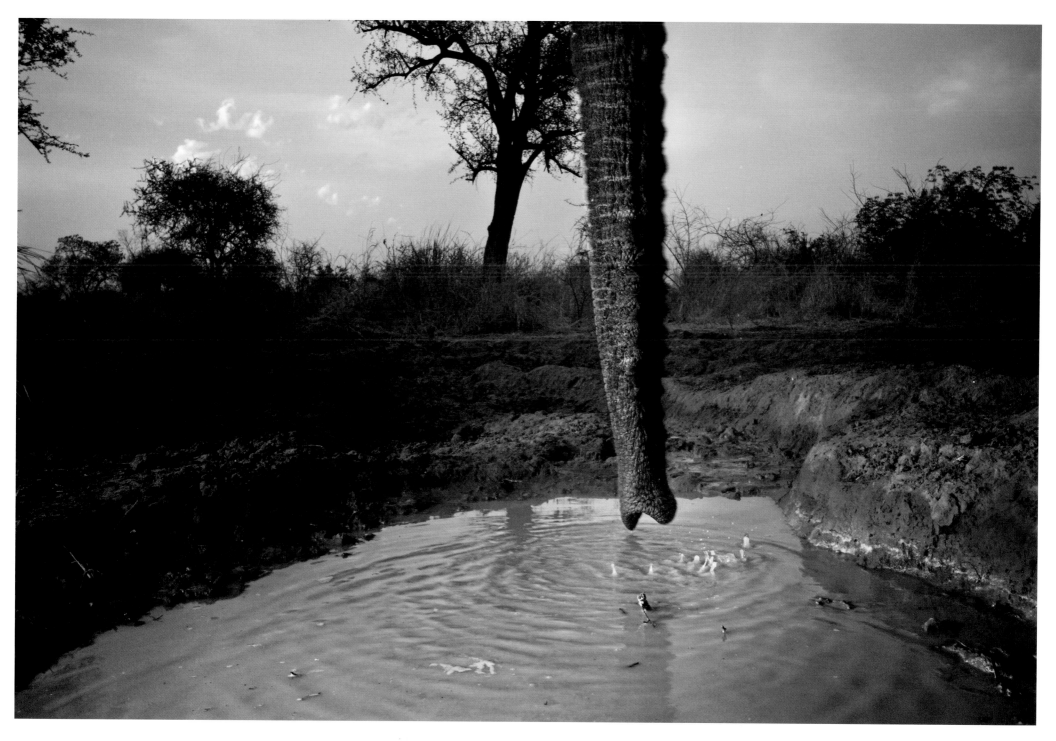

In the dry season, water is extremely precious. My camera trap was positioned by a small pool the elephants visited often. 63

If as recently as the end of the Vietnam War people were still balking at the idea that a soldier, for example, could be physically disabled by psychological harm—the idea, in other words, that the mind is not an entity apart from the body and therefore just as woundable as any limb—we now find ourselves having to make an equally profound and, for many, even more difficult leap: that a fellow creature as ostensibly unlike us in every way as an elephant is as precisely and intricately woundable as we are. . . .

They have no future without us. The question we are now forced to grapple with is whether we would mind a future without them, among the more mindful creatures on this earth and, in many ways, the most devoted. Indeed, the manner of the elephants' continued keeping, their restoration and conservation, both in civil confines and what's left of wild ones, is now drawing the attention of everyone from naturalists to neuroscientists. Too much about elephants, in the end—their desires and devotions, their vulnerability and tremendous resilience—reminds us of ourselves to dismiss out of hand this revolt they're currently staging against their own dismissal. And while our concern may ultimately be rooted in that most human of impulses—the preservation of our own self-image—the great paradox about this particular moment in our history with elephants is that saving them will require finally getting past ourselves; it will demand the ultimate act of deep, interspecies empathy.

—*Charles Siebert,* "An Elephant Crackup?," New York Times Magazine, *October 8, 2006*

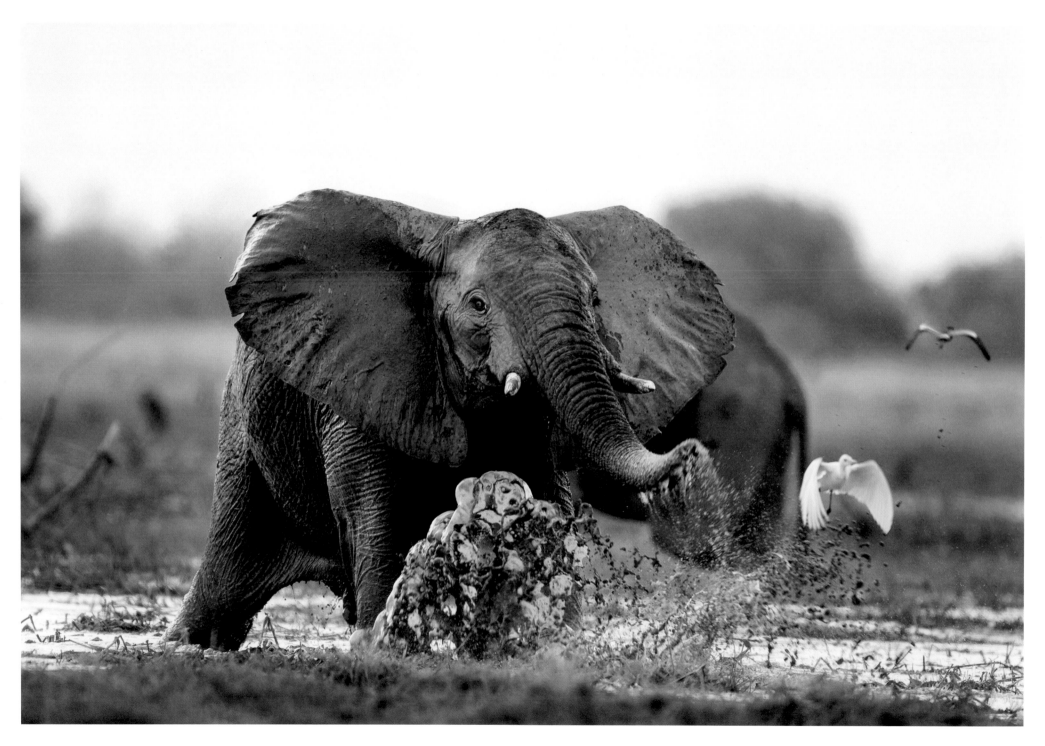

Mike Fay and I quietly approached these elephants, but they charged toward our scent when a distant park ranger accidentally fired his weapon. 65

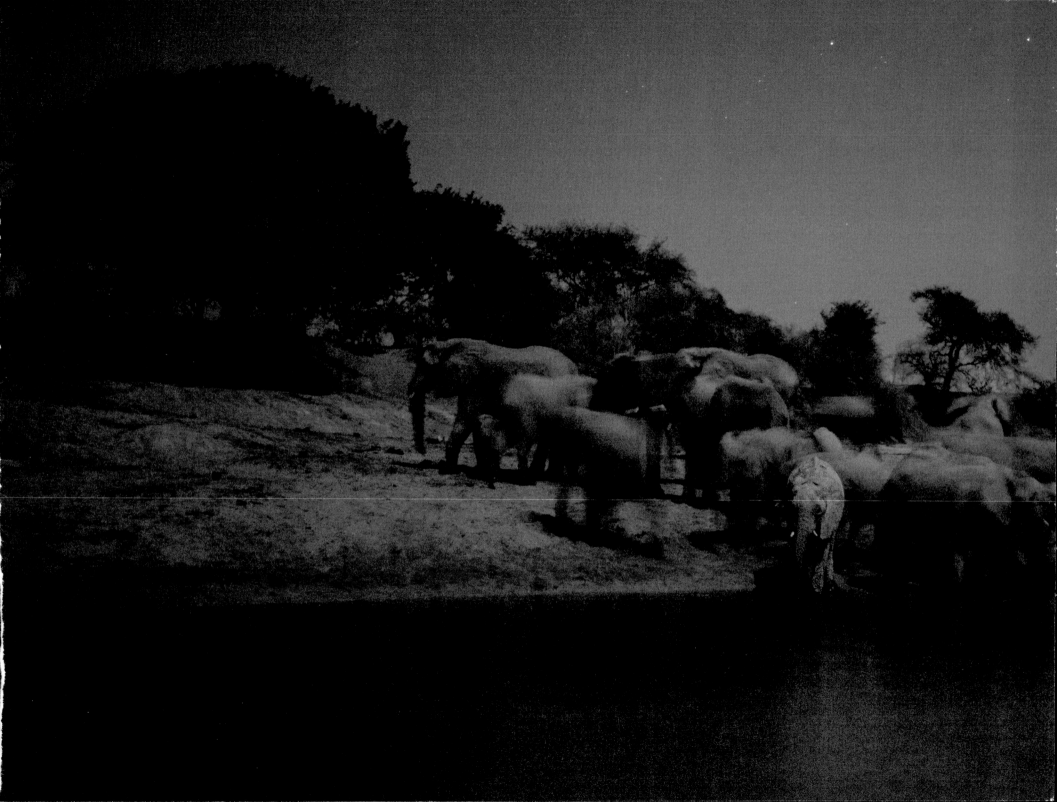

Mike Fay: We collared this one elephant, who we named Annie, on the 23rd of May.

Nick: She's given up information that's unbelievable. She tells us that when she leaves the park, she heads straight for this certain area of good vegetation. She also got out there and realized, these rains are fake rains! They came too early. So, she went back to the park and waited till the real rains had come. She runs all night, then she gets within a kilometer of a road, and she waits all day, till nightfall, and then she crosses the road, and she goes on up. She's telling us, hey, I'm thinking about this whole thing, I know where I'm going, I know what trees I'm looking for to eat, and I know where the roads are.

Mike: So, over about a three-month period, Annie traveled over a thousand miles. That's an amazing statistic.

Nick: But her collar stopped. And we think, oh no. She's been shot. 15th of August.

—*J. Michael Fay and Michael "Nick" Nichols, in* Ivory Wars: Last Stand in Zakouma, *video for* National Geographic *magazine, March 2007*

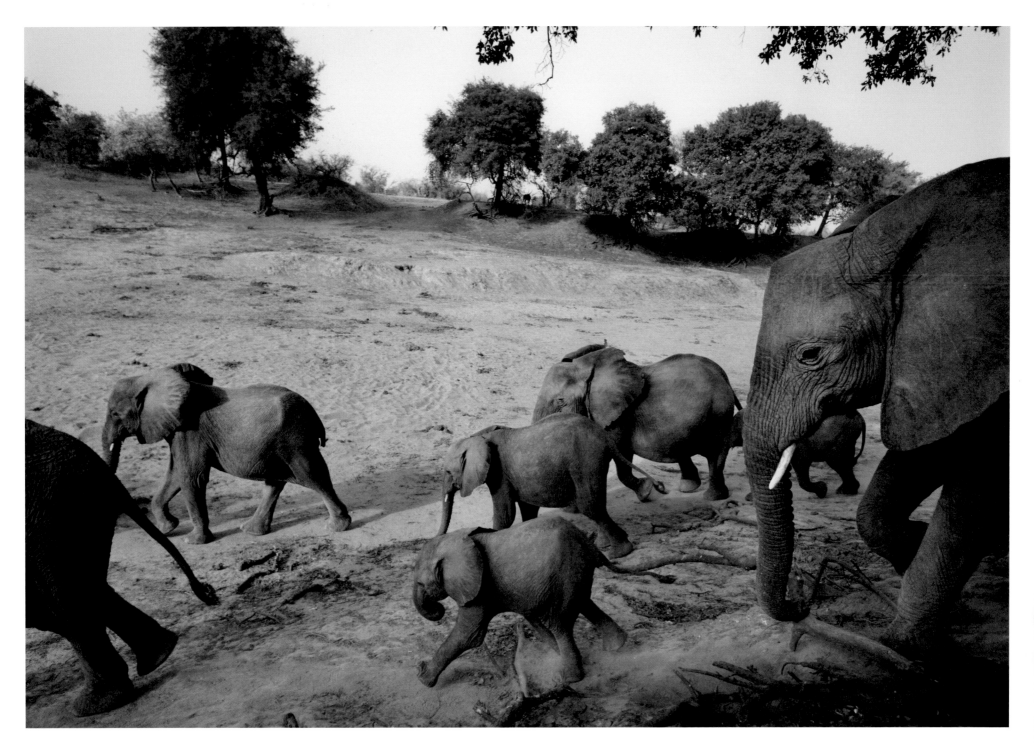

The best way to photograph the frightened Zakouma elephants was with camera traps positioned near water. Often several hundred would pass by at a time.

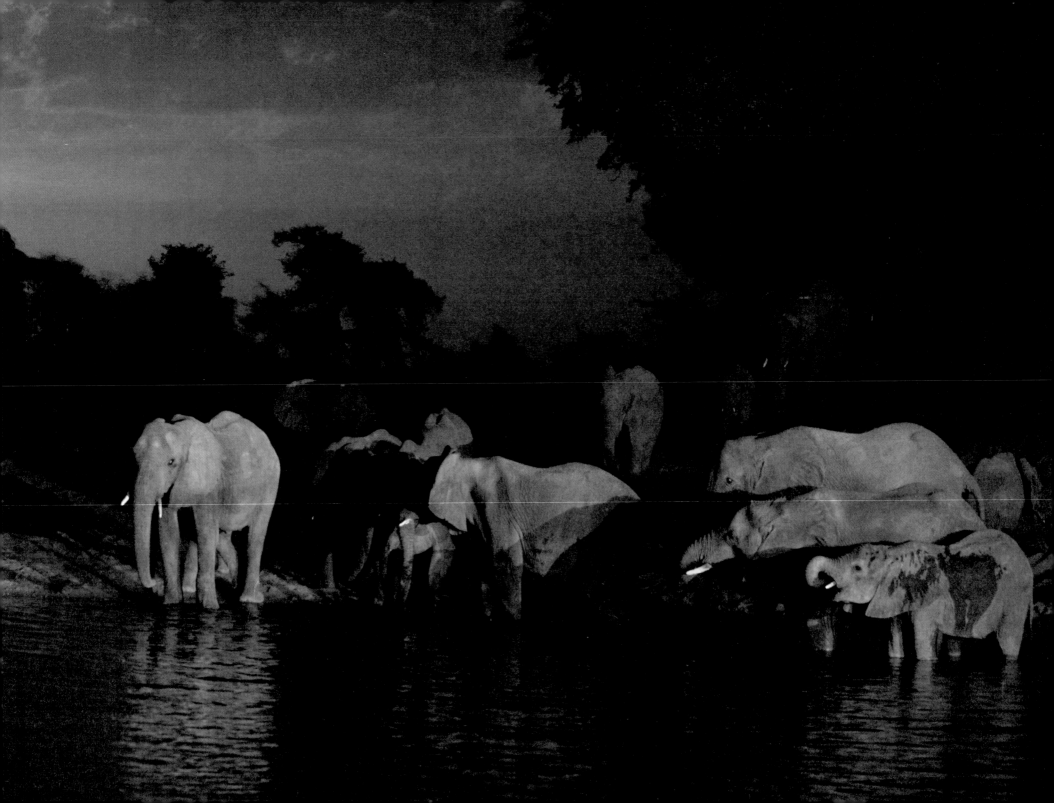

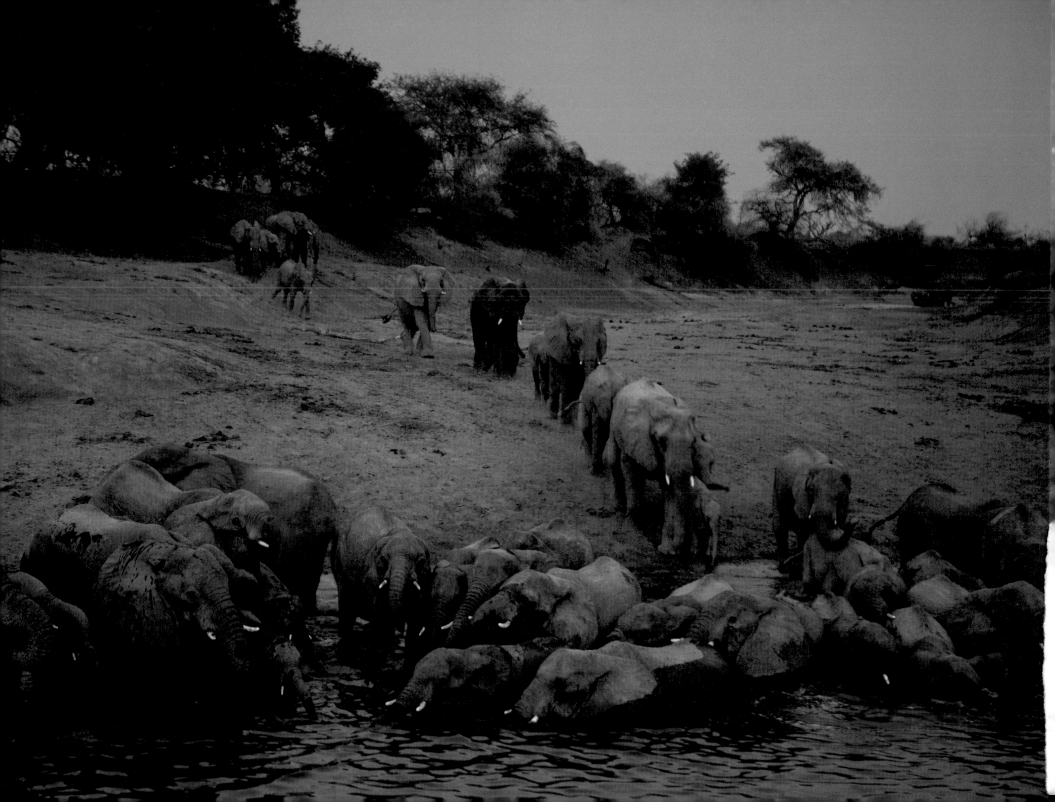

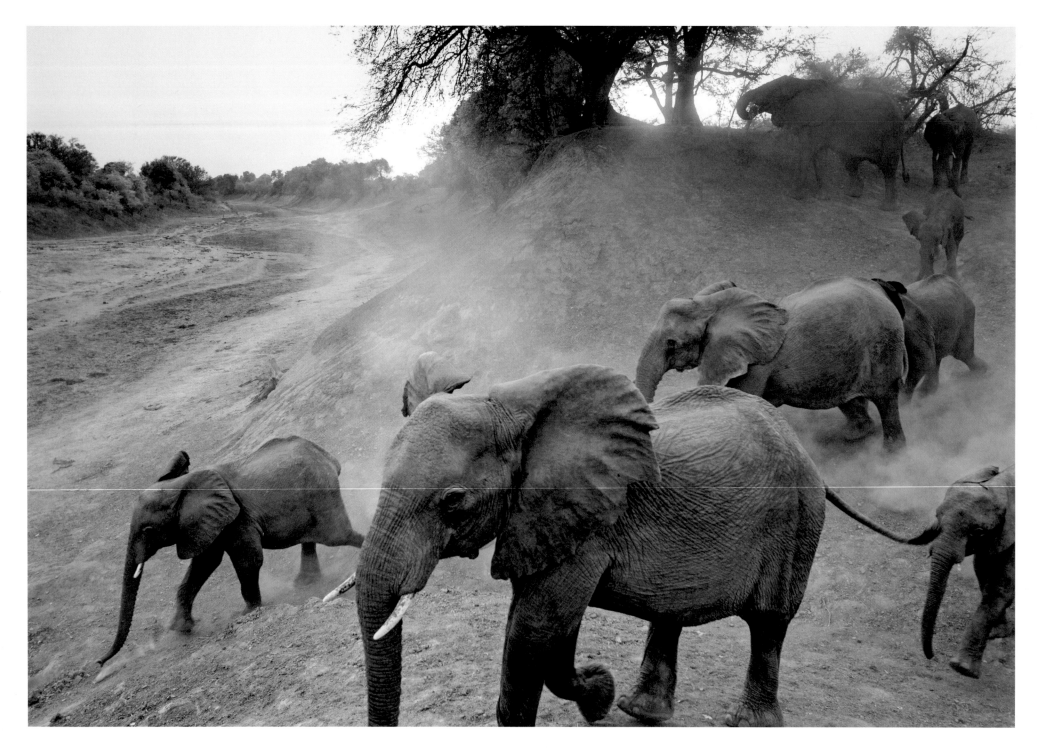

GATEFOLD: Nervous herds came at dusk and by moonlight to drink from a pool near our camp. Startled by any tiny sound, they often bolted before their thirst was quenched.

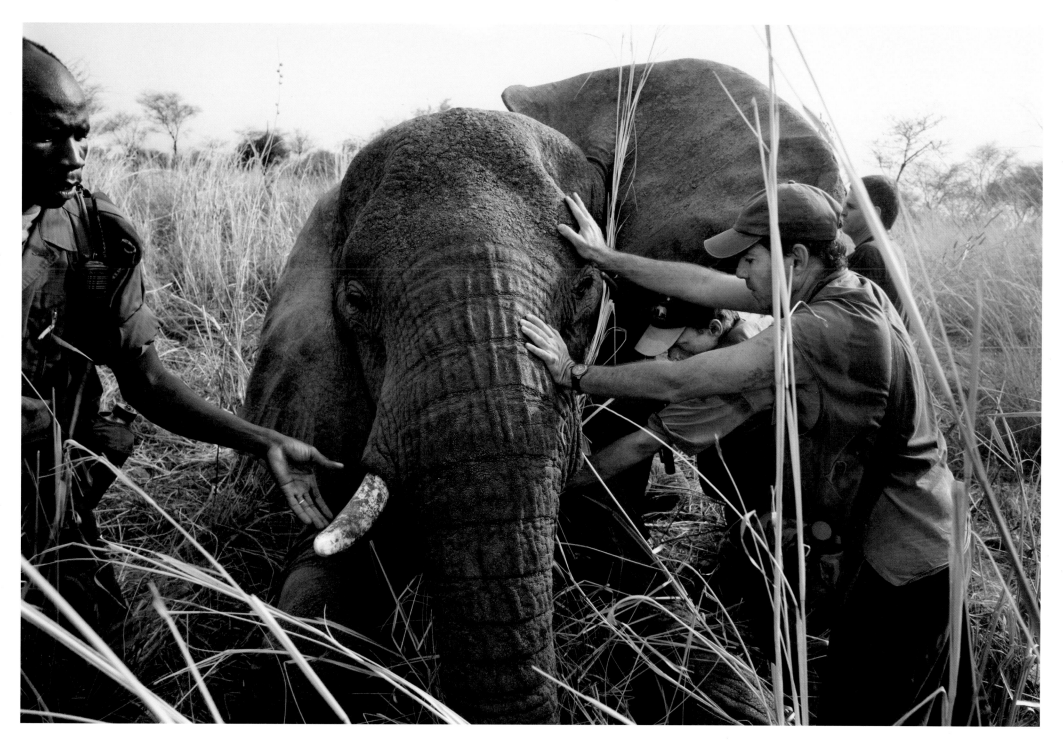

Mike Fay and Luis Arranz undertook a massive GPS collaring operation to find out where the Zakouma elephants go in the rainy season. 73

One of the things that affects me most is when you see a group of

elephants, and as soon as they smell you they start to run. Some of the females

come back to try to protect their young, but you can see the fear in all of

them. They're animals that wouldn't have to be afraid of anything in nature,

but after several centuries of being hunted in such a way, they have this panic

inside them. And it's going to take a lot of time for them to lose it, until

not even one remains that experienced that time period.

—*Luis Arranz*

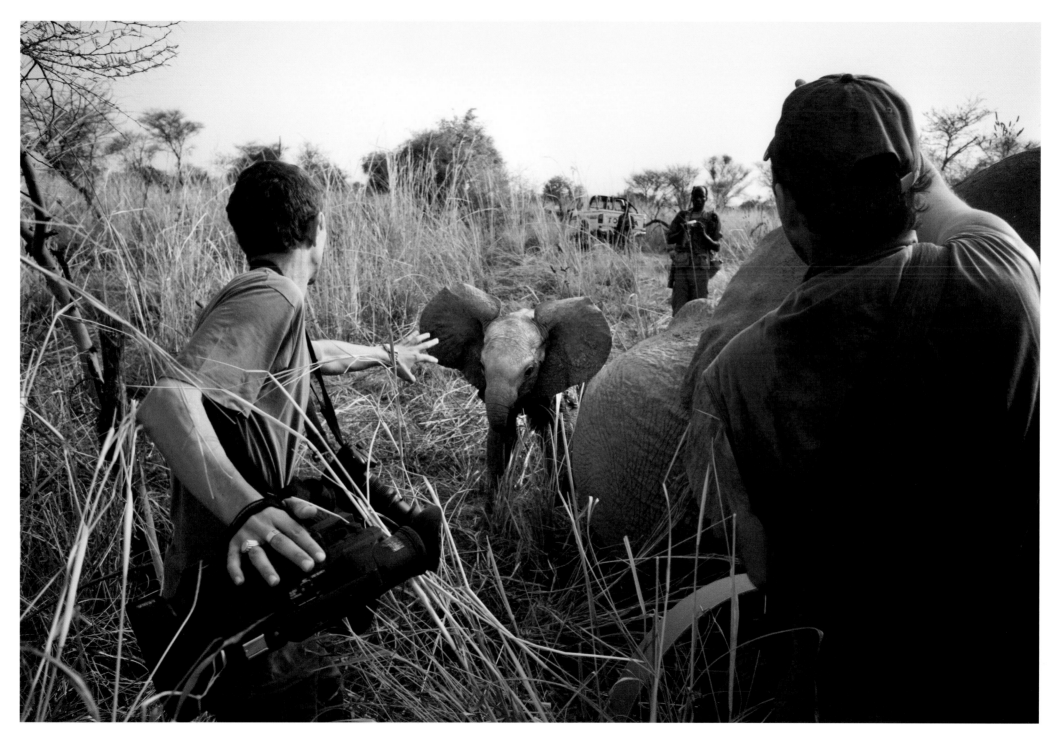

This matriarch elephant was one of the first to be collared. She provided valuable information—until the day she was shot.

The dead elephant, a huge bull, lay on his side, right leg curled as if in wrenching pain. Dirt covered the exposed eye—magic done by poachers to hide the carcass from vultures. The smell of musth and urine, of fresh death, hung over the mound of the corpse. It was a sight I had seen hundreds of times in central Africa. As I passed my hand over his body from trunk to tail, tears poured down my cheeks. I lifted the bull's ear. Lines of bright red blood bubbled and streamed from his lips, pooling in the dust. His skin was checkered with wrinkles. The base of his trunk was as thick as a man's torso. Deep fissures ran like rivers through the soles of his feet; in those lines, I could trace every step he had taken during his thirty years of life.

This elephant's ancestors had survived centuries of raiding by the armies of Arab and African sultans from the north in search of slaves and ivory. He had lived through civil wars and droughts, only to be killed today for a few pounds of ivory to satisfy human vanity in some distant land. There were tender blades of grass in his mouth. He and his friends had been peacefully roaming in the shaded forest, snapping branches filled with sweet gum. Then, the first gunshot exploded. He bolted, too late. Horses overtook him. Again and again, bullets pummeled his body. We counted eight small holes in his head. Bullets had penetrated the thick skin and lodged in muscle, bone, and brain before he fell. We heard forty-eight shots before we found him.

—*J. Michael Fay*, "Ivory Wars: Last Stand in Zakouma," National Geographic *magazine, March 2007*

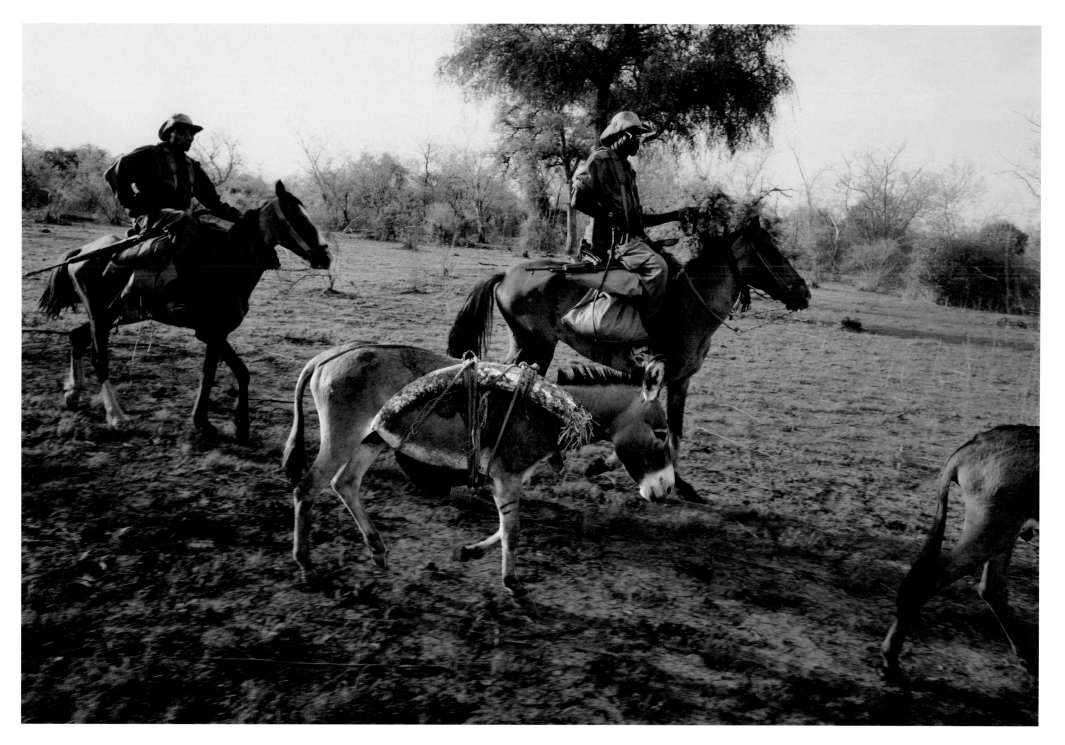

Arab militiamen known as Janjaweed ("devils on horseback") killed a bull elephant within earshot of the park's guard patrol.

At a gallery in Guangzhou, Gary Zeng shows me a photo of a 26-layer "devil's work" ball on his iPhone. The 42-year-old Zeng has just bought two of these ivory balls from the Daxin Ivory Carving Factory, one for himself and one on behalf of an entrepreneur friend. He's come to this retail store to see whether he got his money's worth. I climb into his new Mercedes, drive to his double-gated community, and watch as he hands the less expensive ball to his three-year-old for *National Geographic*'s Brent Stirton to photograph. It will become a centerpiece in a new home Zeng is building, to "hold the house against devils," but for a moment the $50,000 ball is simply a very precious toy. I ask Zeng why young entrepreneurs like him are buying ivory.

"Value," he replies. "And art."

"Do you think about the elephant?" I ask.

"Not at all," he says.

—*Bryan Christy,* "Ivory Worship," National Geographic *magazine, October 2012*

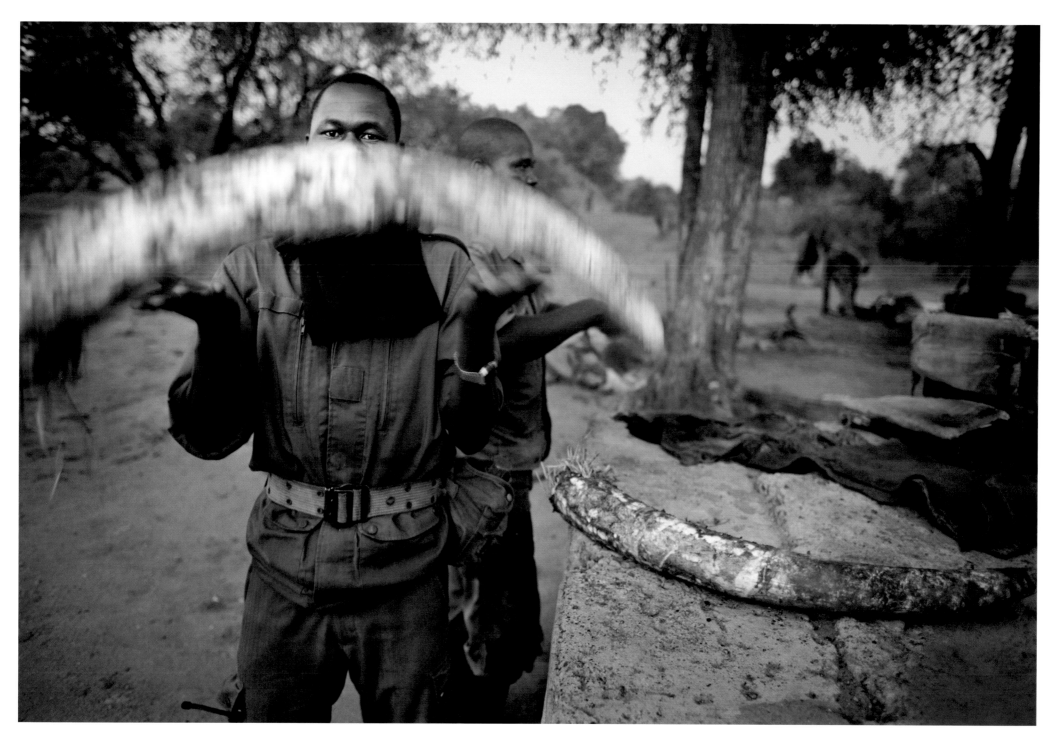

A century ago there were more than a million elephants in Chad. A recent survey tallied approximately four hundred. The attrition is caused primarily by the ivory market. 79

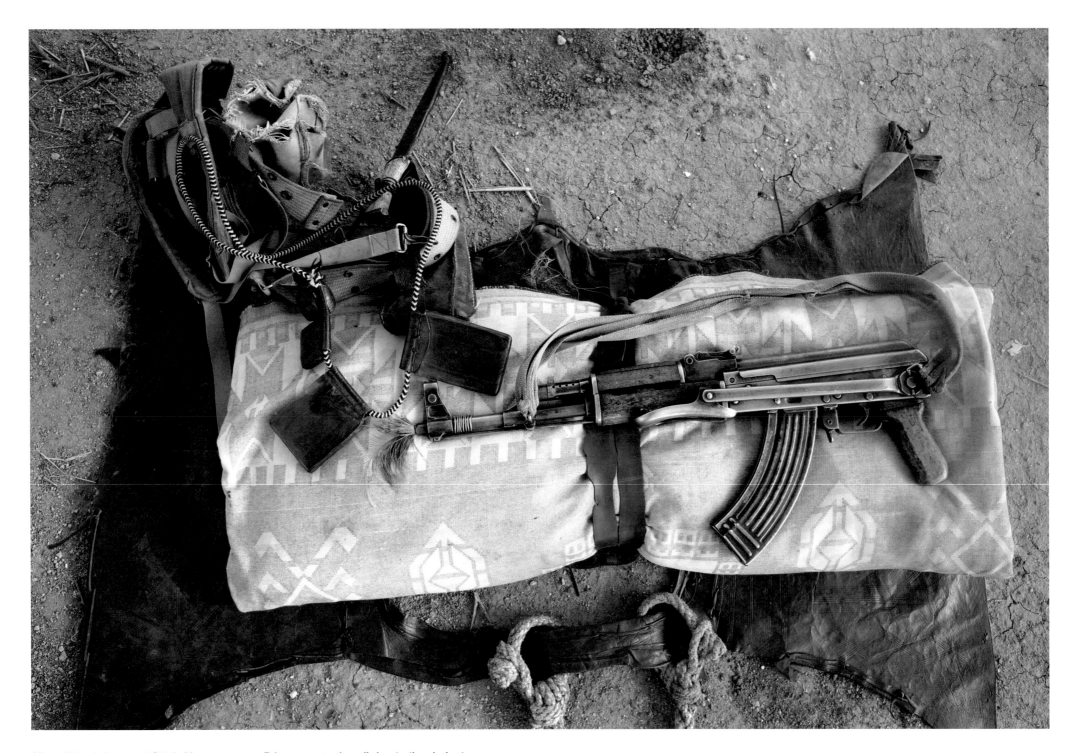

Although they are outfitted with weapons, many Zakouma rangers have died protecting elephants.

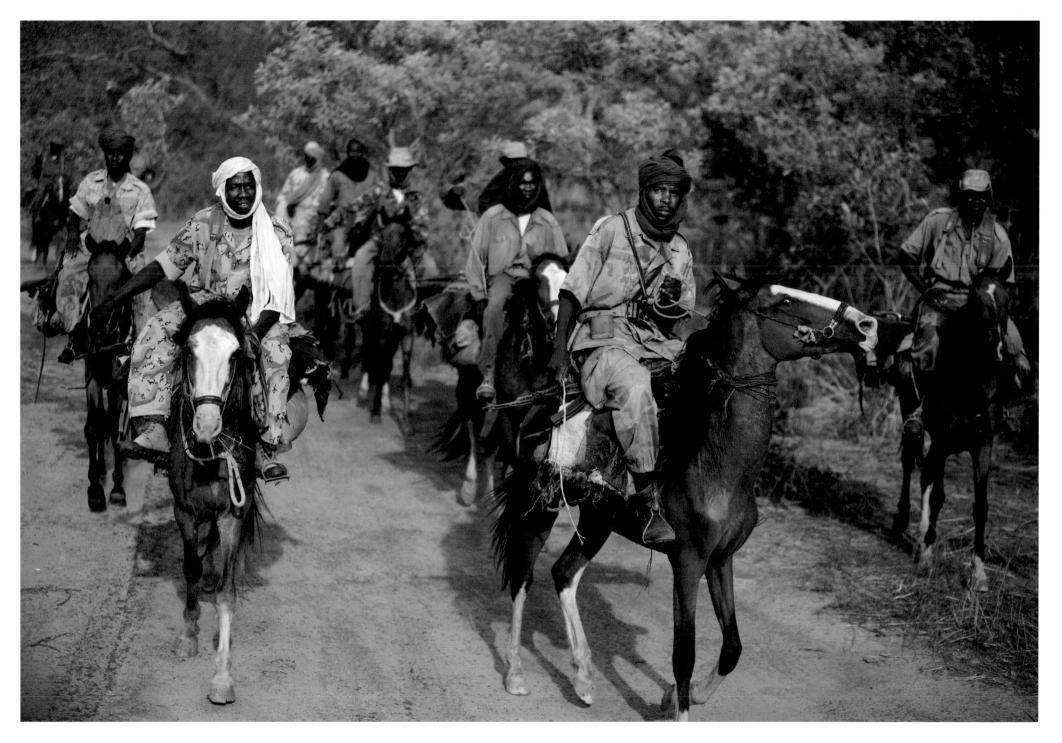

In 2012, while this book was being prepared, six more park workers were killed by Janjaweed gunmen. 81

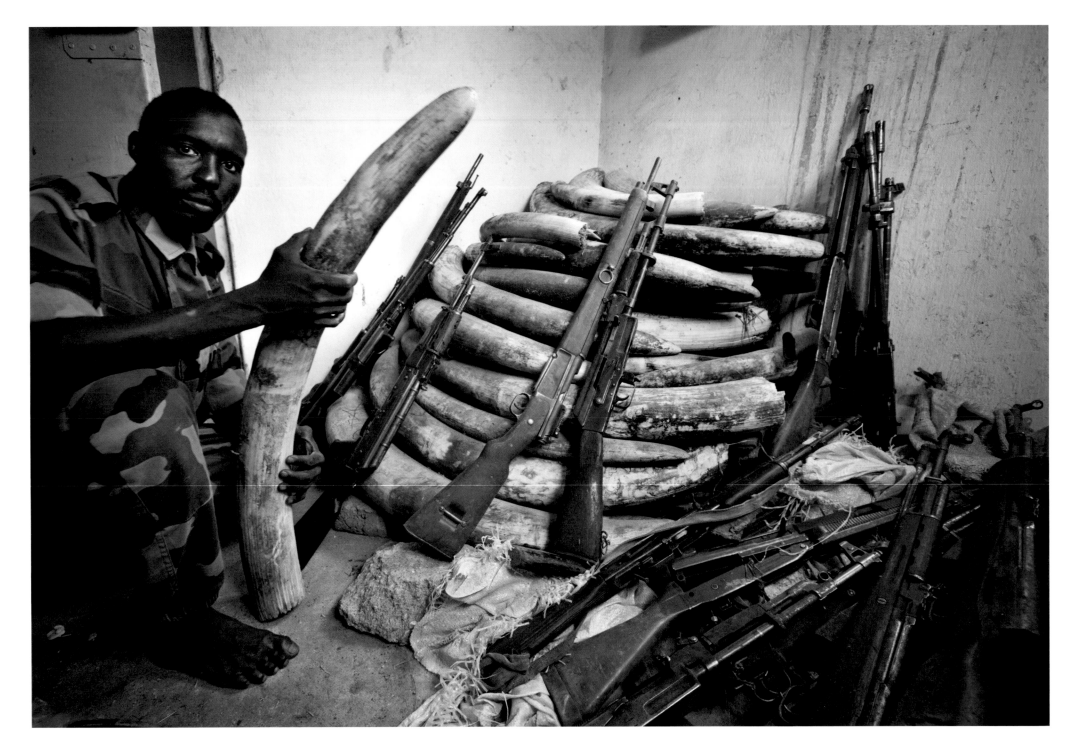

82 The storeroom of confiscated weapons and ivory at Zakouma was attacked in 2008; rangers and poachers were killed in the skirmish.

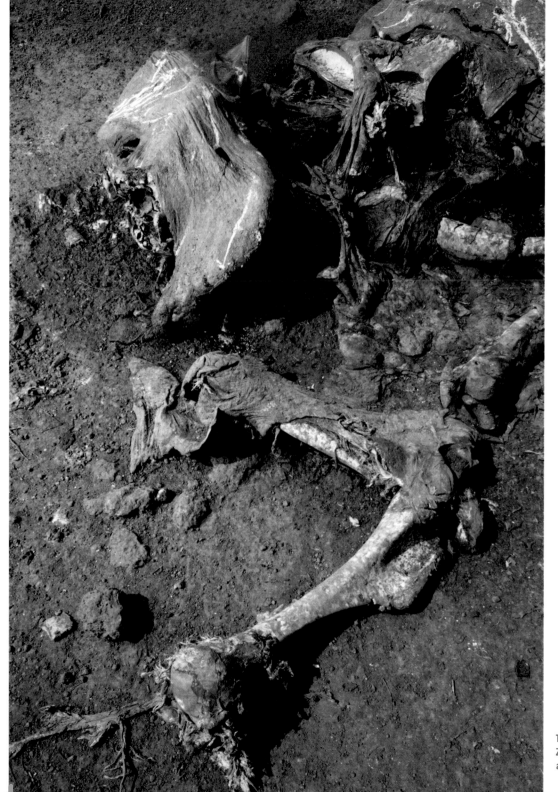

There are few adult elephants left in Zakouma. The last remaining elephants are terrified.

FAMILY TIES

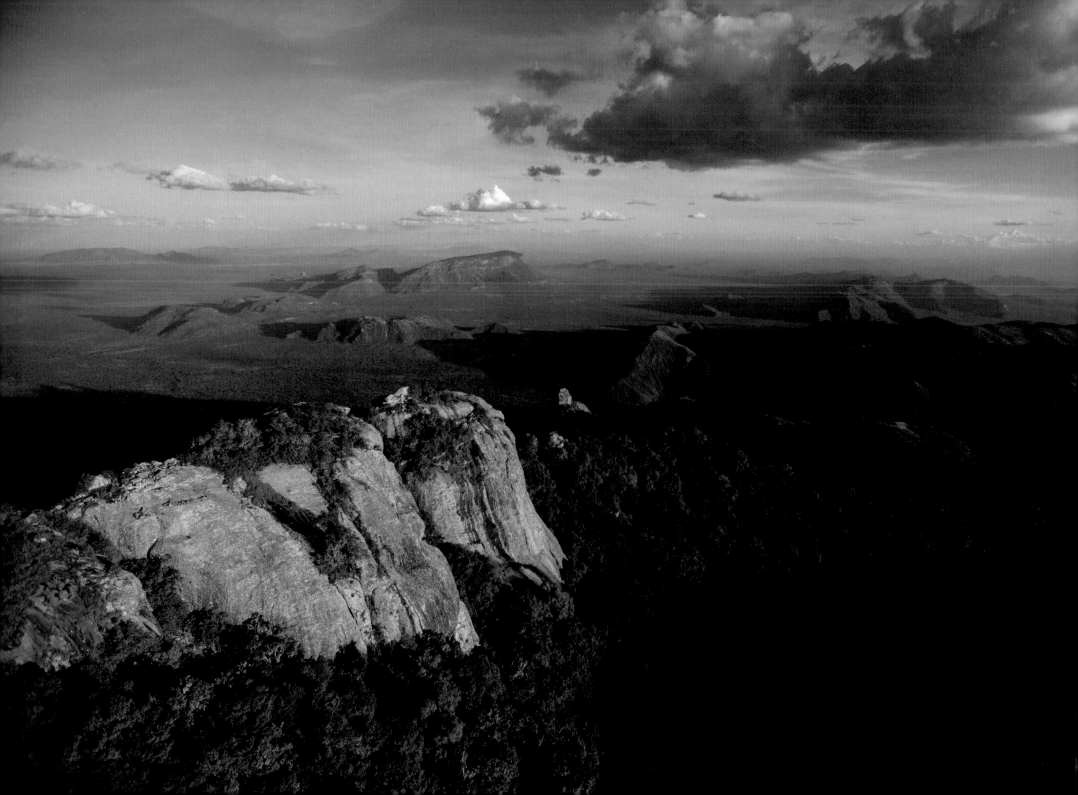

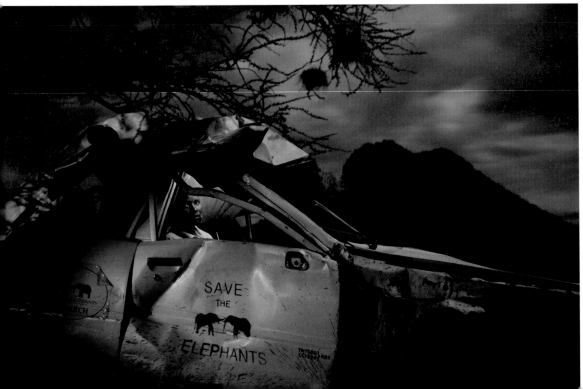

BIOLOGIST IAIN DOUGLAS-HAMILTON

is famous for his conservation work with elephants, and infamous for having nine lives: he has survived at least seven plane crashes while surveying the land from the air. Douglas-Hamilton's organization, Save the Elephants, based in northern Kenya's Samburu National Reserve, was founded in 1993; its purpose is protection and scientific study, and raising awareness of the existence and plight of the African elephant.

After witnessing fear and slaughter in Chad, I was happy to reach the relative calm of the reserve in 2007. There we met Daniel Lentipo, a young Samburu tribesman who had been a research assistant in scientist George Wittemyer's behavioral studies, and who continued the day-to-day monitoring of Samburu's elephants. Daniel could spot and identify almost any elephant, even from a great distance, and knew its given name and the name of its family.

The elephants were protective and suspicious on first meeting, but I found if we were well behaved—following elephant etiquette, letting them make the first approach—eventually they were comfortable enough for us all to doze under a shade tree together. One key to getting close to elephants is consistency: driving the same car (our Land Rover purred—a sound the elephants seem to like), wearing the same clothes, putting out the same odor. All this helps a matriarch recognize when there is no threat.

Upon encountering the elephants, we would park the car, allowing them room to decide what they wanted to do—feed, play, sleep. If I drove in among them too quickly, I would get the dreaded head shake, which meant I'd been very rude. If I parked in a place where they wanted to be, we would find our car surrounded, elephants close in on all sides—snoring, grazing, passing methane, standing over their babies. Those moments of closeness were gifts from Samburu I will never forget.

I'm no "elephant whisperer." Elephants and humans are vastly different—but there were times when the gulf between us seemed very narrow. With the benefit of Daniel Lentipo's interpretation, I was able to document them with an intimacy I had only dreamed of. I opened myself up and looked hard without blinking for those months. Daniel and Save the Elephants provided family histories; each elephant became an individual with a past and present. Each simple photograph of an animal thus took on new weight, meaning, and narrative.

I believe it was my time in Samburu that gave me a new perspective on the world and our place in it. When you begin to experience the overwhelming complexity of nature, it becomes much harder to make decisions that are human-centric. Although I still have far to go in learning that, I wanted to give people a glimpse into the truth that we humans need to step up and take responsibility for our stewardship over this living place.

Samburu seemed an idyll of safety and serenity during my visits there; sadly, it is now under fire. In 2010, after my time shooting there, Save the Elephants was devastated by a flash flood that destroyed virtually the entire study station, and today, the area—like so many others in Africa—is beset by challenges from poaching.

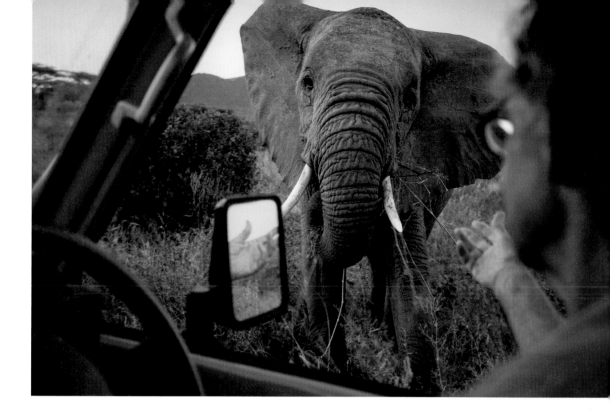

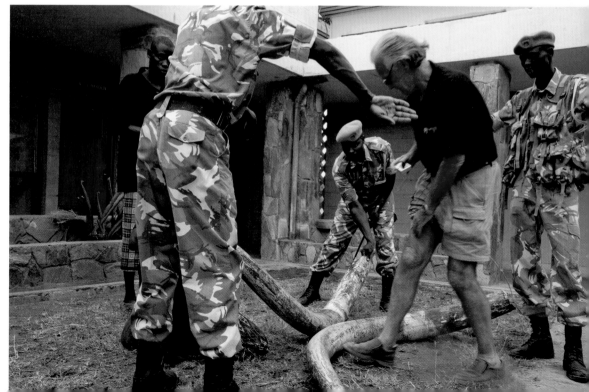

The "Family Ties" images were all made in or around Samburu National Reserve in Kenya in 2007, with the generous support of Save the Elephants. The elephant families were given names as part of an STE behavioral study initiated by scientist George Wittemyer.

PREVIOUS PAGE: The sacred mountains of northern Kenya's Samburu tribe, pastoralists who tend to their treasured cattle, as well as sheep and goats, and who share the land peacefully with elephants. **OPPOSITE, TOP:** Since the 1970s, Iain Douglas-Hamilton has flown small craft surveying the land that elephants use and need for survival. **OPPOSITE, BOTTOM:** Daniel Lentipo, our guide and interpreter with the elephants, survived a car-crushing run-in with a musth-crazed bull. **THIS PAGE, TOP:** The Samburu elephants can be approached, as long as you obey the rules of elephant etiquette. **THIS PAGE, BOTTOM:** Douglas-Hamilton helped the Kenya Wildlife Service with an investigation into the shooting of Samburu's largest bull; ultimately the death was classified as land-conflict killing, not poaching.

Purists might say that it is dangerous naming animals in a scientific study because one might associate names with people one has known and then impose that person's characteristics on the animal. I know that none of us who have worked on the project has found this. An elephant is so much its own being that it soon overshadows any association with a name. I, however, have the opposite problem now. When I am introduced to a person named Amy or Amelia or Alison, across my mind's eye flashes the head and ears of that elephant.

—*Cynthia Moss,* Elephant Memories: Thirteen Years in the Life of an Elephant Family, *1988*

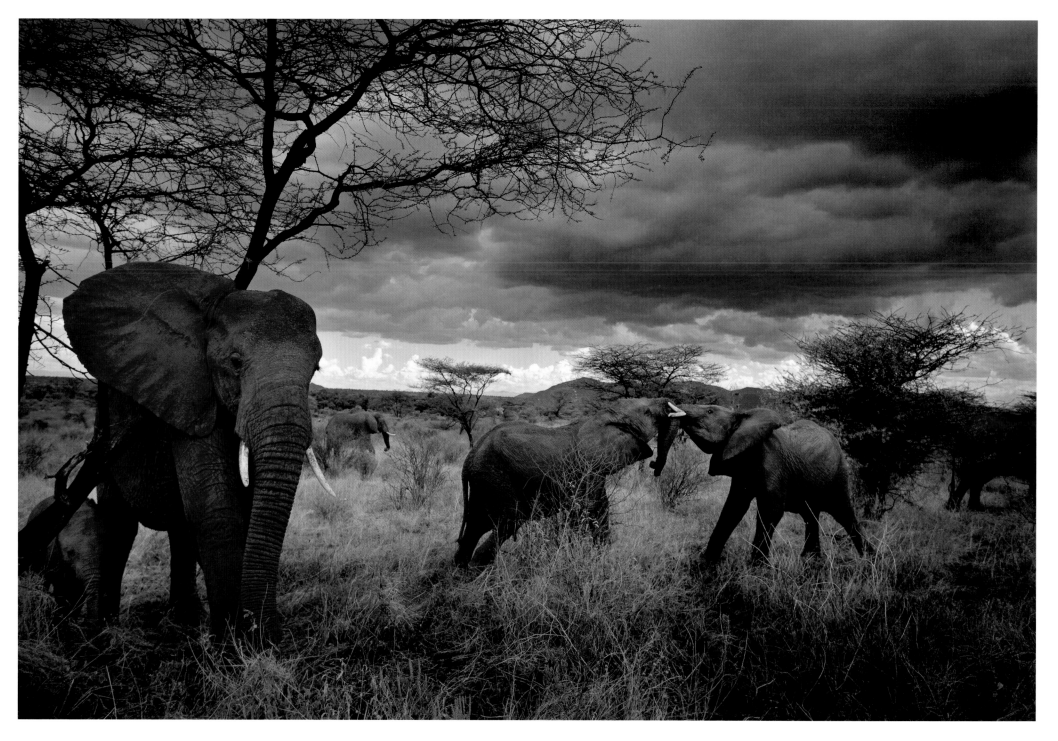

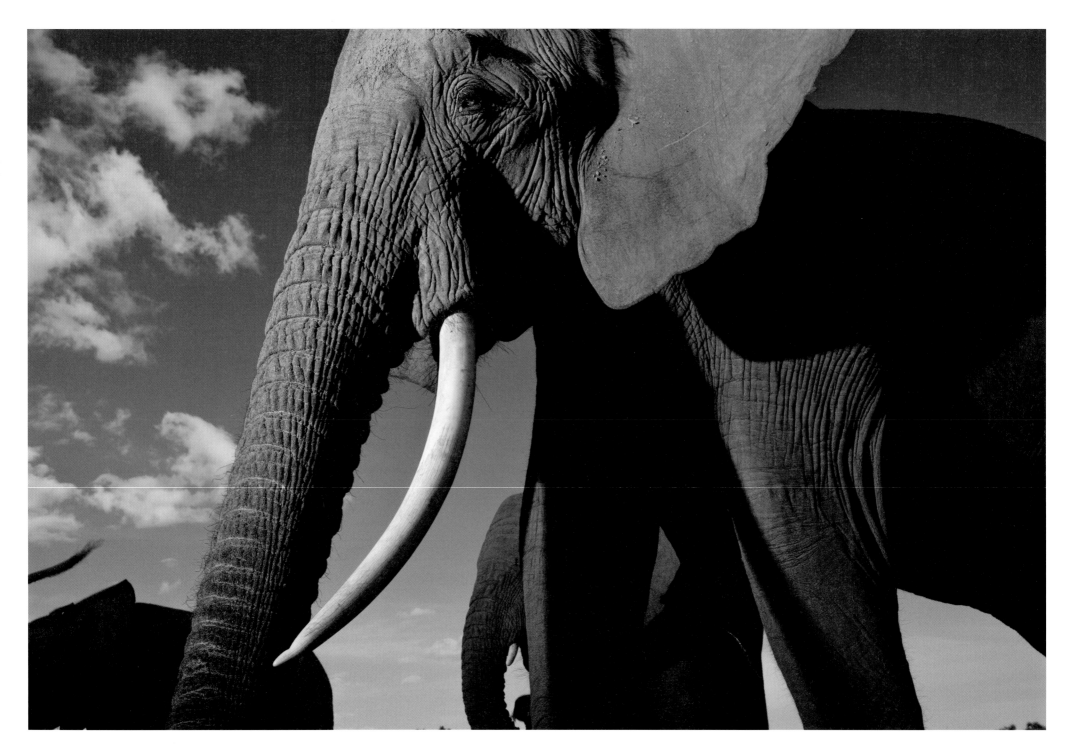

92 Victoria of the Royals, the most powerful family in Samburu.

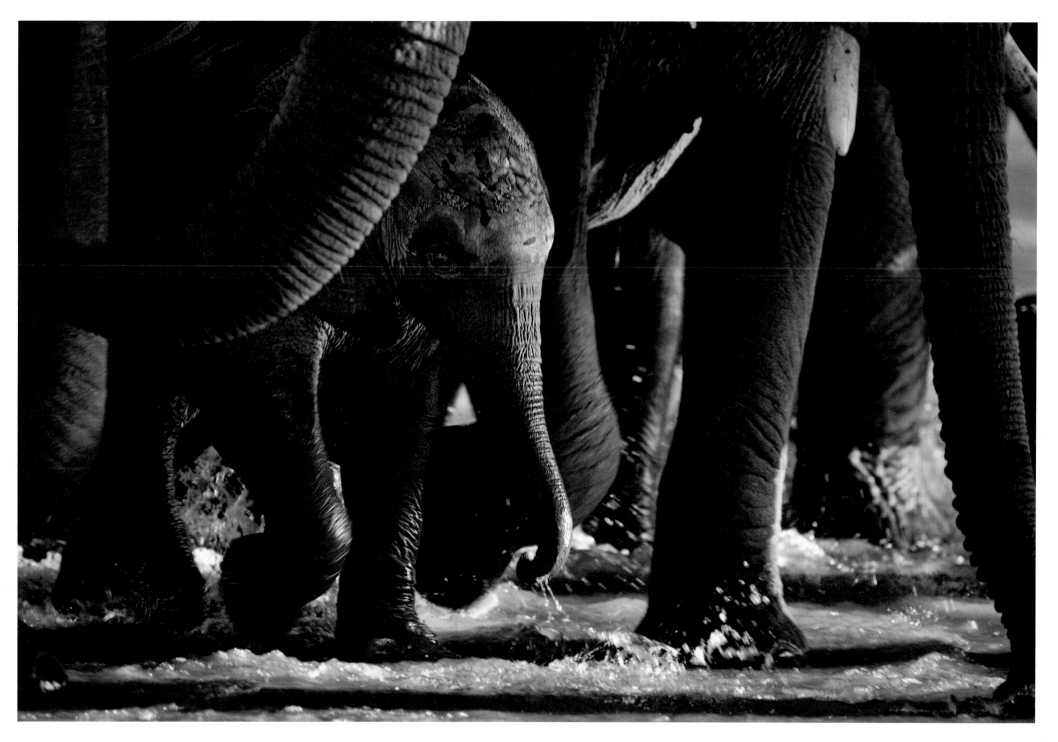

A newborn of the Kenyan Mountains family crosses the Ewaso Ngiro River, sheltered under the legs of family members. 93

Of the cardinal incentives that drive elephant behavior—that is, Douglas-Hamilton's three S's: sex, sustenance, and security—the most difficult to calibrate is the third. Finding food, finding water, and finding reproductive opportunities aren't always simple tasks, but compared with finding security they are relatively straightforward. Real security, lasting security, is more unpredictable and elusive. The local people have a word for it: *neebei*. Every person wants neebei—freedom from danger, menace, uncertainty, fear—and it's not anthropomorphism to say that every elephant does too.

—*David Quammen*, "Family Ties: The Elephants of Samburu," National Geographic *magazine, September 2008*

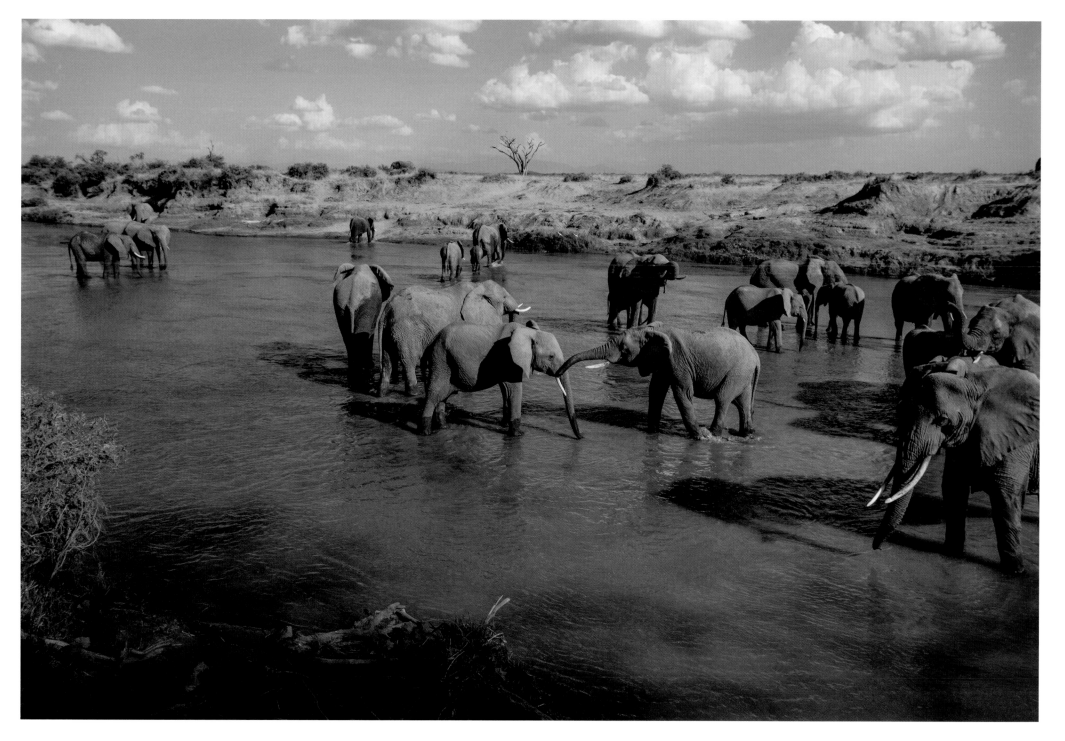

Each dry season day in the Samburu National Reserve brings elephant families to the river to drink and socialize before heading for the surrounding mountains to forage.

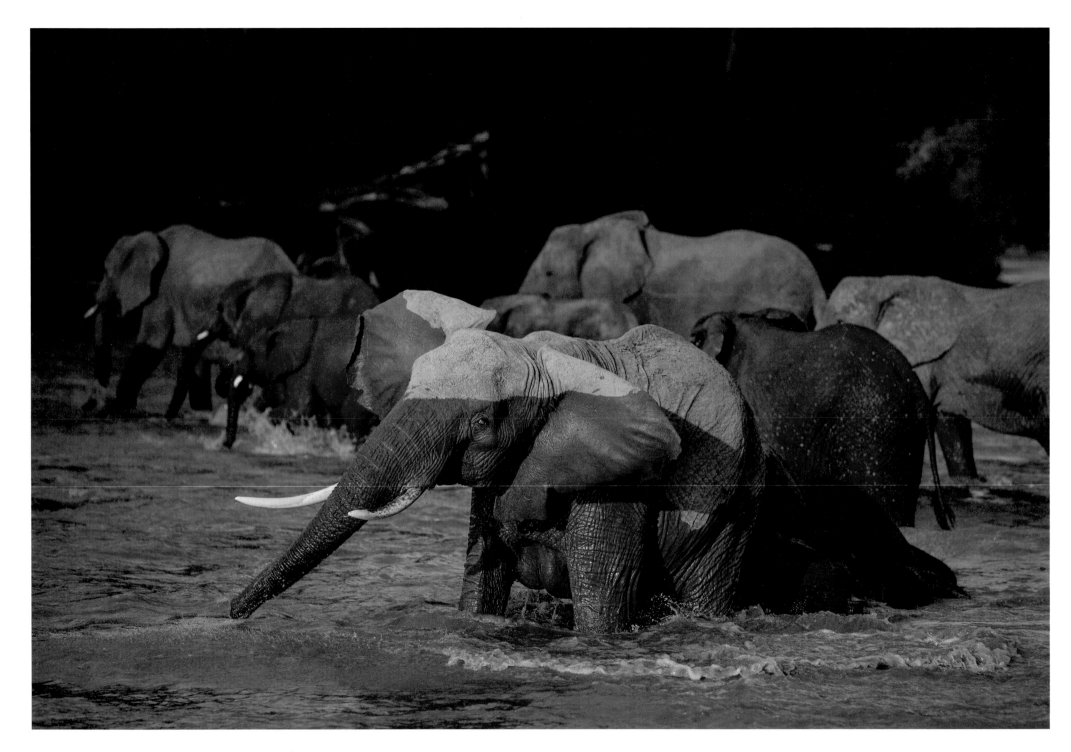

In the evening the Shakespeare Ladies and the Rivers families play and interact.

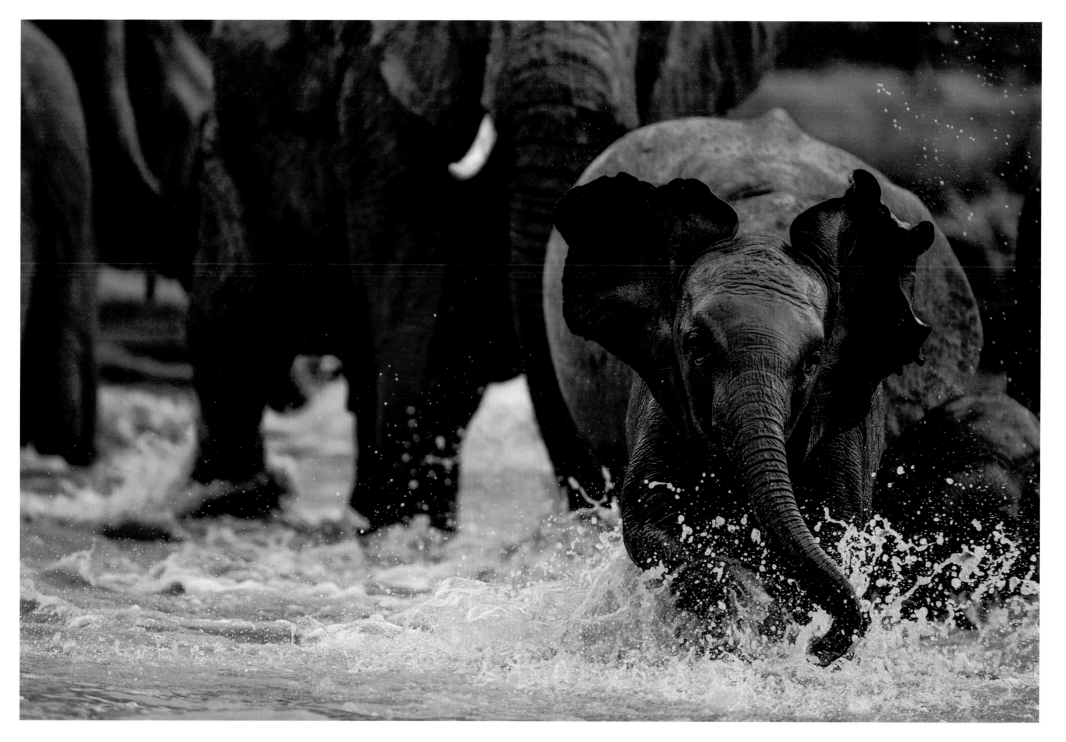

Beyond the family groupings are clans that know each other and travel together when they leave the reserve to forage. Here members of the Spice Girls clan chase the Samburu Ladies out of the river.

A silent, orderly column of cows, towering above young of all sizes, filed thirty yards in front of us, their flanks blue-gray in the shadow. Where their heels scuffed the ground there were bursts of incandescent dust. Some ten crossed peacefully and then the younger females scurried over, turning to look sideways at us with heads held high and backs arched. As soon as they were safely across and almost hidden by bushes they wheeled in unison as if at an order. A gust of wind wafted our scent in their direction. Ears flared and a row of trunks performed a snake dance, waving sinuously above the line of their massive heads, sampling our smell and afterwards expelling their breath with a whoosh. Although their faces were relatively immobile, the infinite variety of trunk postures and movements lent the elephants all the expressiveness of a primate's visage.

—*Iain Douglas-Hamilton,* Among the Elephants, *1975*

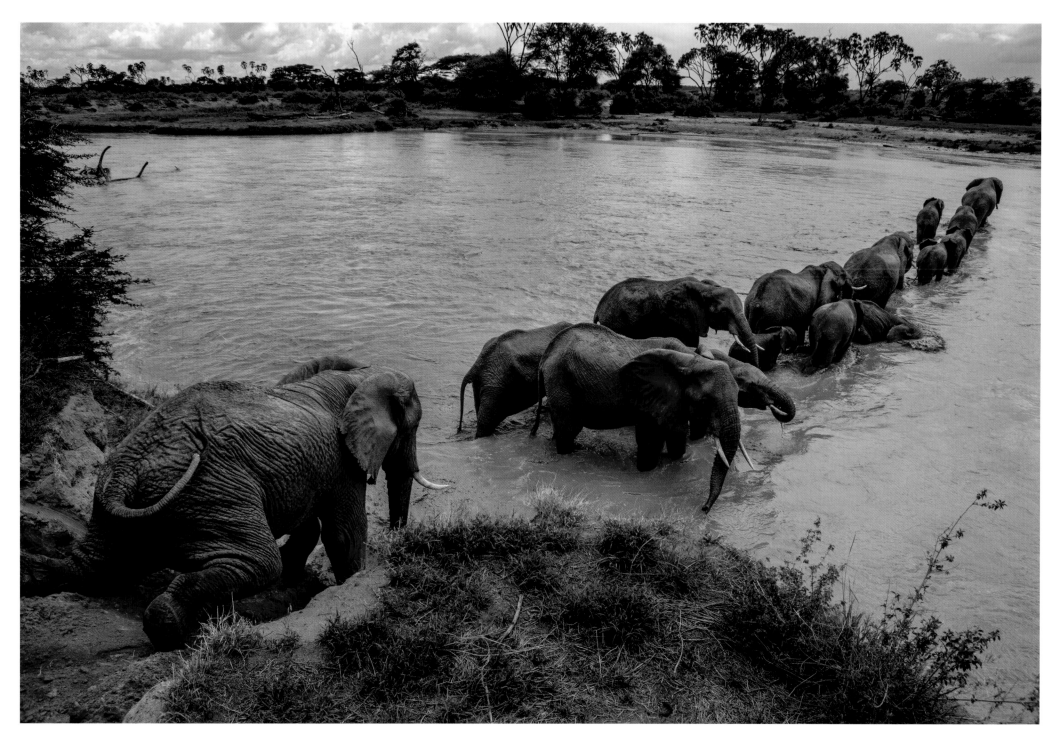

The Winds are led across the river by their matriarch, Mistral, while a younger female, Sydoest, stands ground to discourage a breeding male that seems intent on following. 99

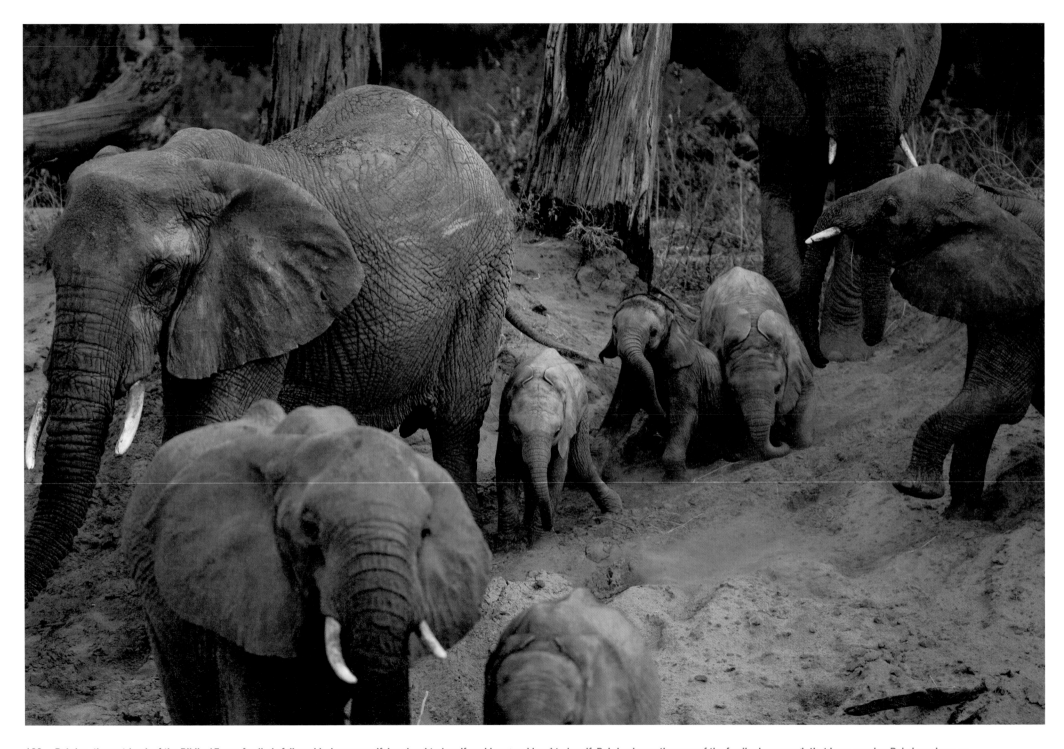

100 Babylon, the matriarch of the Biblical Towns family, is followed by her own calf, her daughter's calf, and her granddaughter's calf. Babylon keeps the pace of the family slow enough that lame member Babel can keep up.

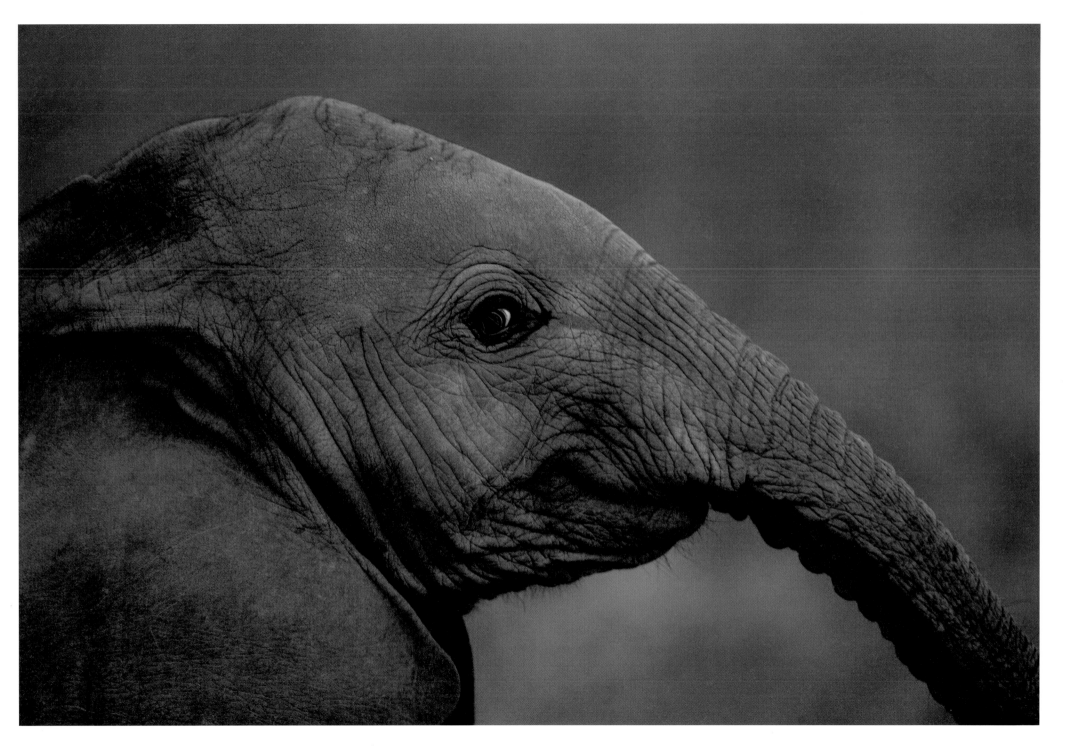

Elephant babies often play until they are exhausted. Youngsters are sometimes escorted by an older sibling back to the mother when the play gets too rough.

Tina could go no farther. The blood pouring from her mouth was bright red and her sides were heaving for breath. The other elephants crowded around, reaching for her. Her knees started to buckle and she began to go down, but Teresia got on one side of her and Trista on the other and they both leaned in and held her up. Soon, however, she had no strength and she slipped beneath them and fell onto her side. More blood gushed from her mouth and with a shudder she died. Teresia and Trista became frantic and knelt down and tried to lift her up. They worked their tusks under her back and under her head. At one point they succeeded in lifting her into a sitting position but her body flopped back down. Her family tried everything to rouse her, kicking and tusking her, and Tallulah even went off and collected a trunkful of grass and tried to stuff it into her mouth. . . . They gave up then but did not leave. They stood around Tina's carcass, touching it gently with their trunks and feet. Because it was rocky and the ground was wet, there was no loose dirt; but they tried to dig into it with their feet and trunks and when they managed to get a little earth up they sprinkled it over the body. . . . By nightfall they had nearly buried her with branches and earth. Then they stood vigil over her for most of the night and only as dawn was approaching did they reluctantly begin to walk away.

—*Cynthia Moss,* Elephant Memories: Thirteen Years in the Life of an Elephant Family*, 1988*

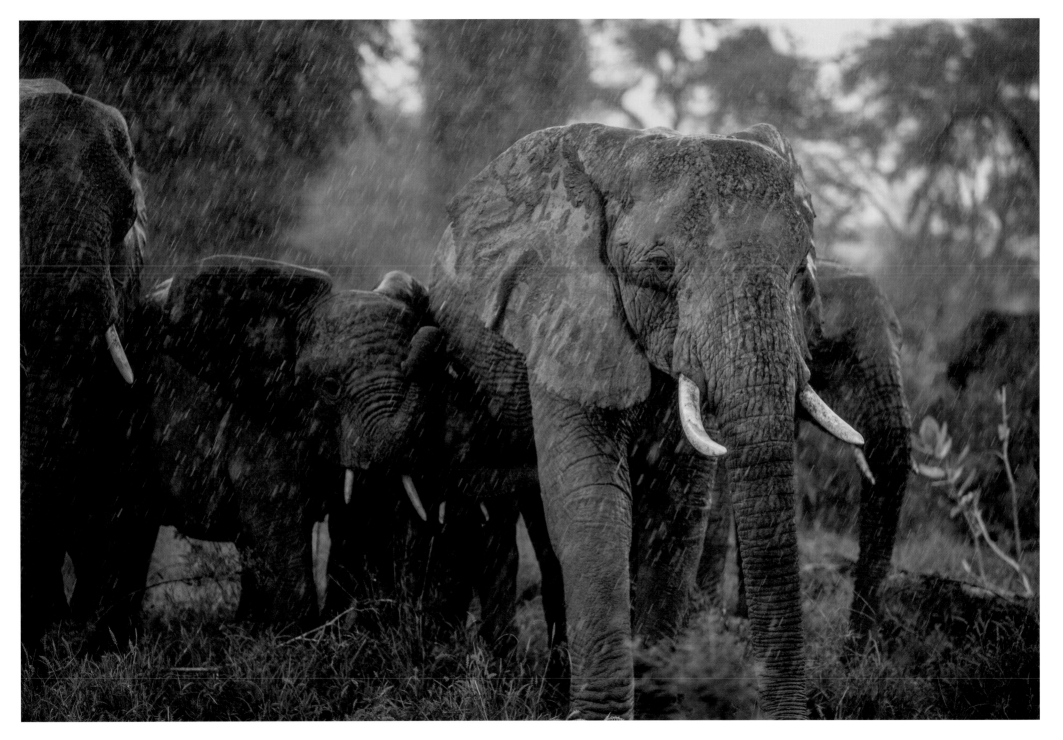

The Acacias family visits the reserve only rarely, coming from far away for the water. Because of the human threat they face outside Samburu, they are nervous and aggressive animals.

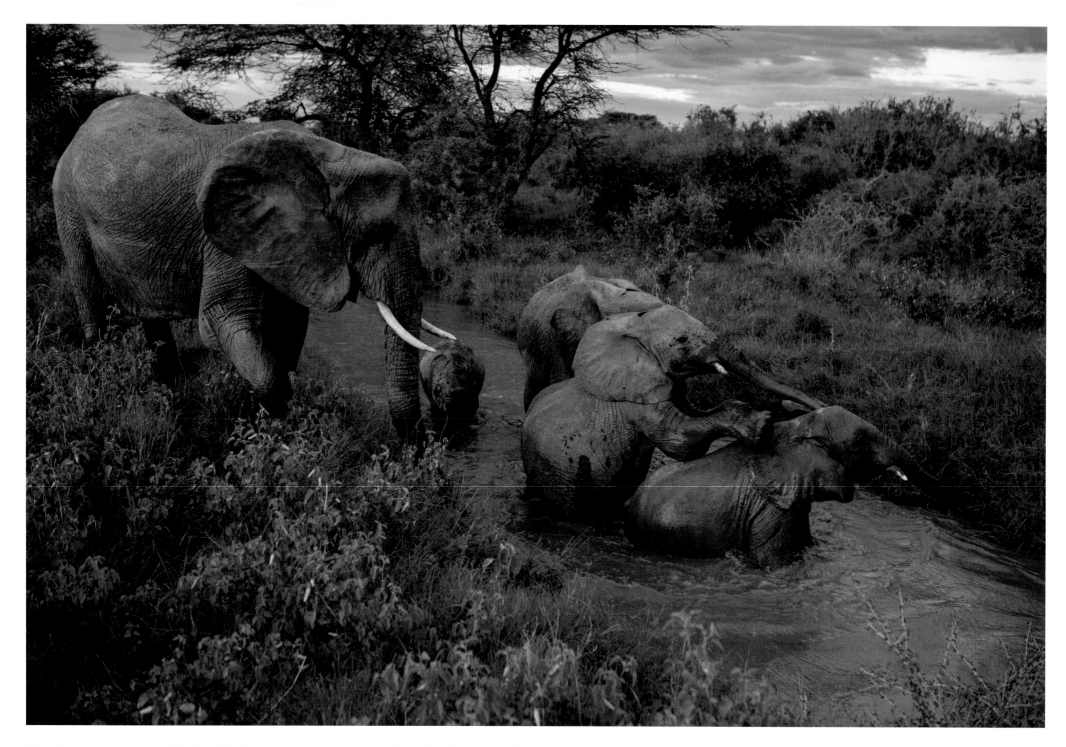

Saturn, an elderly mother of the Planets family, oversees her own two calves and two orphans that are part of her extended brood.

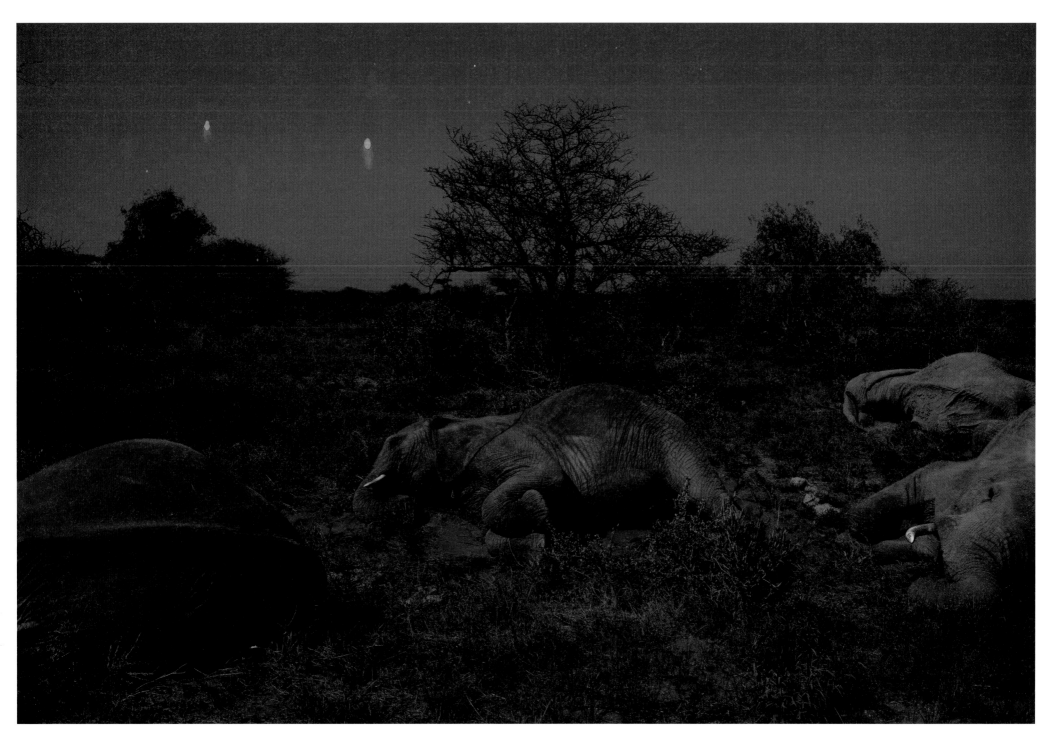

We came upon these members of the American Indians family at 2:00 a.m., calmly sleeping by moonlight. They stood up briefly at our arrival and then lay back down to rest. 105

When I couldn't stand it any longer, I would close my eyes and think of the

herds of elephants at liberty, running freely across Africa, hundreds and hundreds

of magnificent animals that nothing can resist—no cement wall, no barbed wire,

nothing: they rush forward over the great open spaces and smash everything in their

way, and nothing can stop them. That's liberty, I tell you! So when you begin to

suffer from claustrophobia, or the barbed wire fences, the reinforced concrete, the

absolute materialism, just imagine this: herds of elephants charging across the

wide open spaces of Africa. Follow them with your eyes closed, keep their image

inside you, and you'll see, you'll feel better and happier, and stronger.

—*Romain Gary*, Les Racines du ciel/Roots of Heaven, *1956 / 1958*

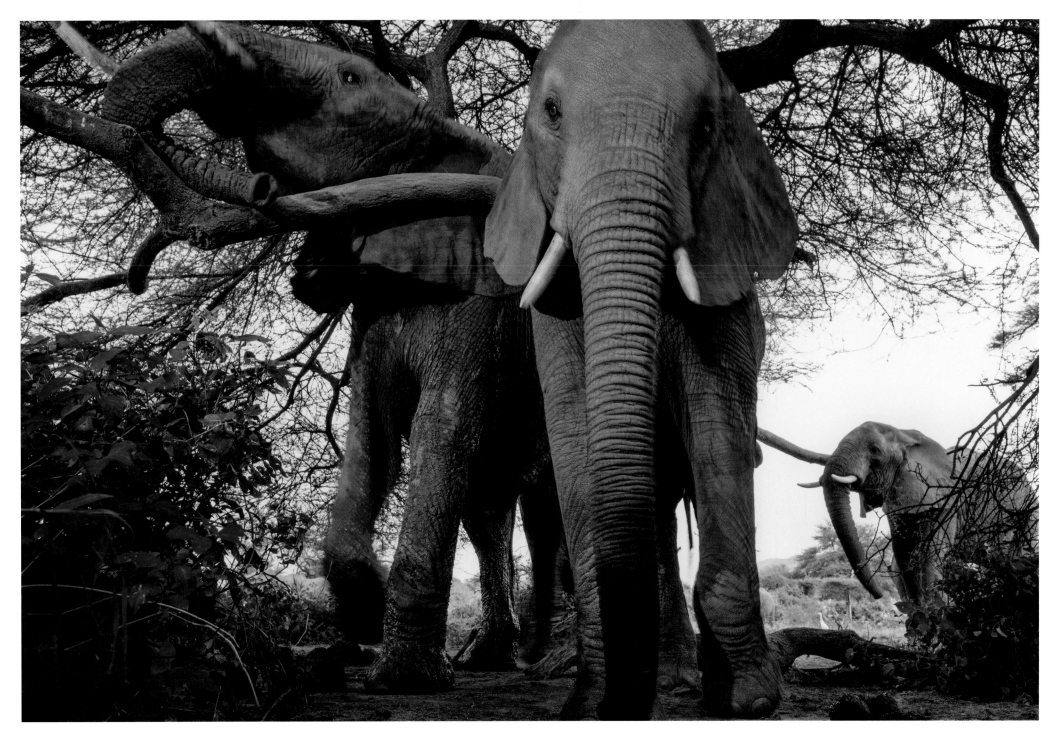

Two young Royals enjoy the midday shade and a bit of scratching beneath an acacia near the river.

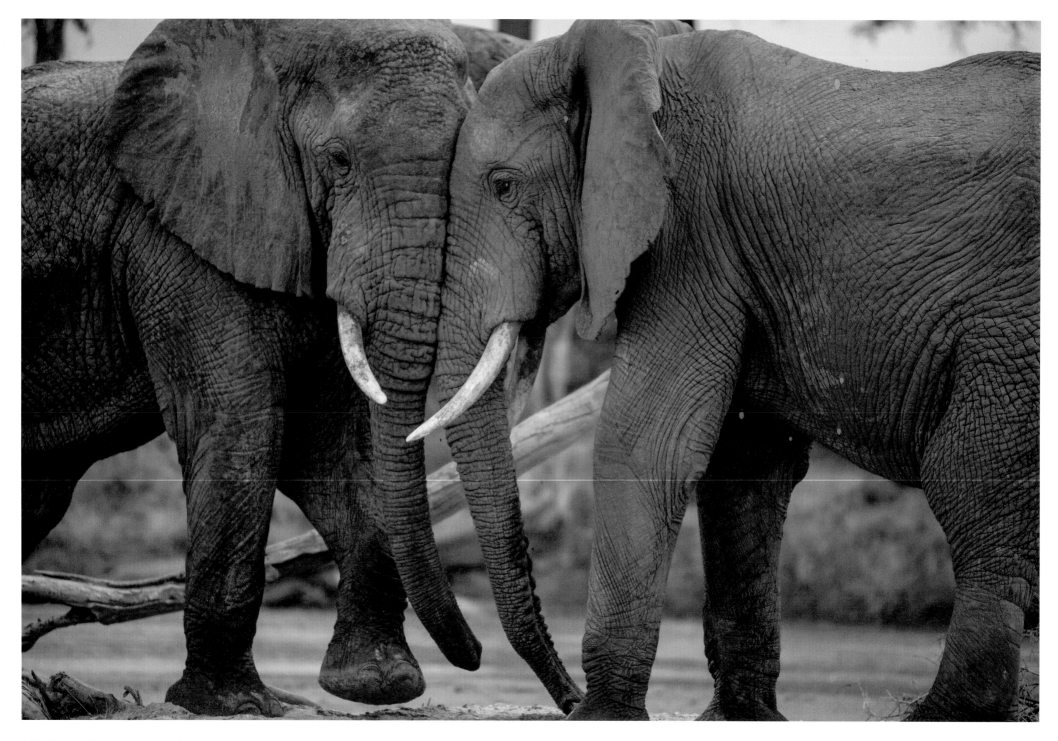

The river is a meeting place. When families that have not seen each other for some time come together; there are ritualized greetings.

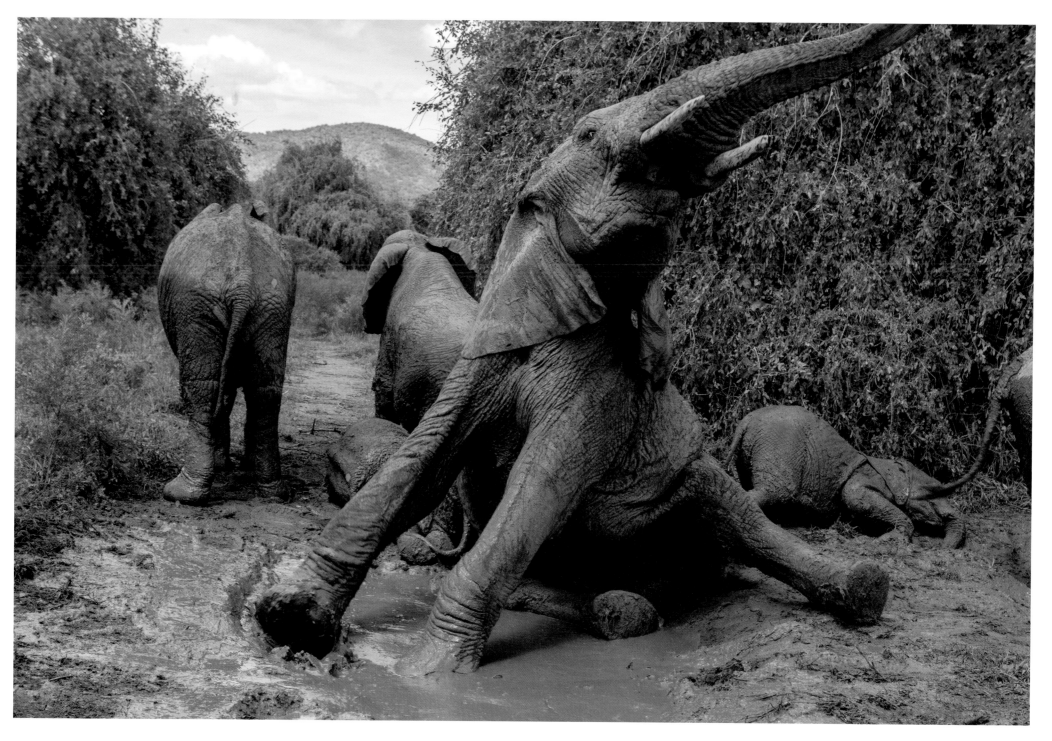

Mud baths serve to cool and protect elephants against sun and parasites. Here an exuberant young male hogs the wallow.

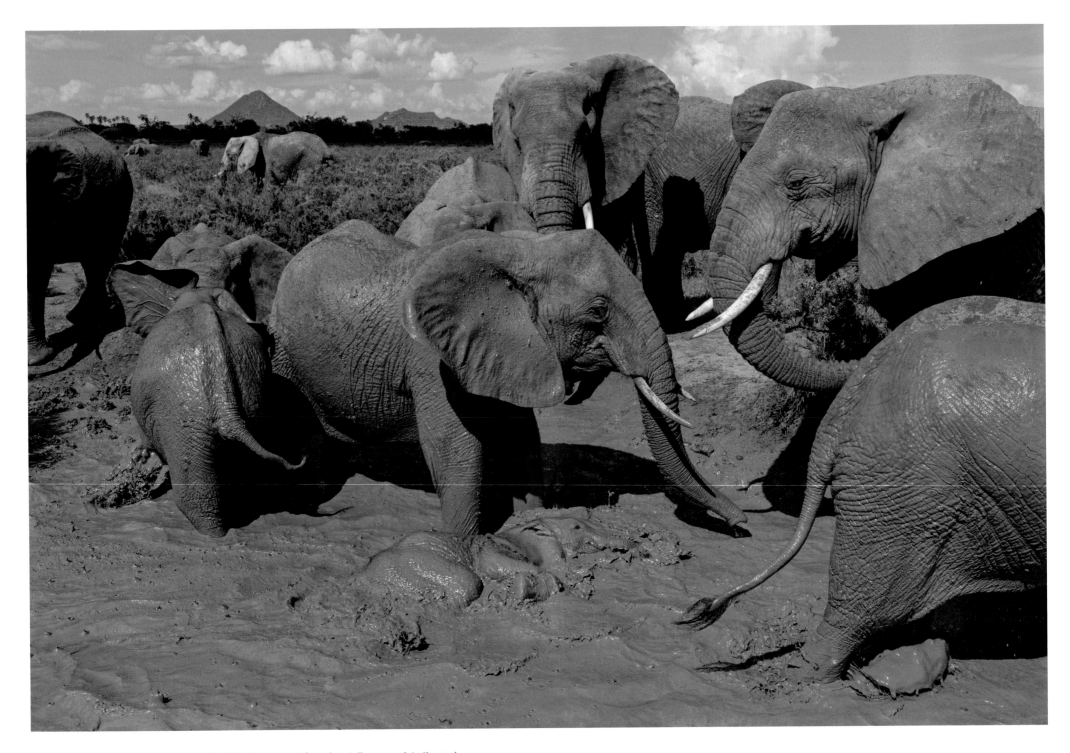

The Biblical Towns family has a mud-bathing frenzy; one infant almost disappears into the mud.

Elephants seem to enjoy "dressing up" in mud and dust.

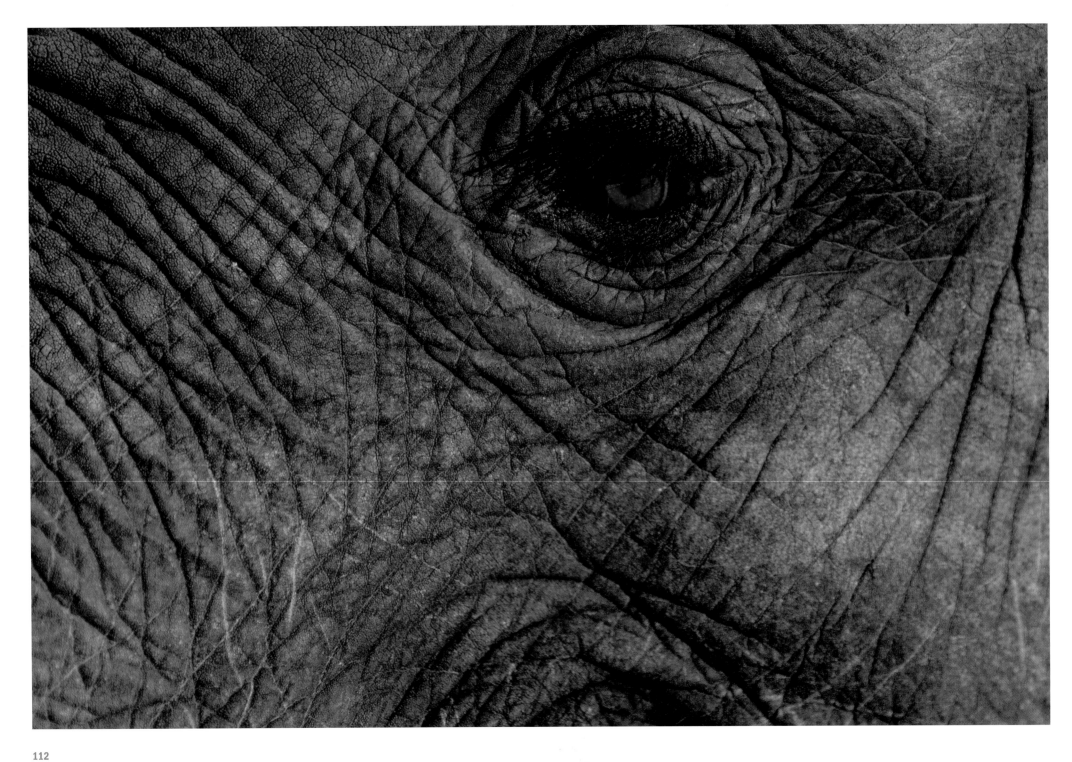

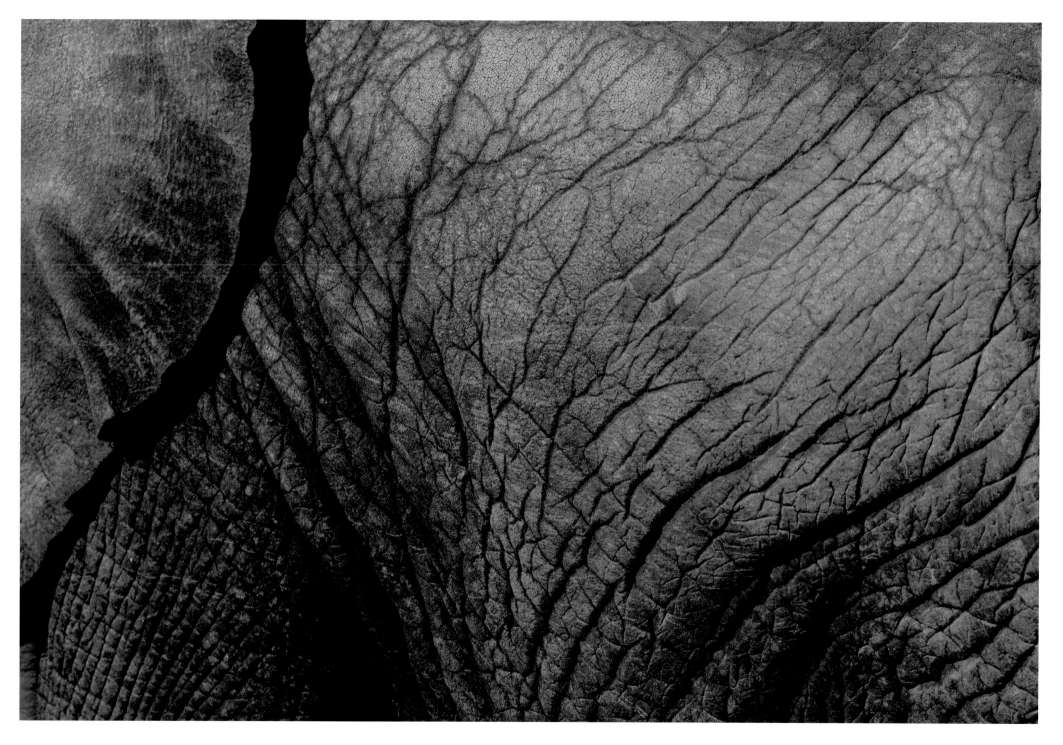

I could spend hours studying the eyes and the texture of the elephants' skin. 113

Elephants, when left to their own devices, are profoundly social creatures. A herd of them is, in essence, one incomprehensibly massive elephant: a somewhat loosely bound and yet intricately interconnected, tensile organism. Young elephants are raised within an extended, multitiered network of doting female caregivers that includes the birth mother, grandmothers, aunts and friends. These relations are maintained over a life span as long as 70 years. Studies of established herds have shown that young elephants stay within 15 feet of their mothers for nearly all of their first eight years of life, after which young females are socialized into the matriarchal network, while young males go off for a time into an all-male social group before coming back into the fold as mature adults.

—*Charles Siebert,* "An Elephant Crackup?," New York Times Magazine, *October 8, 2006*

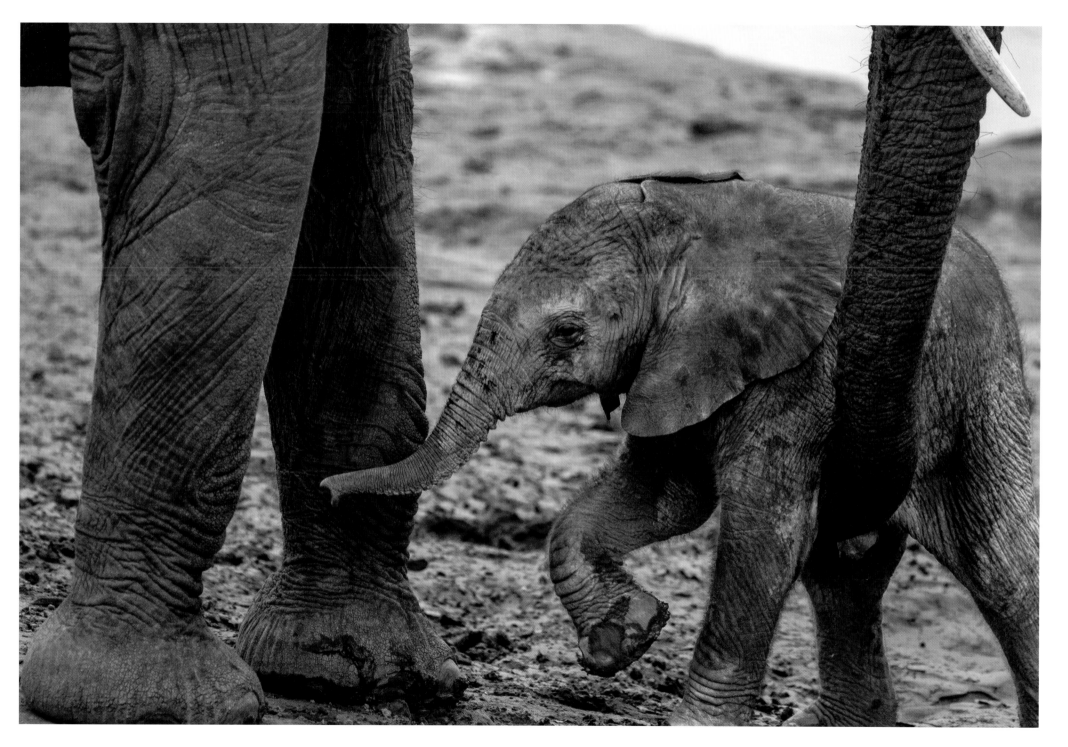

A first-time mother stands guard over her newborn, yet to be introduced to the family.

Soila says that each elephant has its own personality. "Some are talkative, some are bad-hearted, some are stupid," she says. "They are very much like us. Sometimes when I am watching them, I forget that I am working. I forget that they are elephants and I am human." But elephants are not human, of course. They are something much more ancient and primordial, living on a different plane of existence. Long before we arrived on the scene, they worked out a way of being in the world that has not fundamentally changed and is sustainable, and not predatory or destructive. We have been in close association with elephants from the beginning. The few dozen humans who left Africa may have even followed an elephant trail, but the proboscideans are on a distant branch of the tree of life, closer to manatees and aardvarks than to primates. It is amazing, really, that something so antediluvian and unlike us is still here. This is the feeling we get as we are watching these elephants. They are what they are, and they put things into badly needed perspective. The world needs them. We need them.

—*Alex Shoumatoff,* "Agony and Ivory," Vanity Fair, *August 2011*

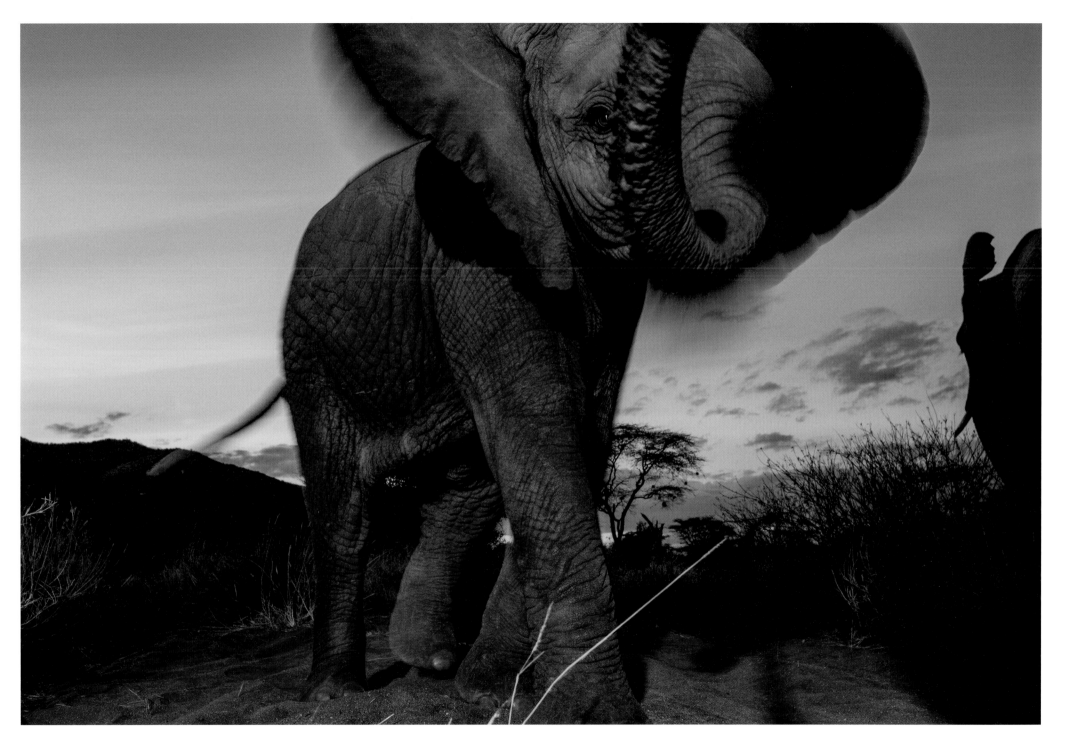

A confident Royals calf, barely three feet tall, plays tough, approaching a camera on the ground. Its mother is protectively close by.

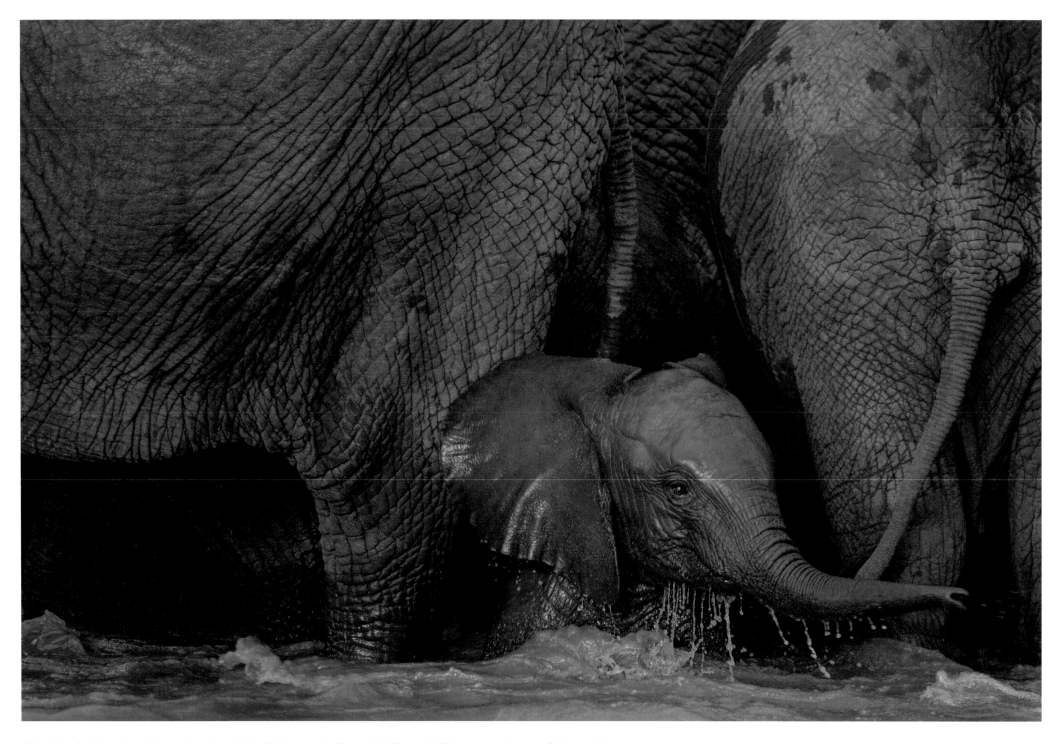

118 When families mix and play together—here it is the Shakespeare Ladies and the Rivers—the little ones are always carefully protected.

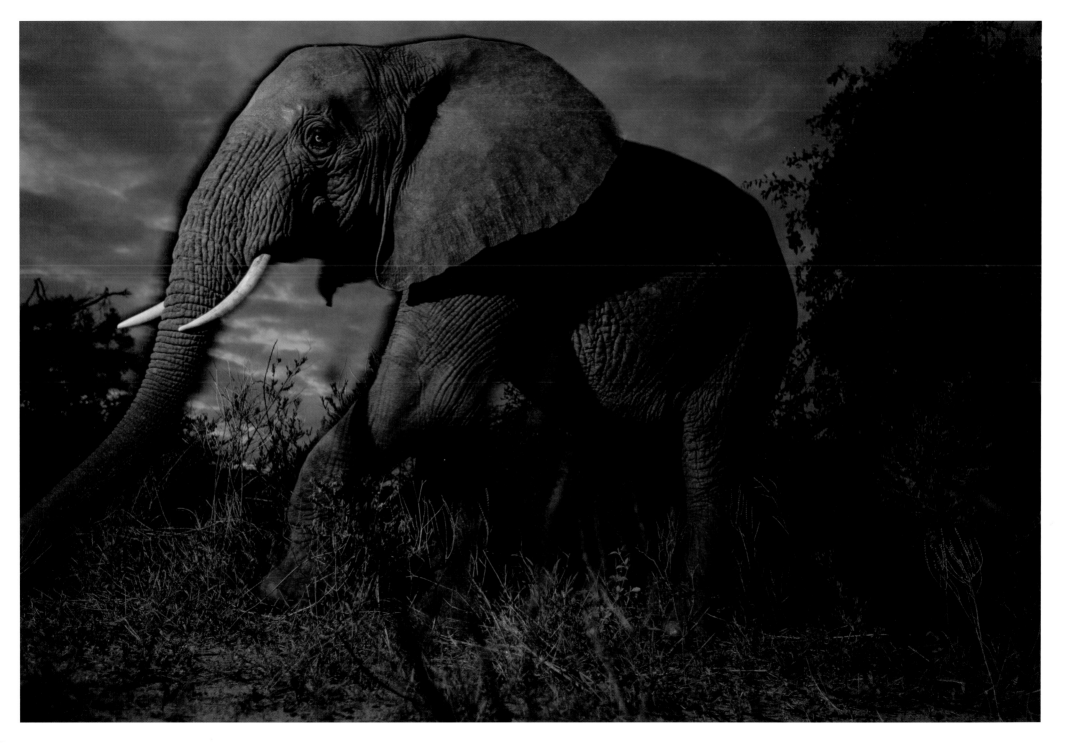

When younger males attempted to mount females during early and late estrus, long chases and loud bellowing by the female were involved, which attracted other males. The noise also attracted the attention of human observers, which further led casual observers to believe that the younger males were responsible for the breeding. Estrous females avoided these younger nonmusth males by walking away and, if caught and mounted, they would simply walk forward, causing the young male to fall off. Younger males had a further disadvantage; it seemed to take some years of practice before they learned to control their highly mobile penises.

—*Joyce Poole,* Coming of Age with Elephants: A Memoir, *1996*

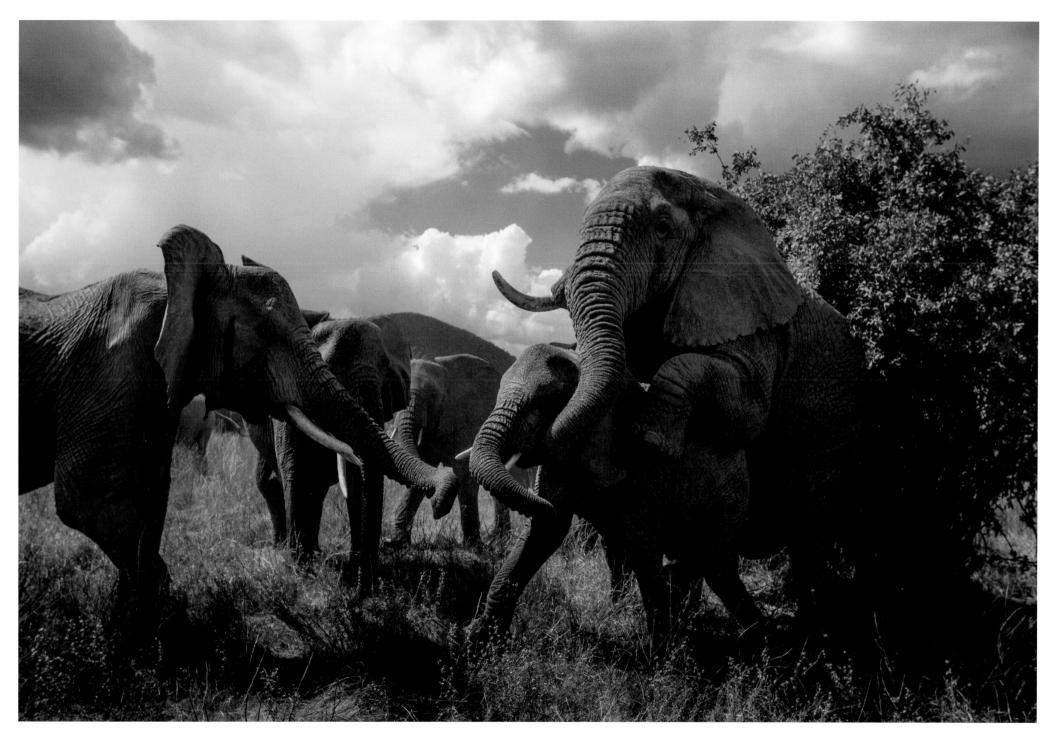

A young female in her first estrus is mounted by Leopold, a large bull. She is vulnerable to his great size, and with much trumpeting and aggression he is driven off by her family, the First Ladies.

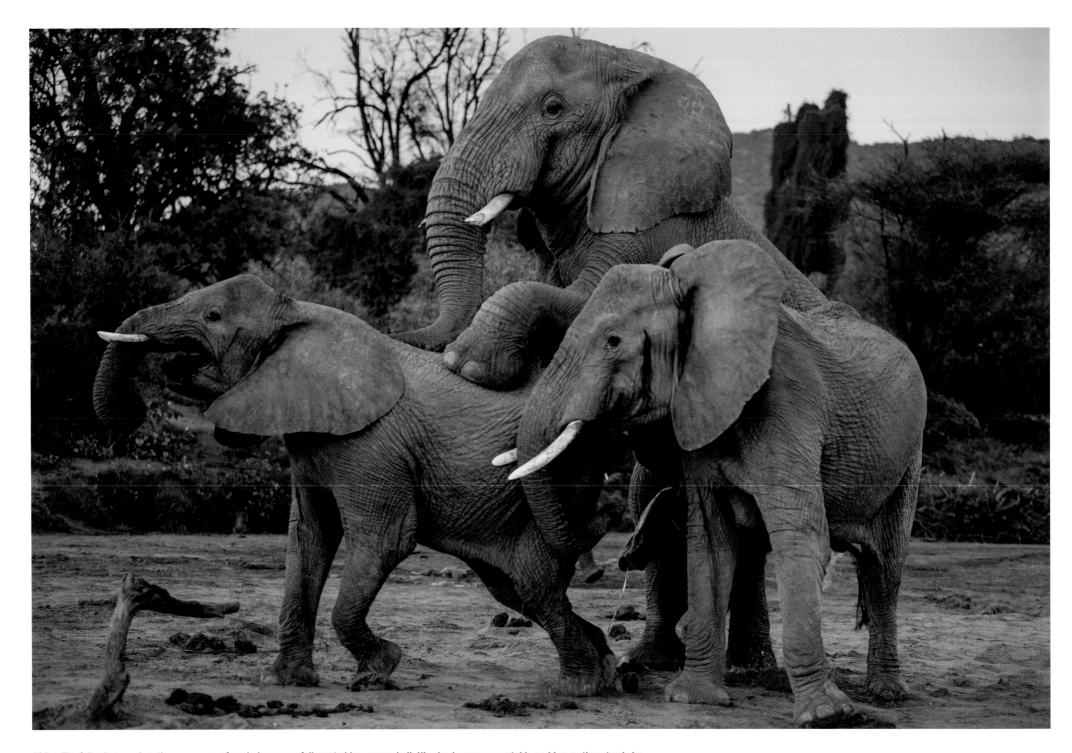

122 The following evening, the same young female is successfully mated by a young bull. His size is more acceptable and her mother stands by.

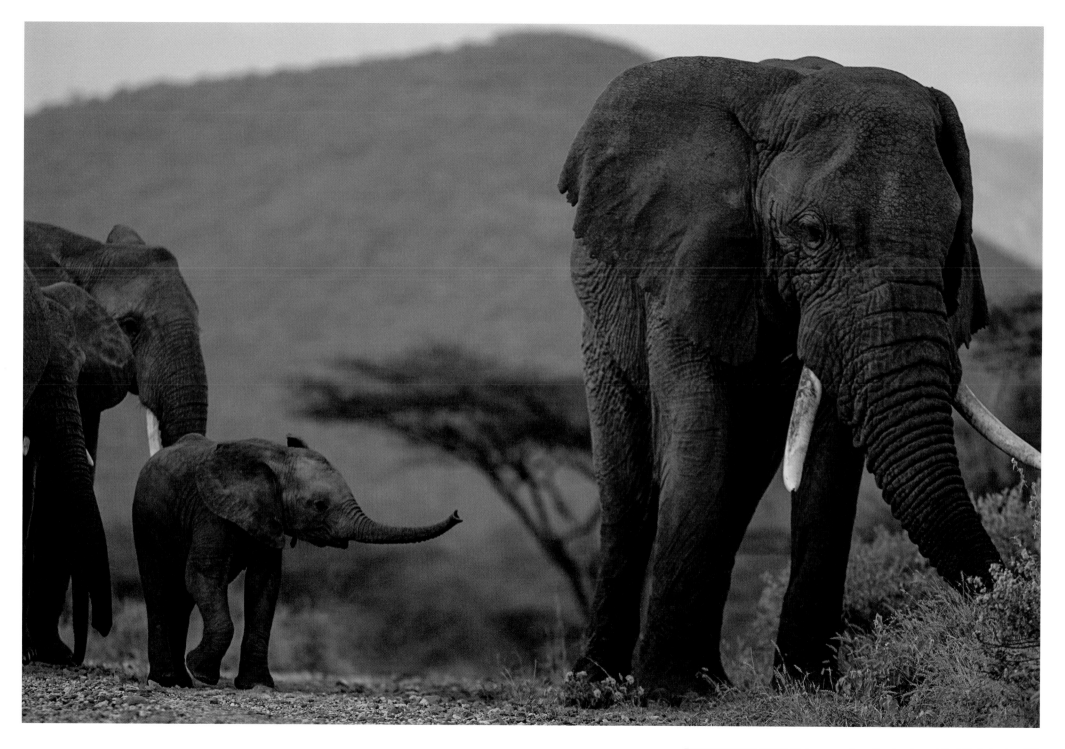

When I opened my eyes again, you were asleep. I suppose you had not seen

me or had taken one look at me and become overcome with boredom. Anyway,

you were standing there, your trunk limp, your ears collapsed, your eyes closed,

and I remember that tears came to my eyes. I was seized by an almost irresistible

urge to come close to you, to press your trunk against me, to huddle against

your hide, and there, fully protected, to sleep peacefully forever.

—*Romain Gary,* "Dear Elephant, Sir," Life *magazine, December 22, 1967*

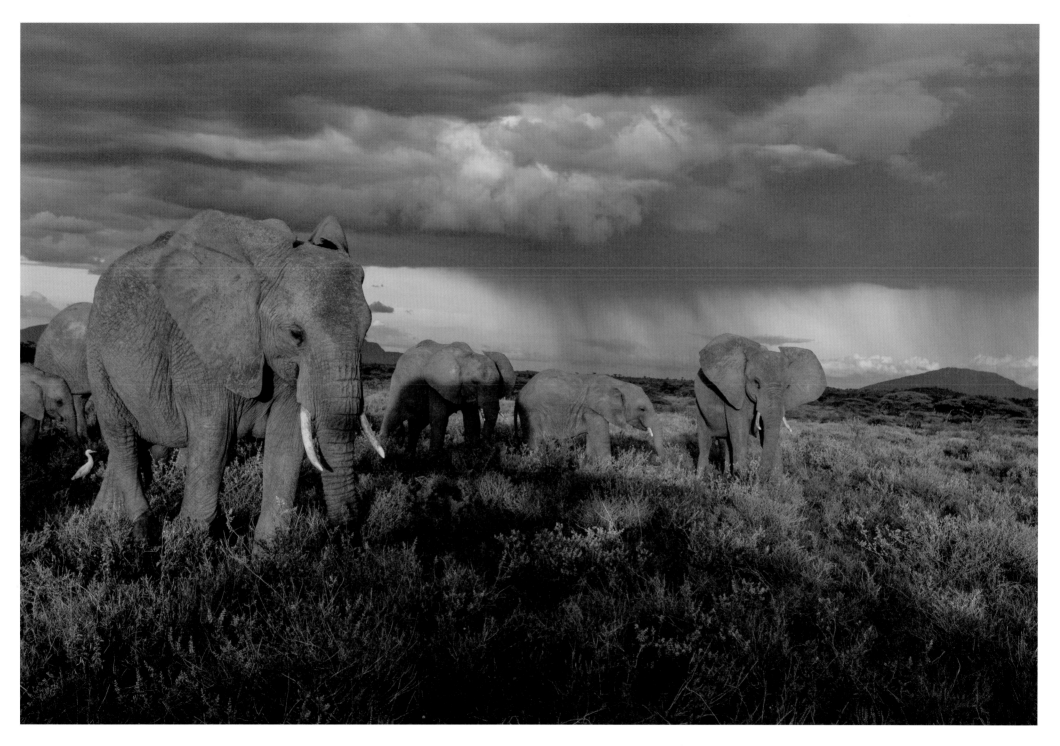

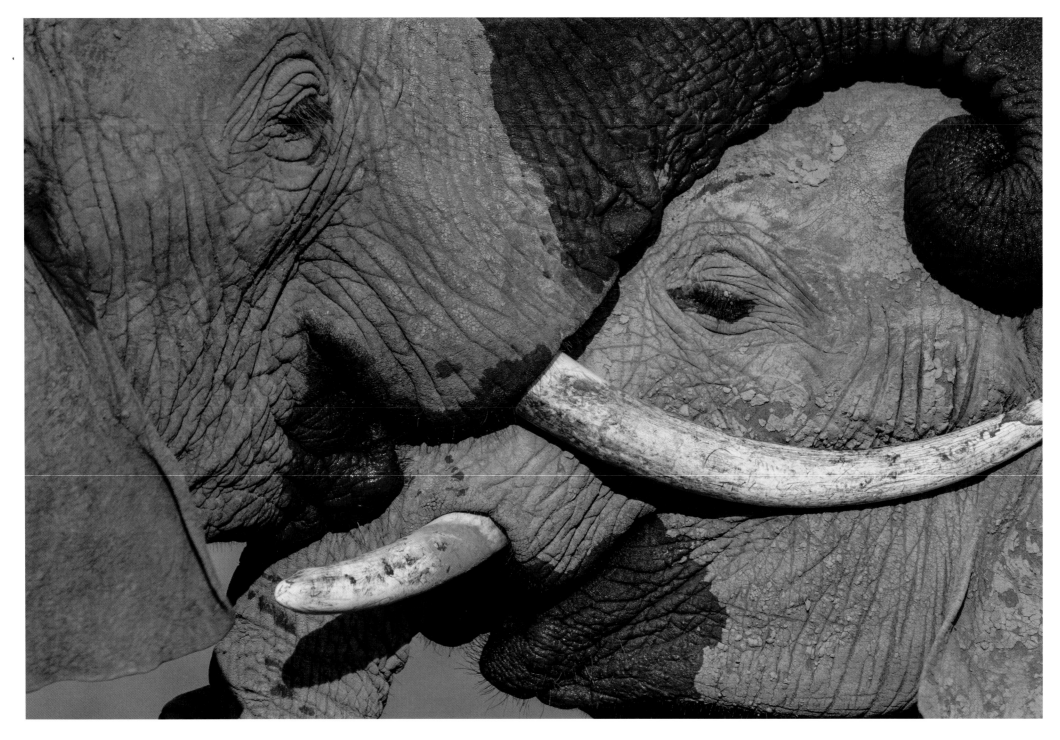

126 Young bulls constantly grapple and test each other, learning valuable skills they will need in their adulthood.

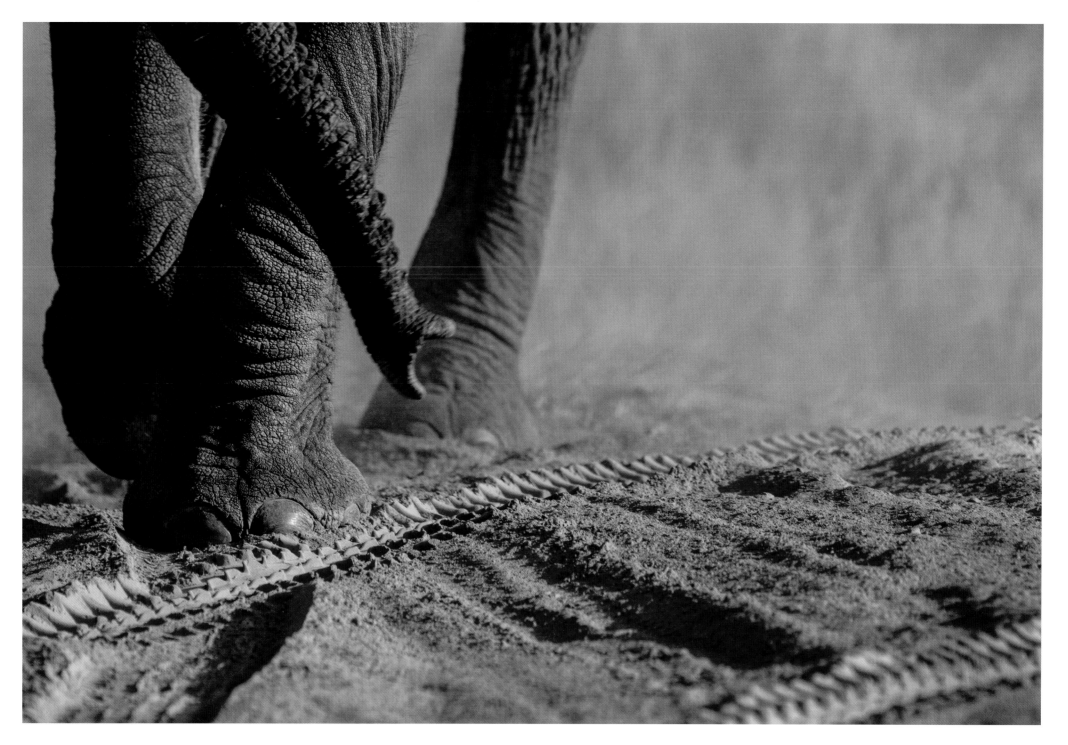

All males leave the family when they become sexually mature. They join with other males—most often playmates from youth. 127

After 18 years of watching elephants I still feel a tremendous thrill at witnessing a greeting ceremony. Somehow it epitomizes what makes elephants so special and interesting. I have no doubt even in my most scientifically rigorous moments that the elephants are experiencing joy when they find each other again. It may not be similar to human joy or even comparable, but it is elephantine joy and it plays a very important part in their whole social system.

—*Cynthia Moss*, Elephant Memories: Thirteen Years in the Life of an Elephant Family, *1988*

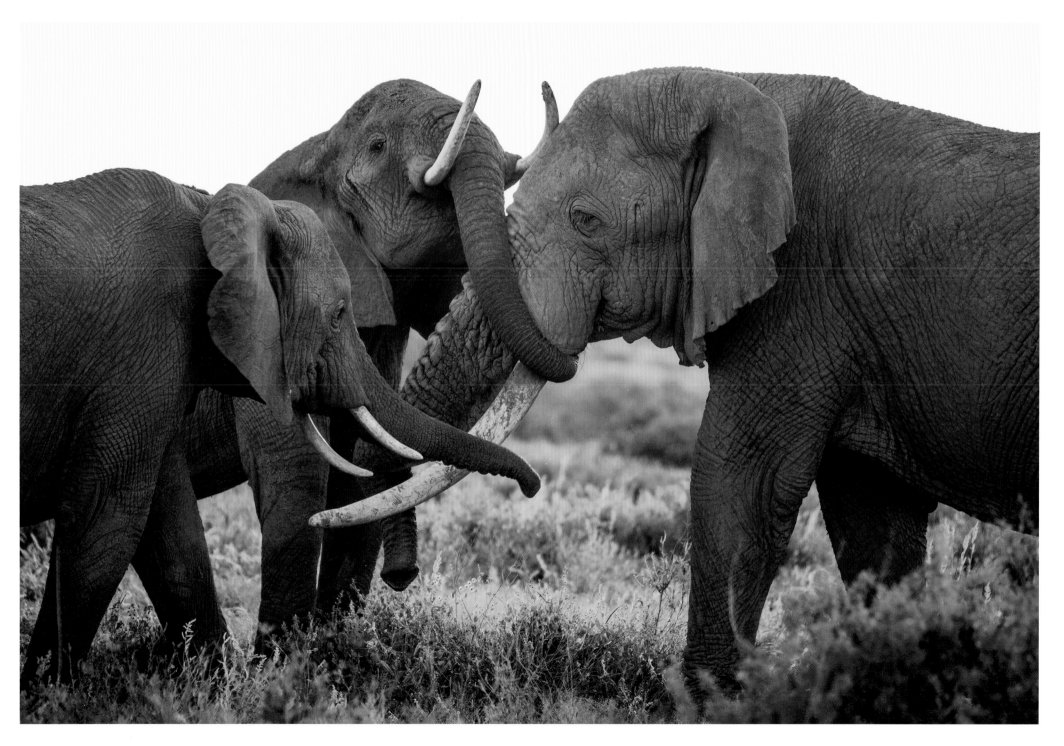

Maya, the matriarch of the Poetics herd, and her daughter greet Boone, an elderly bull that spends most of his time east of the reserve.

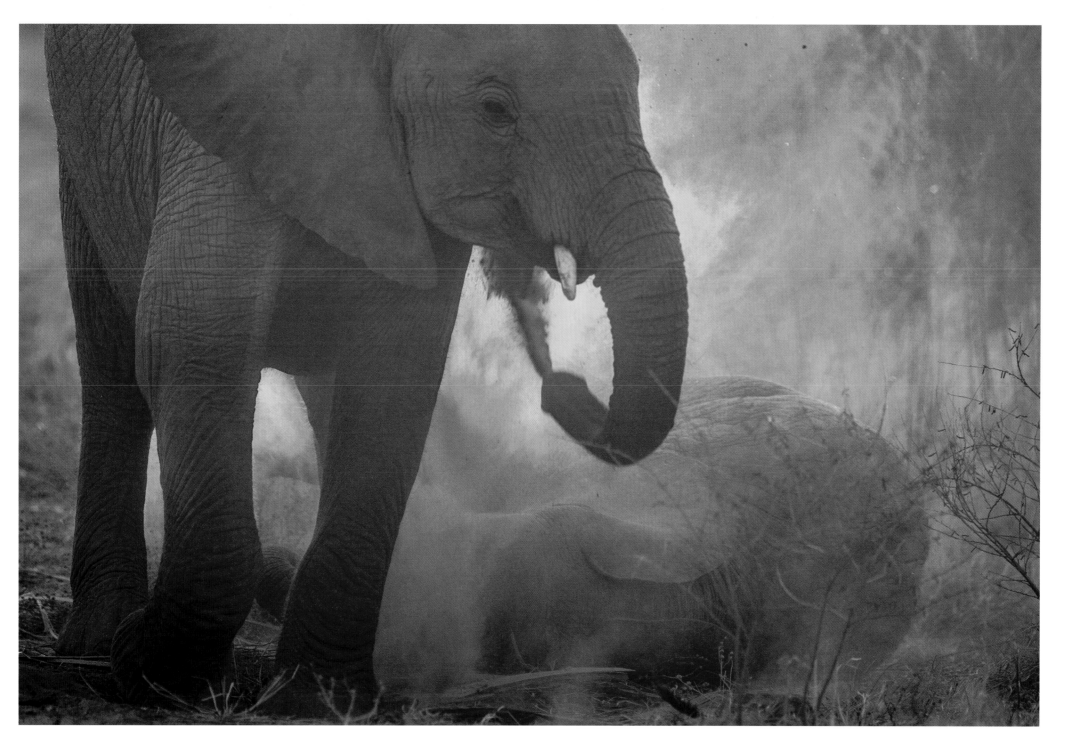

We never met again, and yet in our thwarted, restricted, controlled, indexed

and repressed existence, the echo of your irrepressible thundering march through

the open spaces of Africa keeps reaching me, awakening a confused longing.

It sounds triumphantly like the end of acceptance and servitude, an echo

of limitless freedom that has haunted our soul since the beginning of time.

—*Romain Gary,* "Dear Elephant, Sir," Life *magazine, December 22, 1967*

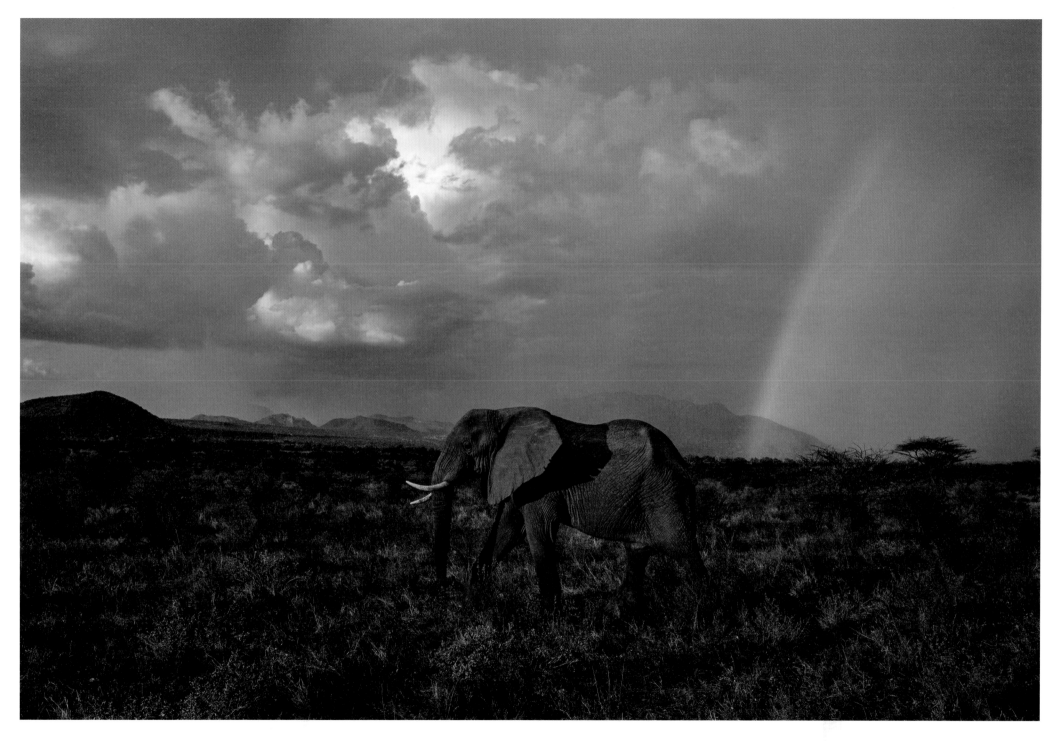

ORPHANS

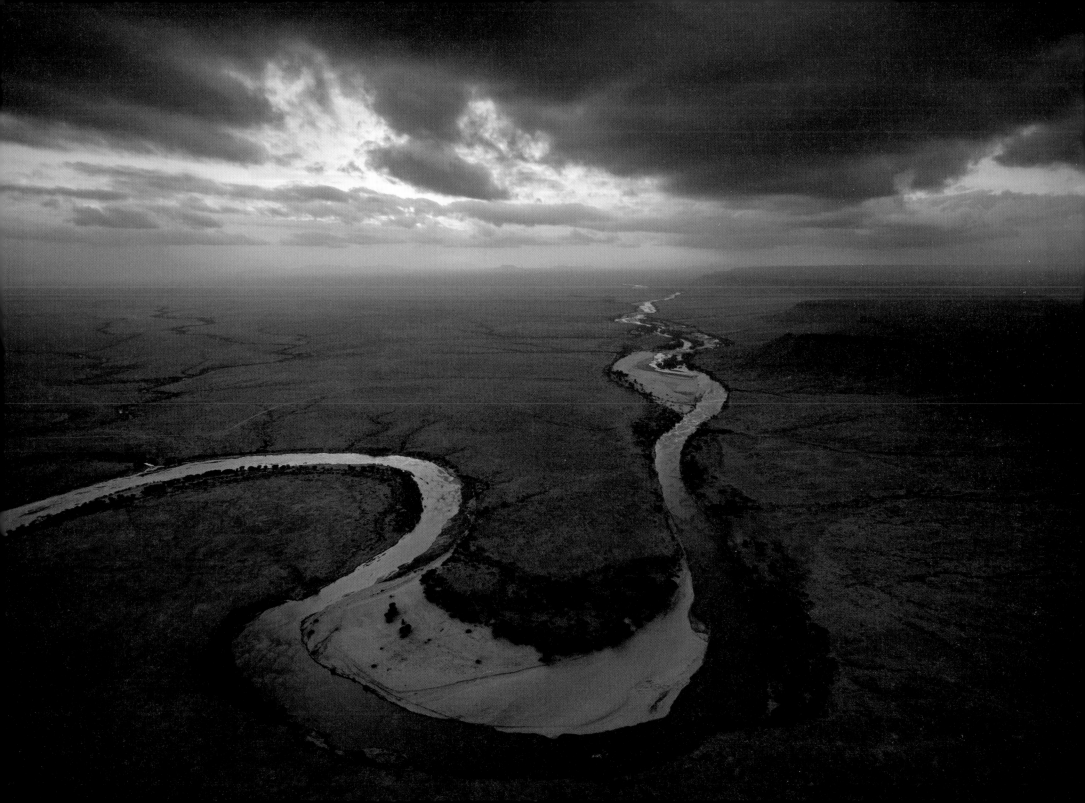

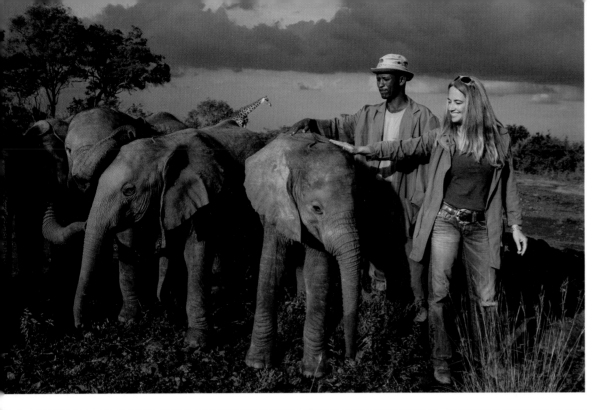

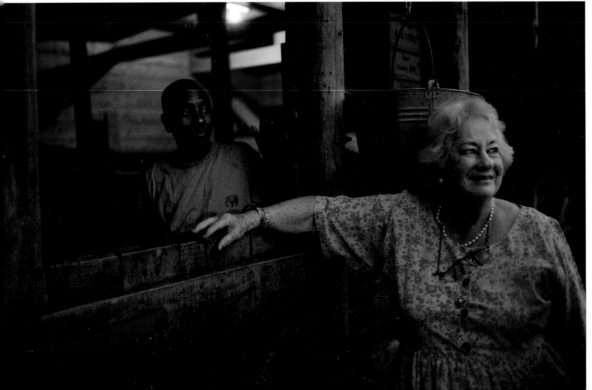

DAPHNE SHELDRICK DECIDED

early in her life to foster every orphaned creature that crossed her path. She has worked at Kenya's David Sheldrick Wildlife Trust (named for her late husband) for many years with that goal. Daphne knows well that keeping a motherless elephant alive is one of the hardest things that can be attempted: they are extremely fragile creatures and the death rate is high. After decades of trial and error, she has learned how best to provide the sustenance, conditions, and environment that will allow these youngsters to survive and ultimately to be released back into the wild. Today Daphne and her daughter Angela run the Trust, based in Nairobi and Tsavo National Park, with a highly skilled staff of keepers.

The care for the animals is meticulously planned. Each orphan sleeps with a different keeper every night; this is partly to prevent the elephants from becoming too attached to any particular human. (The rule was established after a hard lesson: years ago, after successfully bottle-raising her first infant elephant, Daphne had to leave the compound for a few days. The young elephant became disconsolate, would not eat, and quickly died.) The daily transition from one keeper to the next takes place only when the baby is contentedly full of milk and sleeping.

Baby elephants do not see well: their world is primarily tactile and olfactory. The orphans, especially the youngest ones, wear blankets, which swaddle them and give them the comforting smell of other elephants—in some sense, the blanket serves as a surrogate for the mother.

All rescued orphans are immediately socialized. An arriving youngster is paired with another elephant that is known to be gregarious and can handle the task of introducing the new elephant around. The

stalls all have open slats so that the animals' trunks can reach out to one another for contact. (The smallest babies are an exception: they are too delicate to handle any roughness from the older infants, who are eager to greet and to mother them.)

The orphans are excellent ambassadors. Tourists and local schoolchildren pour into the daily noontime mud-bath and bottle-feeding demonstrations at the Nairobi nursery, to see and touch these extraordinary animals. Much of the Trust's funding comes from small donations given to "adopt" an orphan. (I myself adopted a favorite, Kilaguni, for my mother. She follows Kilaguni's progress on the Sheldrick website and proudly keeps me up to date on how "her" elephant is doing.)

With the adoption income, supplemented with donations and grants, the Sheldrick Trust has managed to save many precious lives, and to release dozens of orphaned elephants back to the wild. Their work gives us some small hope that the future of this species will not be as museum specimens or facsimiles.

Human-animal relations are complex. My work with many species has shown me that animals are far more sentient than we care to admit. I believe that elephants are among the most sensitive and wise of all the earth's creatures. We must find a way to protect their peace and place in the landscape.

The "Orphans" images were made in 2010, at the Nairobi nursery and at the reintroduction sites, Voi and Ithumba, in Kenya's Tsavo National Park. These photographs were made under the auspices of the David Sheldrick Wildlife Trust.

PREVIOUS PAGE: Tsavo National Park is one of the largest in Africa. Its ecosystem is split by the life-sustaining waters of the Galano River. **OPPOSITE, TOP:** Angela Sheldrick was raised in Tsavo with all manner of animal orphans; today she runs the operations at the David Sheldrick Wildlife Trust. **OPPOSITE, BOTTOM:** Daphne Sheldrick learned from years of trial and error how to raise and care for milk-dependent orphan elephants. **THIS PAGE:** Angela and Rob Carr-Hartley are fifth-generation Kenyans. Their children have grown up playing with orphan elephants and caring for hyrax, warthogs, and other wildlife.

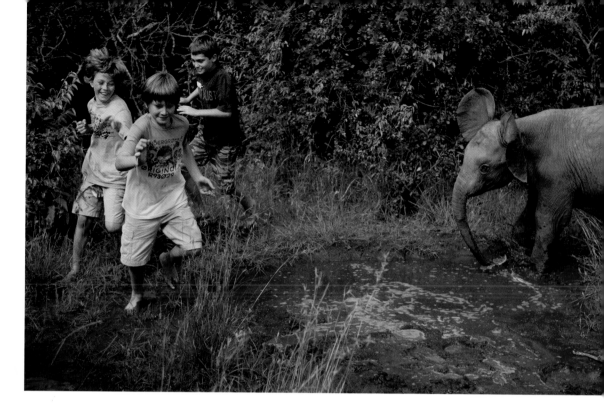

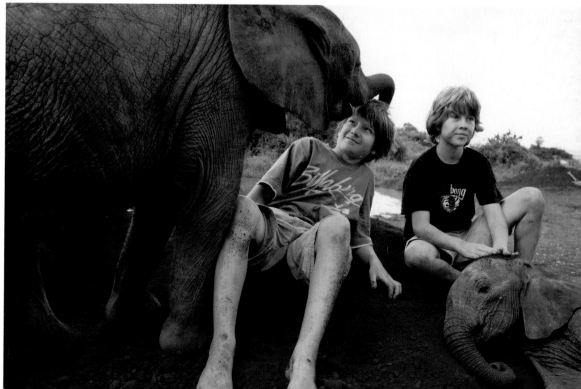

The fact that elephants never forget has been proved to us time and time again, once by Eleanor in her forties, when she returned to the stockades after many years of wild living and a man who was a stranger to the incumbent keepers happened to be approaching from a distance. Up went Eleanor's trunk, her ears stood out, and much to everyone's alarm, she ran at speed towards the stranger, enveloping him with her trunk and treating him to a highly charged elephant greeting. It turned out that he had been her keeper when she was five years old, and even though thirty-seven years had passed since she had seen him last, her recognition was instant.

—*Daphne Sheldrick,* Love, Life, and Elephants: An African Love Story*, 2012*

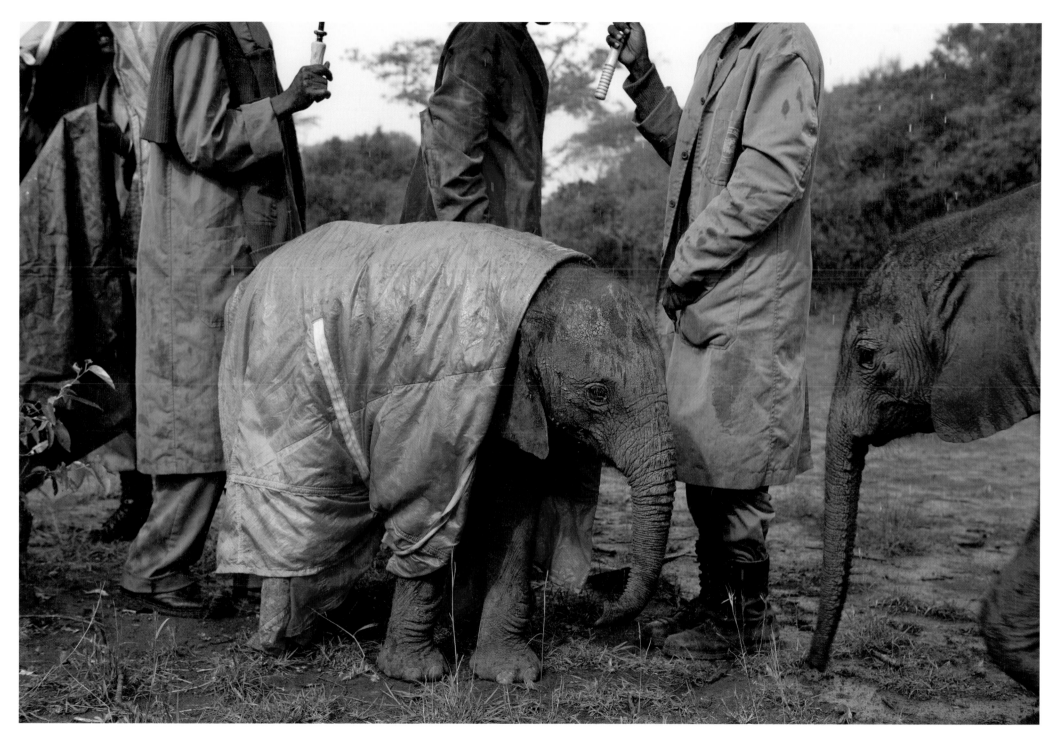

Baby Shukuru is shielded from the rainy season risk of pneumonia with a custom-made raincoat. 141

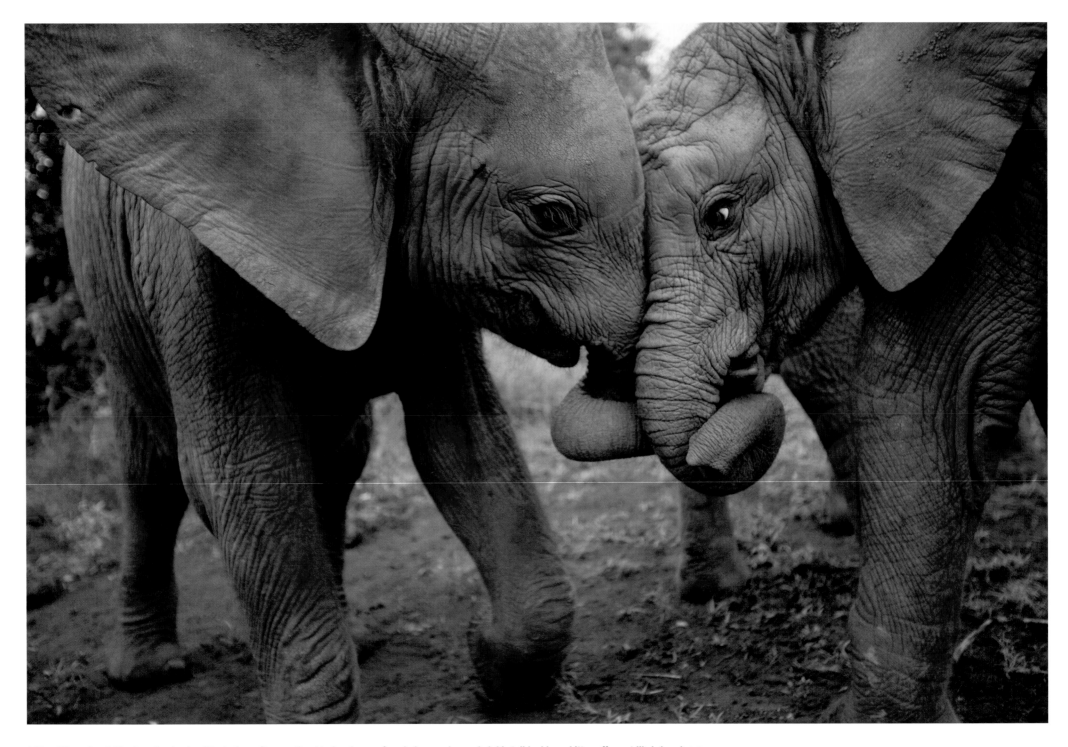

142 Kilaguni and Kibo learning to play. Kilaguni was five months old when he was found alone and wounded; his tail had been bitten off, most likely by a hyena.

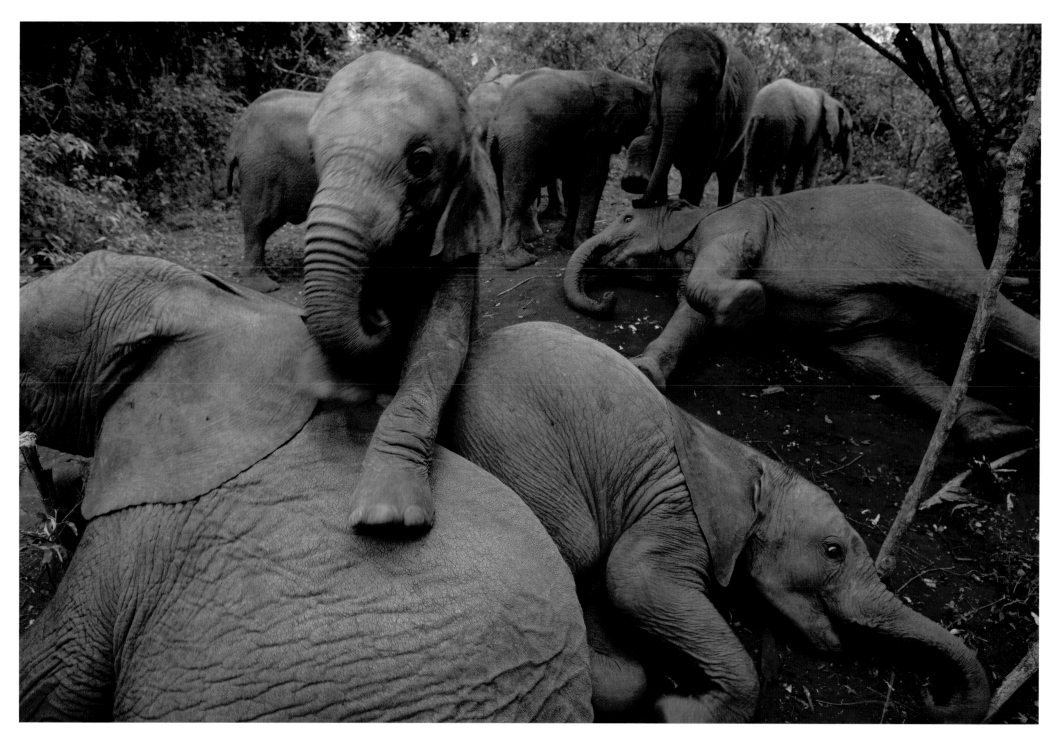

The orphaned elephants instinctively form into family groups. Here the older animals lie down, inviting the younger ones to play on top of them.

What makes this particular moment in the fraught history of elephant-human relations so remarkable is that the long-accrued anecdotal evidence of the elephant's extraordinary intelligence is being borne out by science. Studies show that structures in the elephant brain are strikingly similar to those in humans. MRI scans of an elephant's brain suggest a large hippocampus, the component in the mammalian brain linked to memory and an important part of its limbic system, which is involved in processing emotions. The elephant brain has also been shown to possess an abundance of the specialized neurons known as spindle cells, which are thought to be associated with self-awareness, empathy, and social awareness in humans. Elephants have even passed the mirror test of self-recognition, something only humans, and some great apes and dolphins, had been known to do.

—*Charles Siebert,* "Orphans No More," National Geographic *magazine, September 2011*

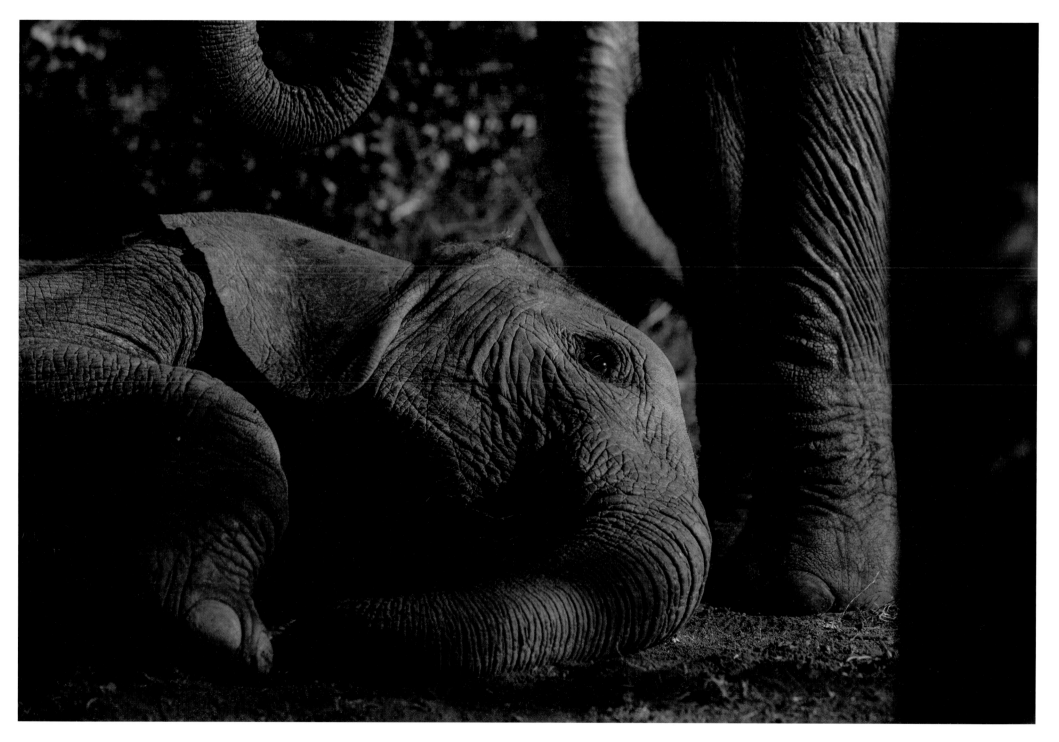

At the Nairobi nursery, a baby orphan elephant rests in the shade, protected from the bright sun by another youngster. 145

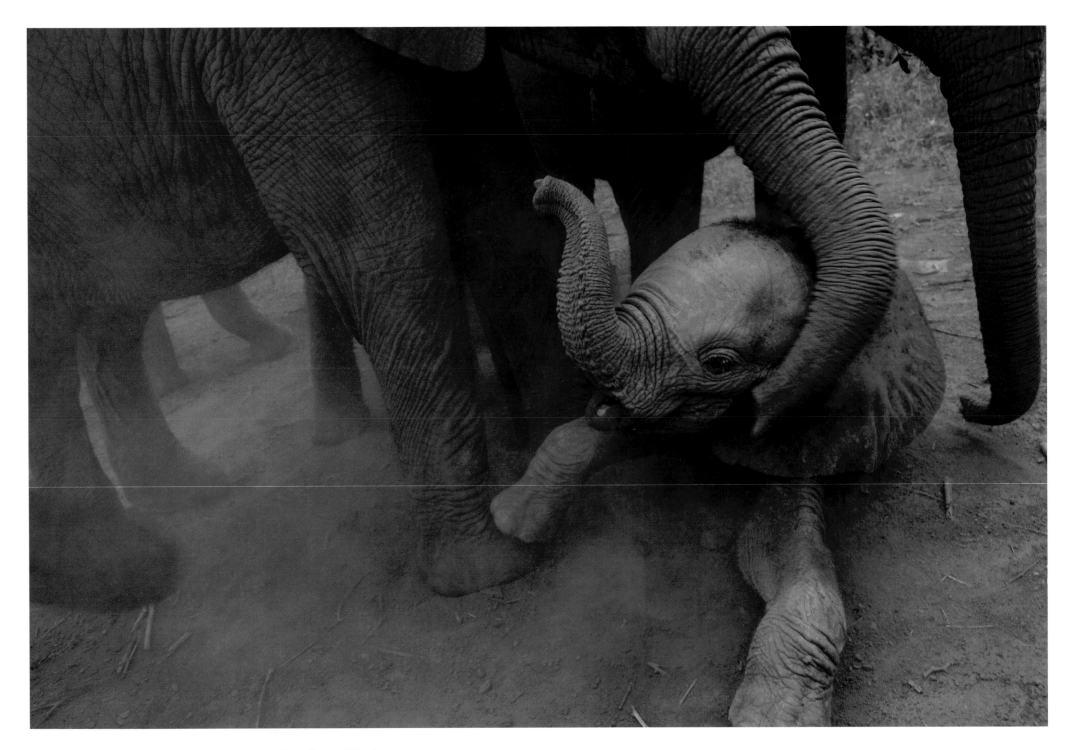

146 Tiny Sities is cared for often by the protective two-and-a-half-year-old Suguta.

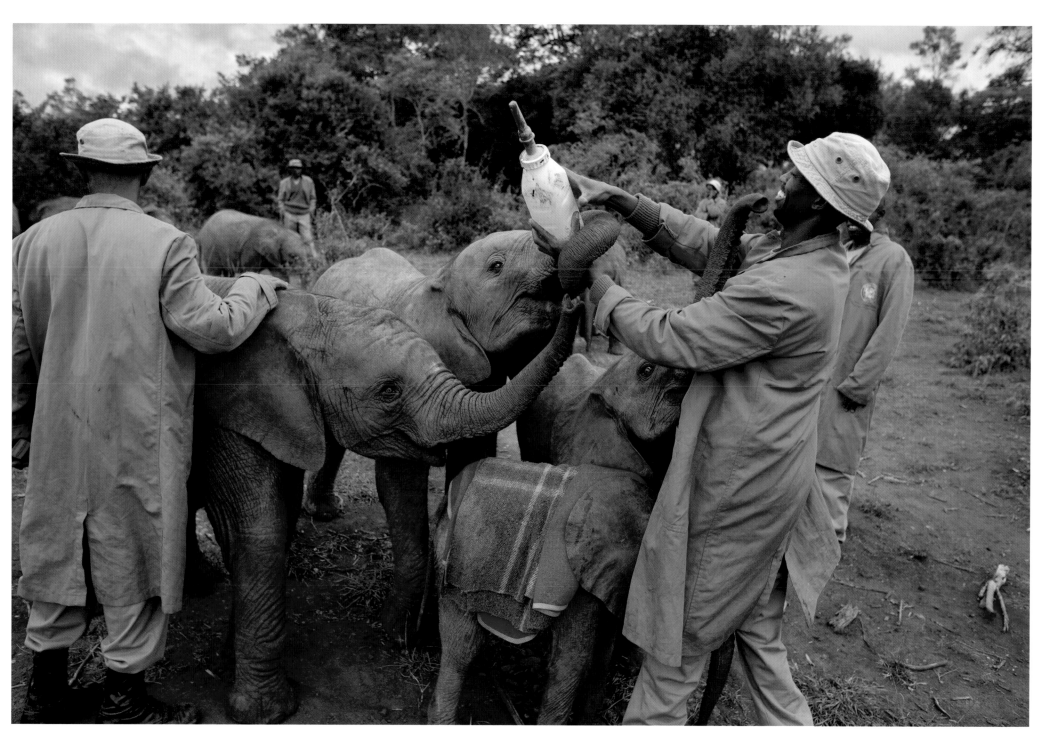

Elephants are milk dependent until at least four years of age, and each orphan requires a specific formula mix. The nursery orphans are fed every three hours. 147

When walking with their keepers out in the bush, our orphans will protect their

human family when confronted by a threat. Tsavo's wilderness remains a hostile

environment for an unarmed human on foot, inhabited as it is by fearsome lions

with man-eating tendencies, by grumpy old buffalo bulls holed up in thickets, and by

aggressive elephants that have no reason to trust or love humans, having been harassed

and poached for decades. Yet the keepers know they can rely on the orphans to detect

a threat and protect them, crowding around while the more senior orphans chase

off any suspected danger. Although elephants are essentially peaceful animals, living

in harmony with all other members of the animal kingdom, they are the strongest

mammal on earth, and if turned aggressive due to cruelty and harassment, they can be

a formidable foe, especially since they, like us humans, can reason, plan and think.

—*Daphne Sheldrick,* Love, Life, and Elephants: An African Love Story*, 2012*

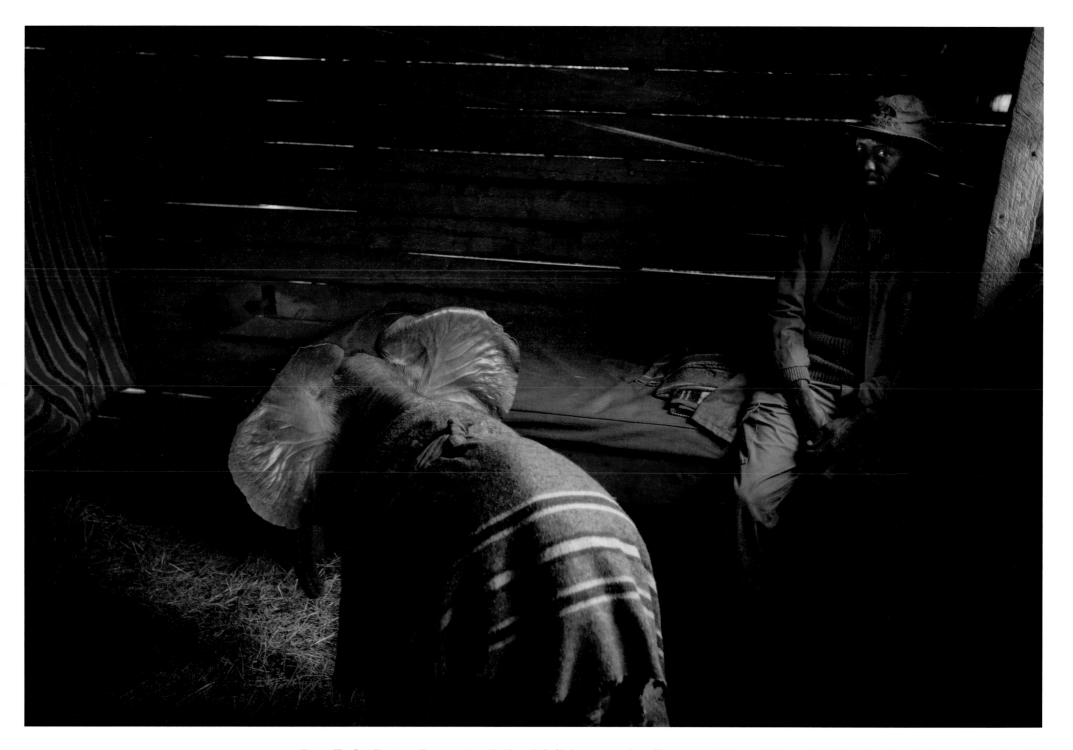

Keeper Jiba Gagallo was on the rescue team that brought in Shukuru as a newborn. She was so small he was able to carry her to the plane. Here she is seven months old. 149

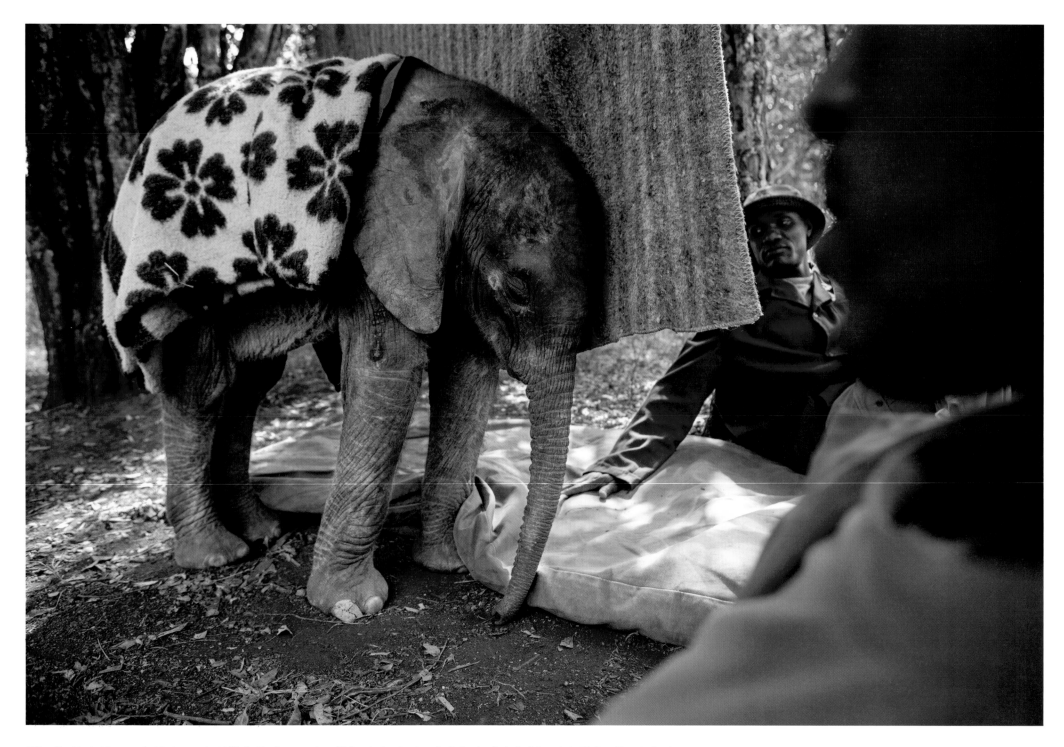

The blanket is a comfort to two-week-old Wasin. Two keepers stay with her during the day; she is too fragile to be integrated with the other elephants.

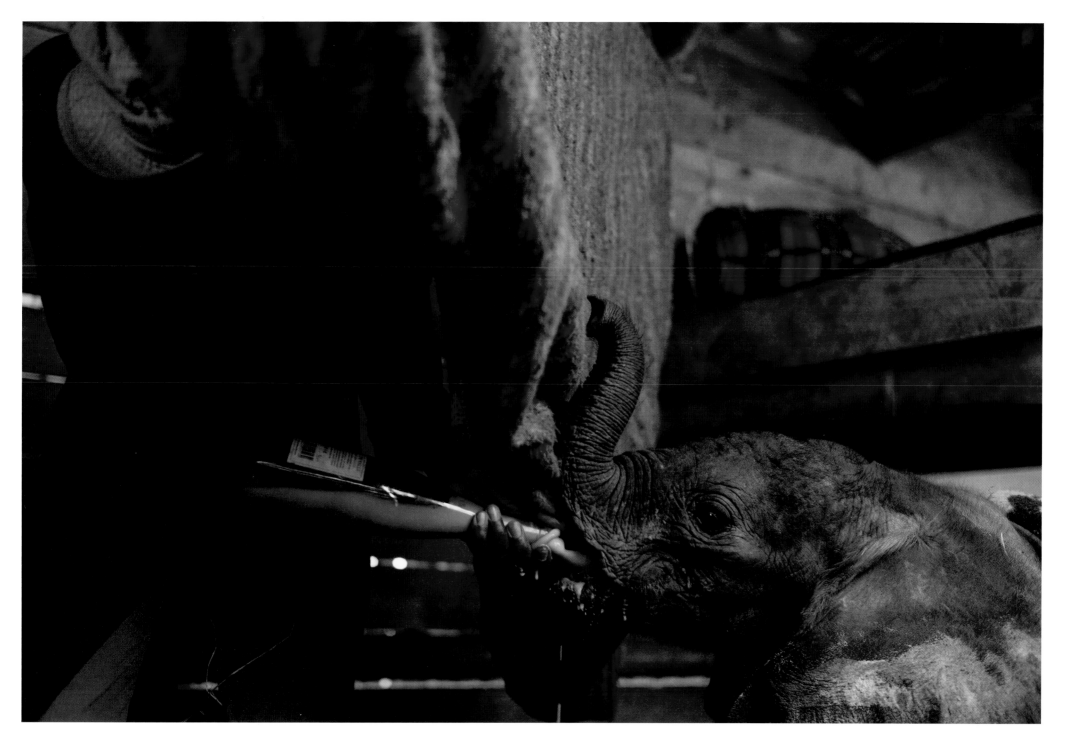

The orphans have an uncanny knack of being able to read your heart, so it is

in a new recruit's interest to work towards earning the love and respect of

his charges, interacting and talking gently to them, touching and caressing them,

playing with them, picking suitable leaves and, most importantly, exuding a

genuine affection. And because elephants never forget, it is essential that they

be treated only with love and kindness.

—*Daphne Sheldrick,* Love, Life, and Elephants: An African Love Story, *2012*

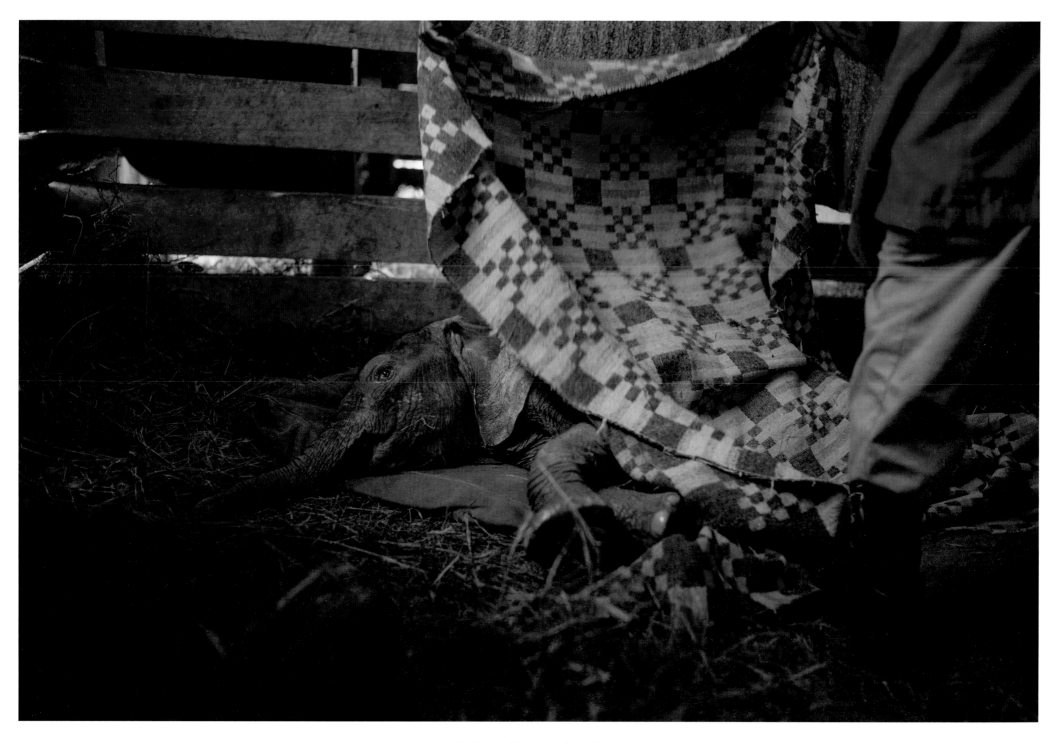

Sadly, no matter how much expert care and love are given, the rescued orphans are at risk. Wasin died abruptly of unknown causes.

Elephant society in Africa has been decimated by mass deaths and social breakdown from poaching, culls and habitat loss. From an estimated ten million elephants in the early 1900s, there are only half a million left today. Wild elephants are displaying symptoms associated with human PTSD: abnormal startle response, depression, unpredictable asocial behaviour and hyperaggression. Elephants are renowned for their close relationships. Young elephants are reared in a matriarchal society, embedded in complex layers of extended family. Culls and illegal poaching have fragmented these patterns of social attachment by eliminating the supportive stratum of the matriarch and older female caretakers.

—*G. A. Bradshaw, Allan N. Schore, Janine L. Brown, Joyce H. Poole, and Cynthia J. Moss,*
"Elephant Breakdown," Nature *magazine, February 25, 2005*

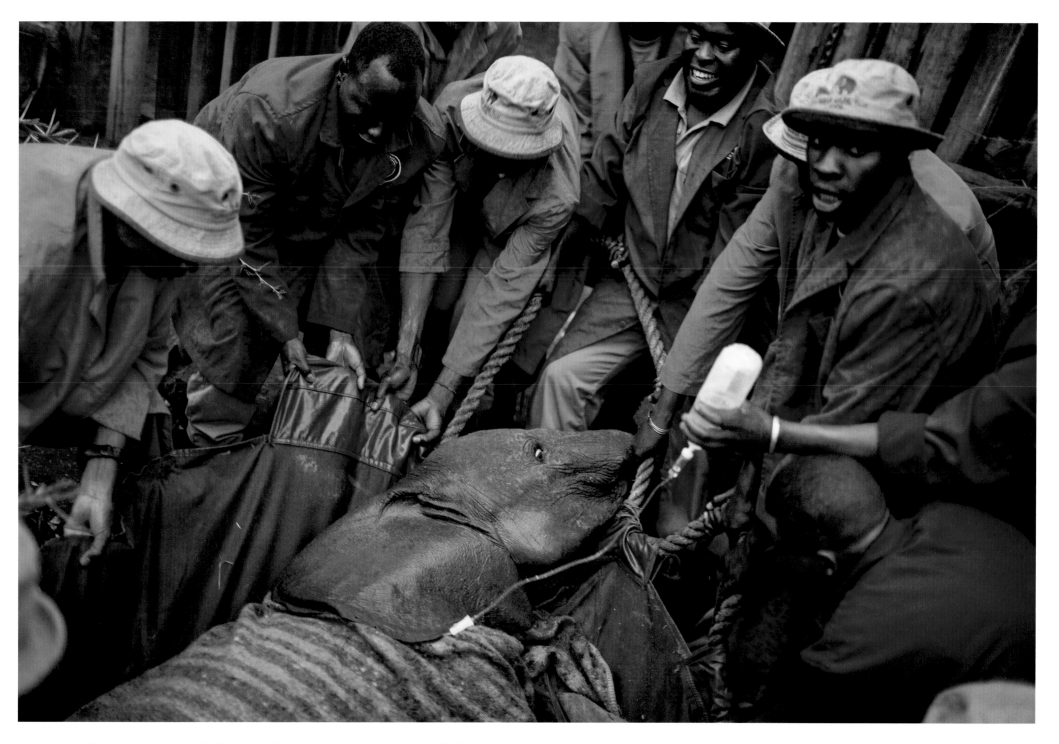

It took ten strong men to lift this two-year-old into her stall at the nursery. Angela Sheldrick suspected that she would not survive, having been severely traumatized by the loss of her family; in fact she died the next day.

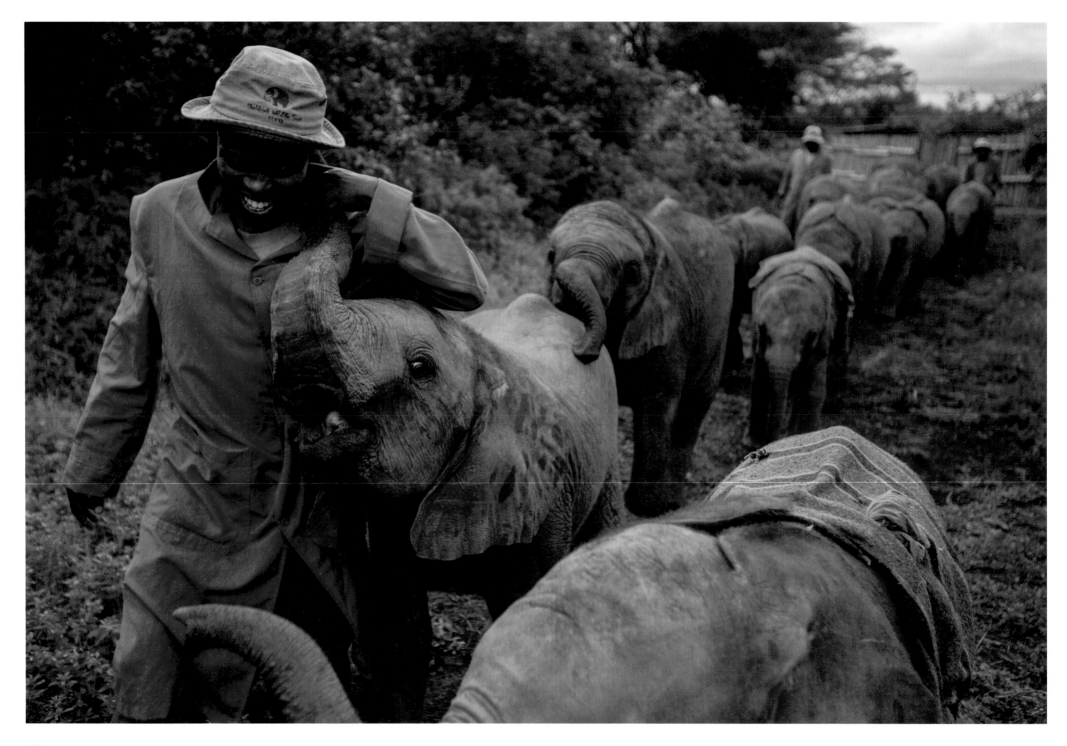

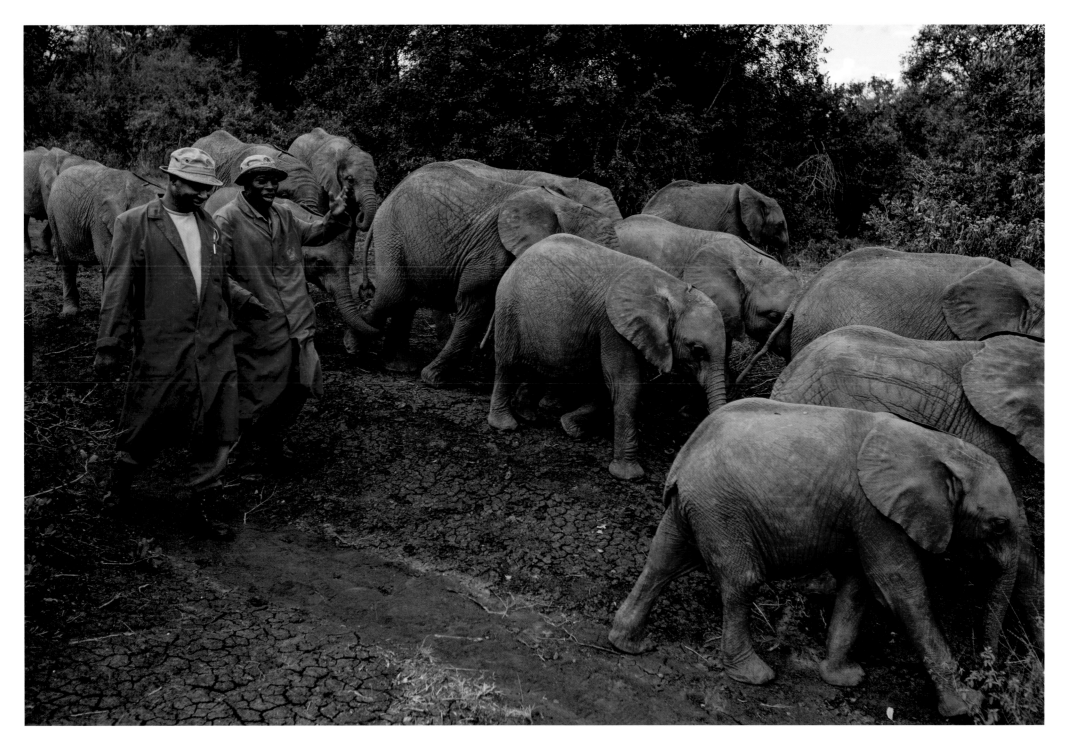

The nursery orphans are always treated as a family, led by their "matriarchs," the human keepers, to and from the stables for foraging. 157

I also have always felt that elephants have a sense of themselves *as* elephants, that they see themselves as different from other species. Elephants seem to have categories in which they classify other animals. They have a particular dislike for species that are either predators or scavengers, even if those animals are not a threat to elephants or are scavengers that are not feeding on an elephant carcass. For example, if an elephant comes across a group of jackals and vultures feeding on a zebra carcass, typically it chases them off or at least shakes its head in what I would characterize as annoyance. It is as if elephants do not like the sight of blood or have a particular aversion for carnivores.

—*Joyce Poole,* Coming of Age with Elephants: A Memoir, *1996*

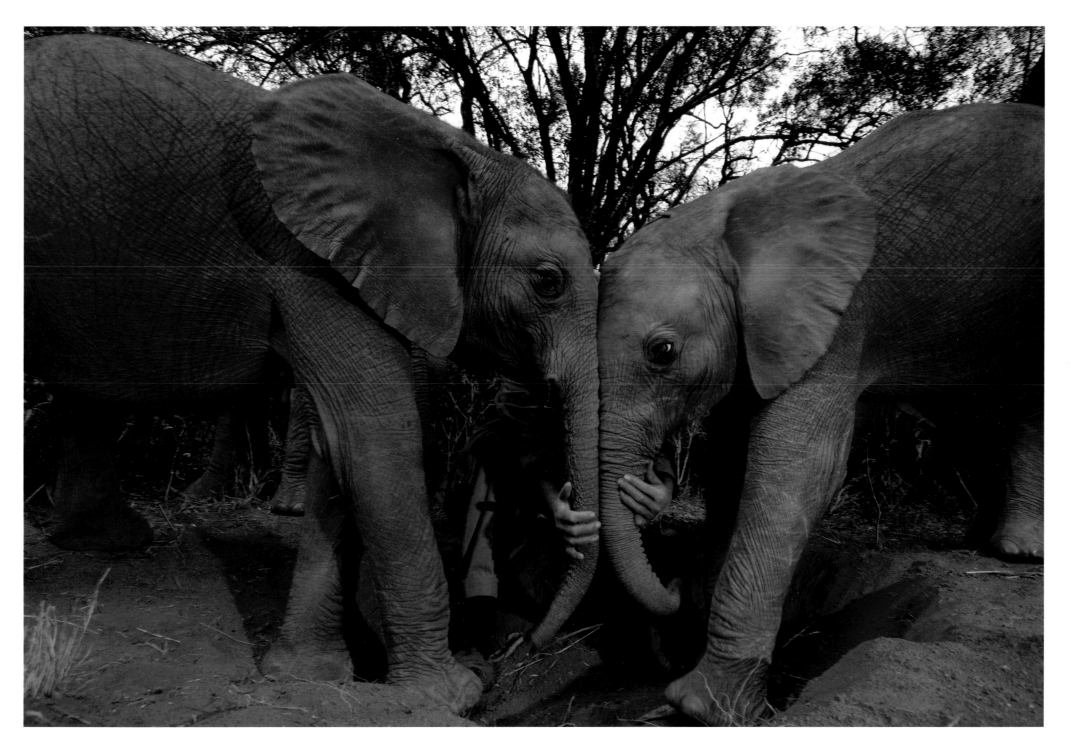

When orphans arrive at the nursery they are scared and most of all need other elephants. The process of socializing begins as soon as they are strong enough to interact.

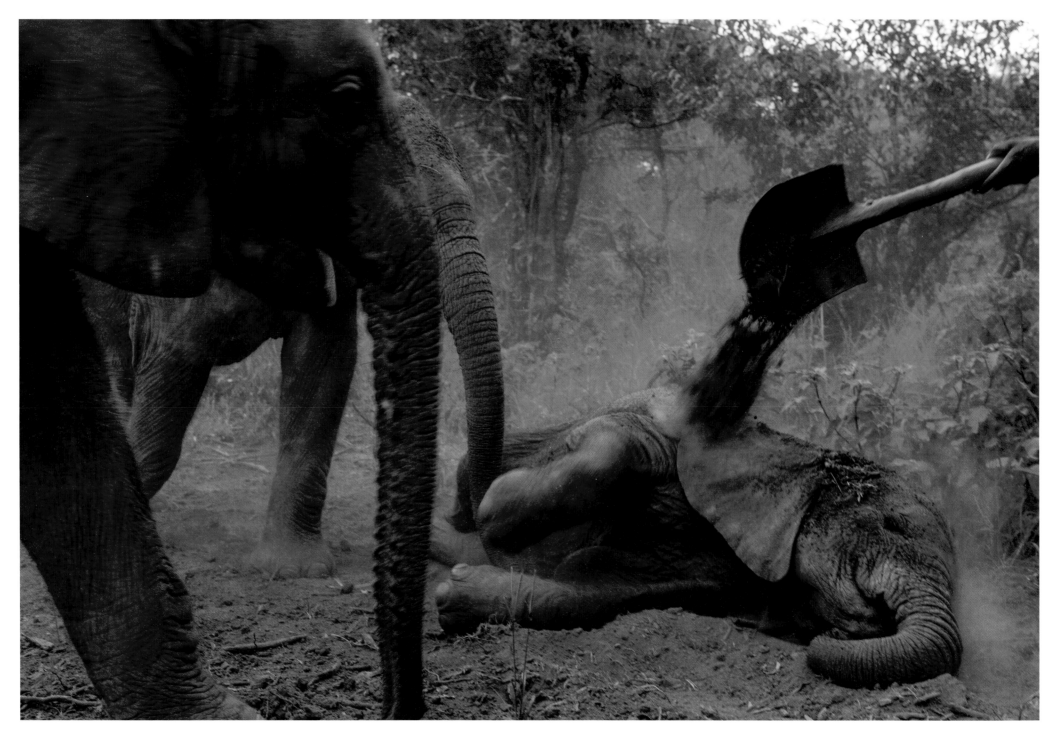

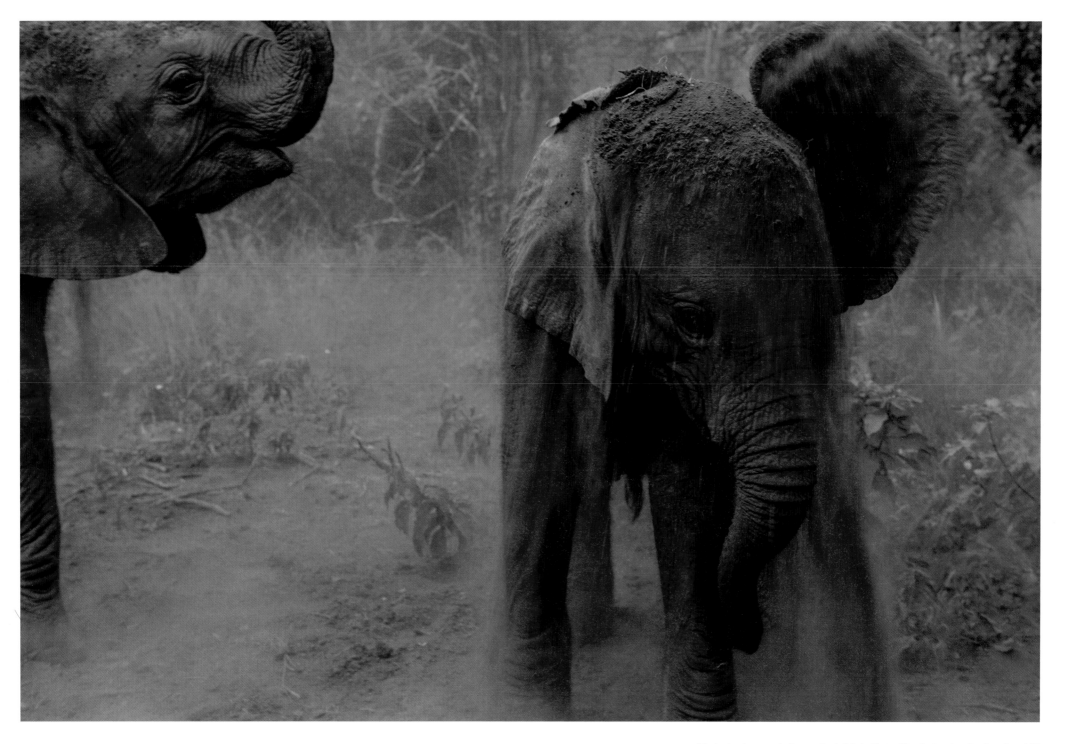

All elephants seem to love a good dirt dusting, either by trunk or by shovel. 161

A recent arrival at the Nairobi nursery was an elephant named Murka, rescued near Tsavo National Park with a spear lodged deep between her eyes and gaping spear and axe wounds along her back and sides. The spear had penetrated ten inches, rupturing her sinuses, which prevented her from using her trunk to drink. Her deep wounds were filled with maggots. Most likely orphaned by poachers who killed her mother for profit, the one-year-old baby is believed to have been subsequently attacked by local Maasai tribesmen who were angry about losing their traditional grazing land to the park. A mobile vet unit was able to tranquilize her, clean her wounds, and extract the spear. . . .

We walk over to the stable marked Murka—the orphan that had been found with a spear lodged in her head. "Now look at her," Daphne says, as Murka, with only the slightest indent in her forehead to show for her brutal ordeal, approaches the half-opened door of her stable and takes two of my fingers to suckle on. "The vets didn't expect her to make it through the first night."

"And she's healed psychologically," Angela adds. "She was one extremely traumatized little elephant when she first woke up, lashing out at everyone—and rightly so. But slowly she began to trust again, and after about a month she wasn't just fine about people, she was seeking them out. And it wasn't just our doing. She would never have recovered so quickly without the input of other elephants."

—*Charles Siebert,* "Orphans No More," National Geographic *magazine, September 2011*

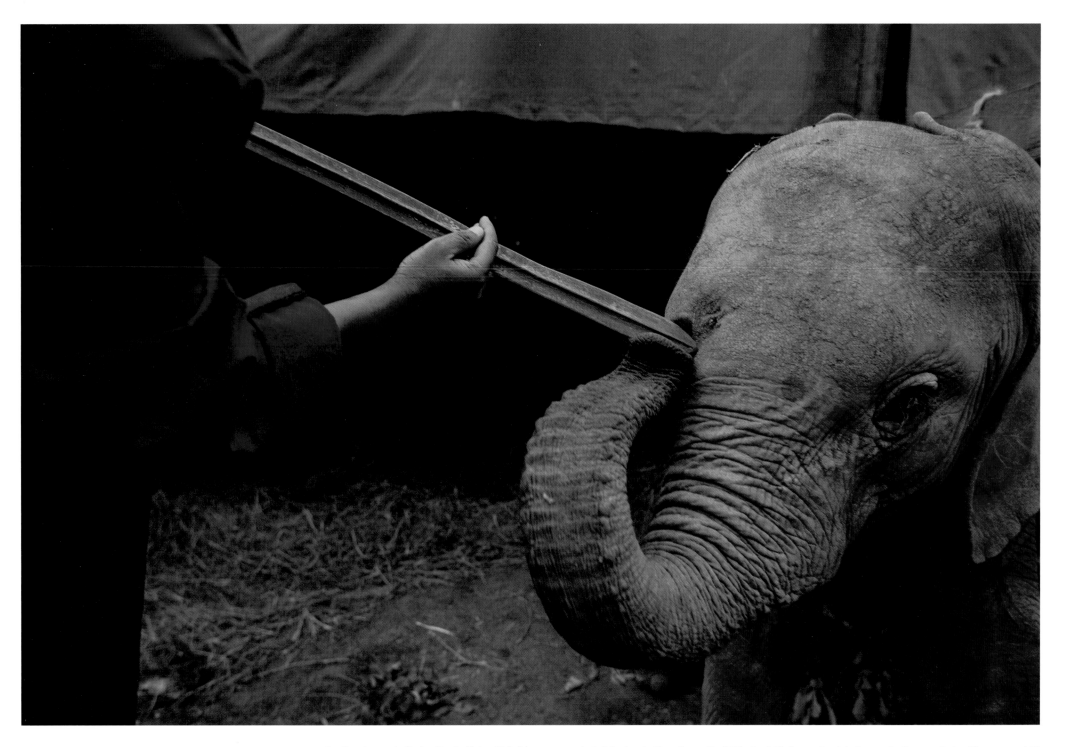

Gently, a keeper indicates the depth to which this spear penetrated the head of twenty-month-old Murka. Initially very fearful, she eventually came to trust humans. 163

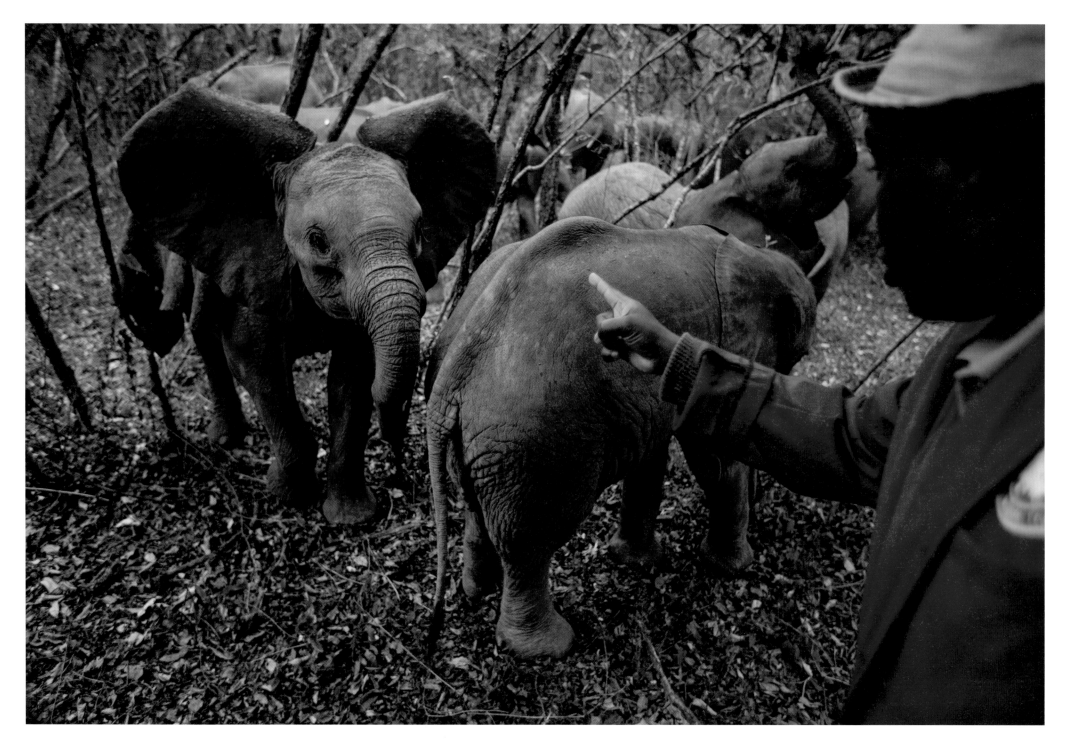

164 On Kitirua's first day among the other orphans, her rough behavior is corrected with a gesture and by saying her name in a strong tone.

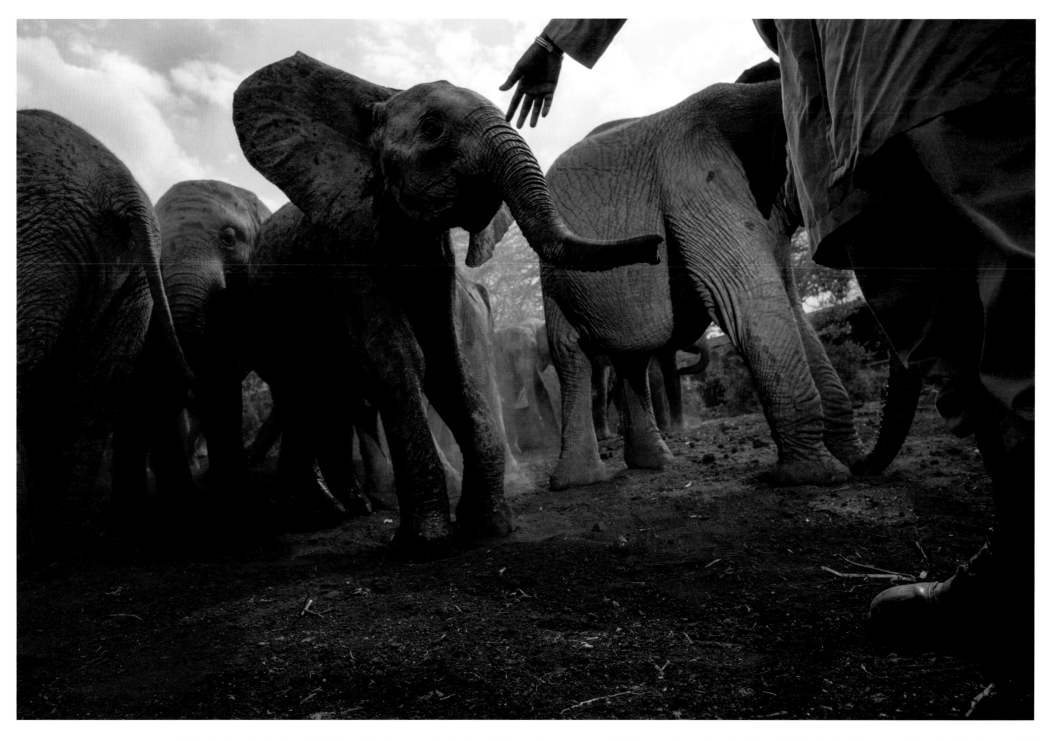

This benign but effective form of discipline is in extreme contrast to the methods used in some zoos and all circuses, where a sharp hook is prodded into tender skin to control the animals' behavior. 165

There is no doubt that in the name of total rationalization you should be destroyed, leaving all the room to us on this overpopulated planet. Neither can there be any doubt that your disappearance will mean the beginning of an entirely man-made world. But let me tell you this, old friend: in an entirely man-made world, there can be no room for man either. . . . We are not and could never be our own creation. We are forever condemned to be part of a mystery that neither logic nor imagination could fathom, and your presence among us carries a resonance that cannot be accounted for in terms of science or reason, but only in terms of awe, wonder and reverence. You are our last innocence.

—*Romain Gary*, "Dear Elephant, Sir," Life *magazine, December 22, 1967*

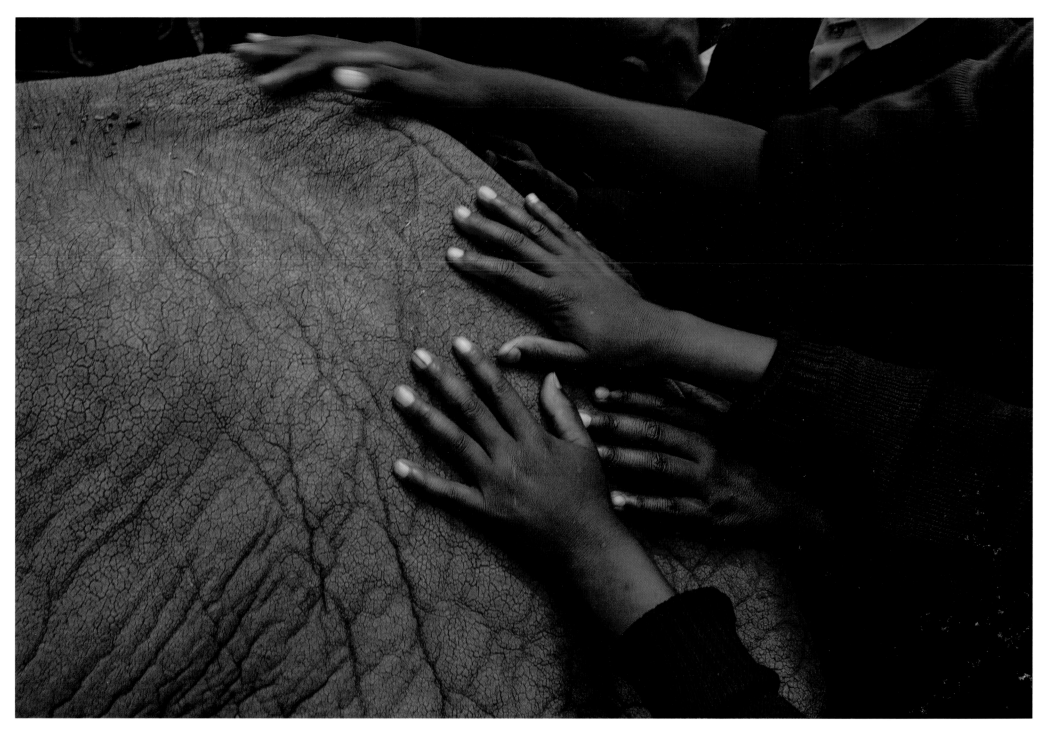

Kenyan schoolchildren regularly visit the Nairobi nursery, where they are allowed to touch the animals. 167

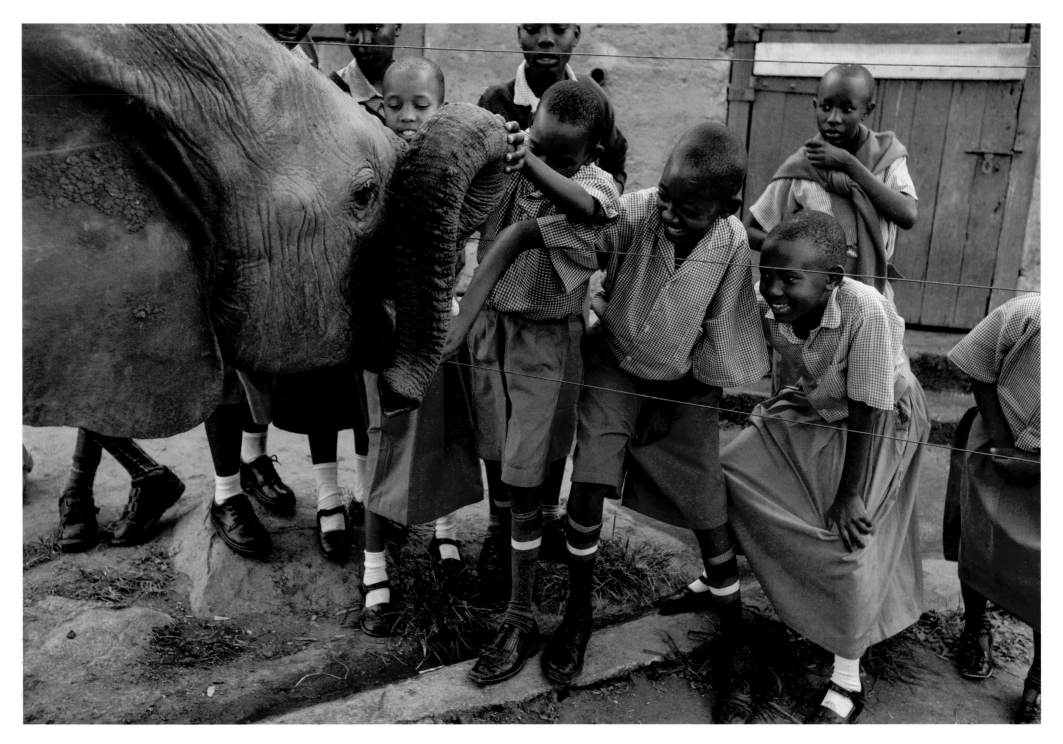

168 At Voi Rehabilitation Center, the orphan Mzima greets and enjoys the company of schoolchildren.

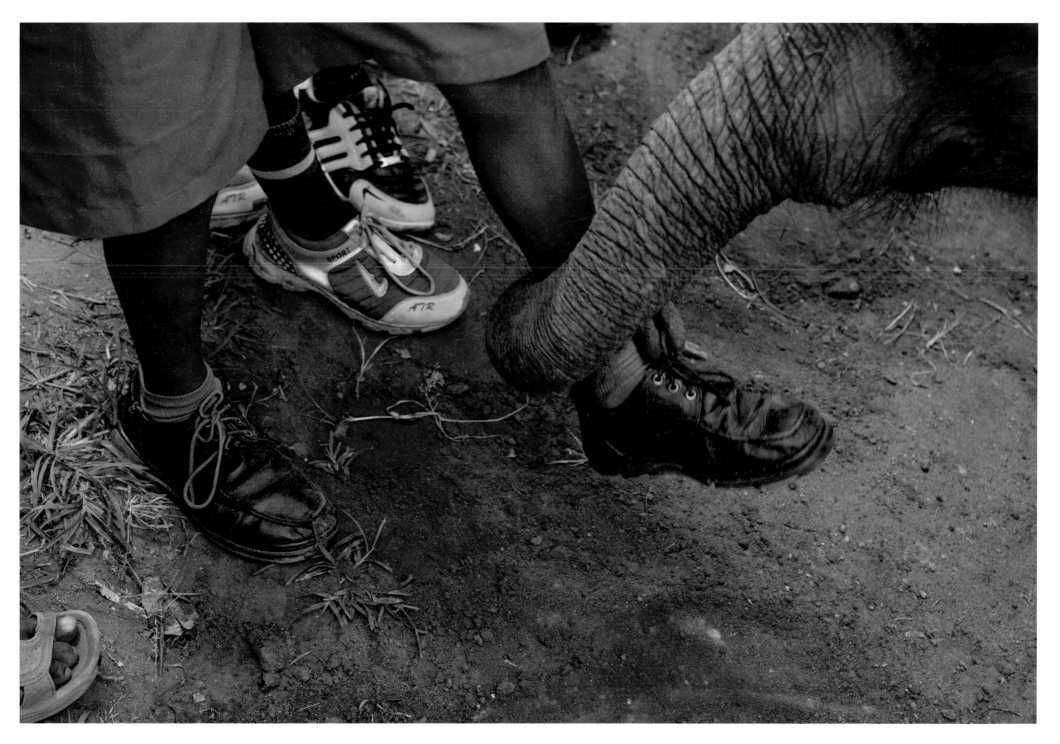

The children were silent and frightened before seeing the elephants at the nursery; a few minutes with Mzima dissipated the tension. 169

Older orphans instruct newcomers with gentle patience, teaching them not to touch electric fencing, escorting newcomers out to browse, joining them at their noon mud bath, introducing them to known friendly wild elephant herds they happen to meet in their daily wanderings. It is usual for senior ex-orphan females to select a smaller baby as their "chosen" one. This is a much sought-after privilege, when leader elephants will allow smaller calves to head a column on the way out of the stockades in the morning or to and from the noon mud bath and back again in the evening. Although elephants are born with a genetic memory programmed with elements important to survival, this memory has to be honed by gradual exposure to a wild situation. Our elephants are never just tipped out into a wild situation but are rather just introduced gradually, through access and exposure that can span ten years to enable such natural instincts to become honed. As all the orphans who have grown up together regard themselves as family, those that have accomplished the transition to "wild" status like to keep in touch with others that remain keeper-dependent, returning from time to time to keep contact with whoever is still in the stockades, understanding that others like themselves can benefit from elephant reassurance and guidance.

—*Daphne Sheldrick,* Love, Life, and Elephants: An African Love Story, *2012*

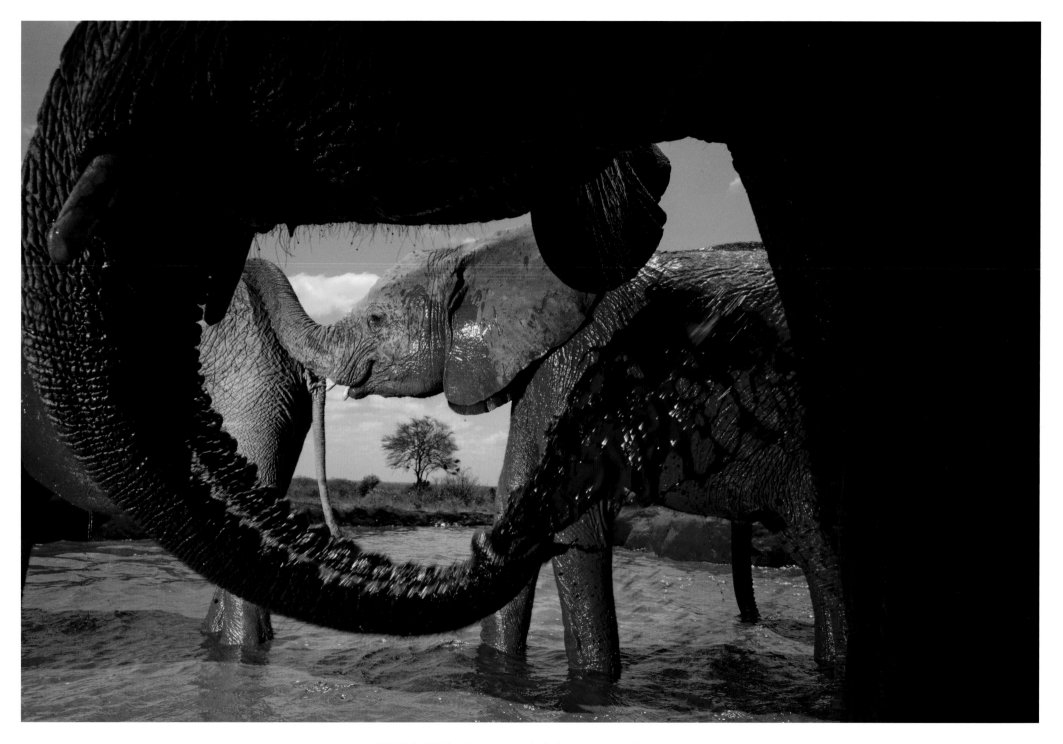

At Voi Rehabilitation Center, orphans bathe in red mud, a playful midday ritual that provides sunscreen and insect control for the vulnerable youngsters.

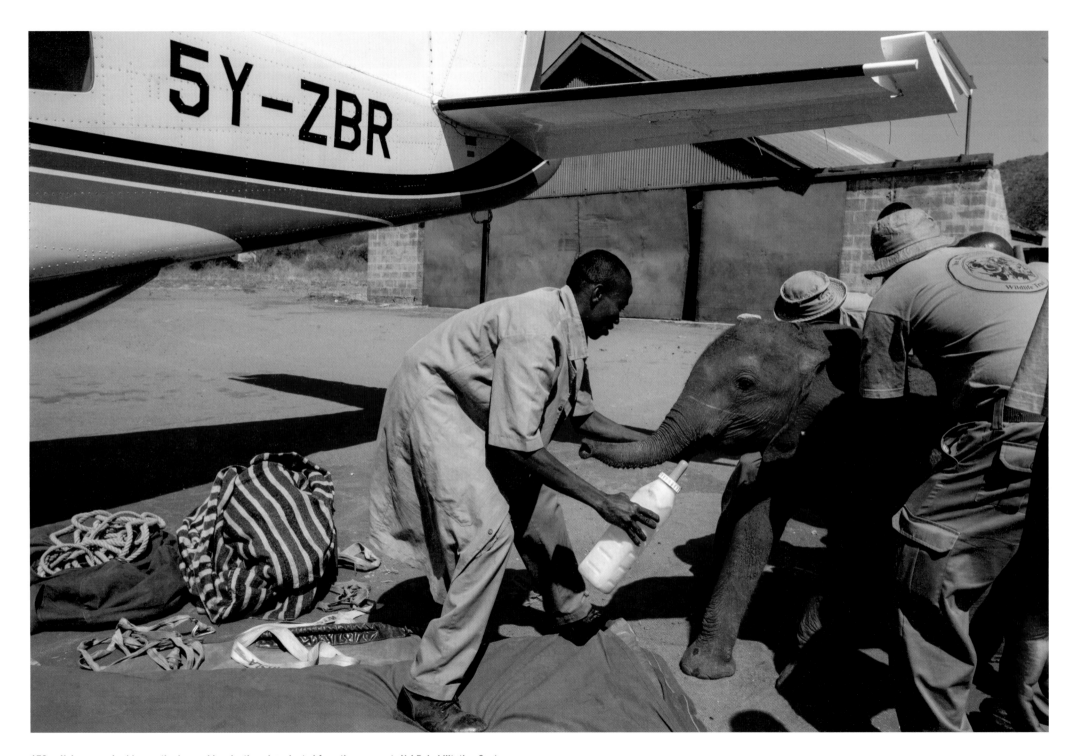

172 Kalama survived her mother's poaching death and graduated from the nursery to Voi Rehabilitation Center.

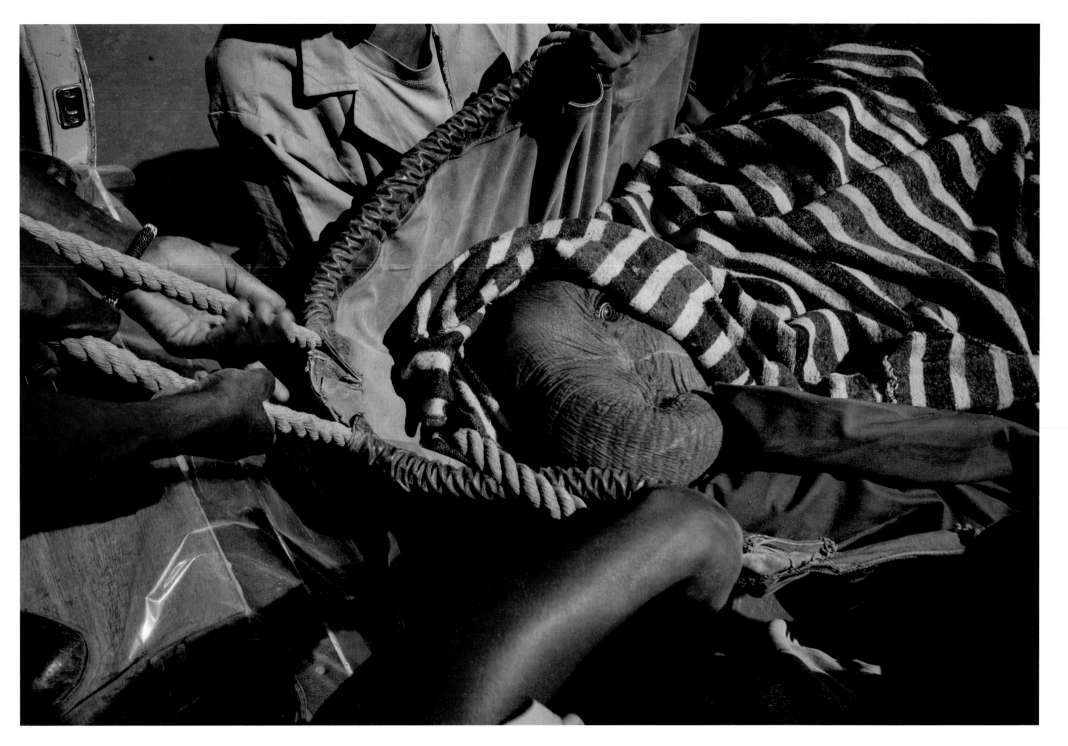

Kalama was sickened by something she ate and was evacuated to Nairobi, where she soon died. Her loss affected all the keepers; the physical and emotional investment in each orphan is substantial. 173

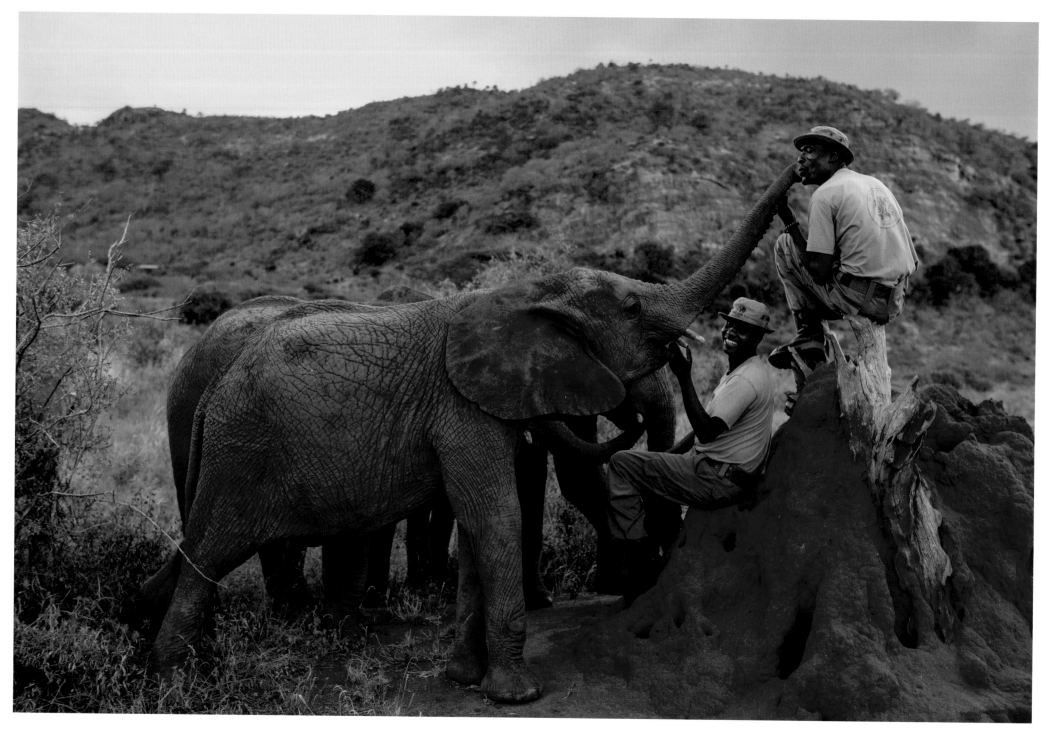

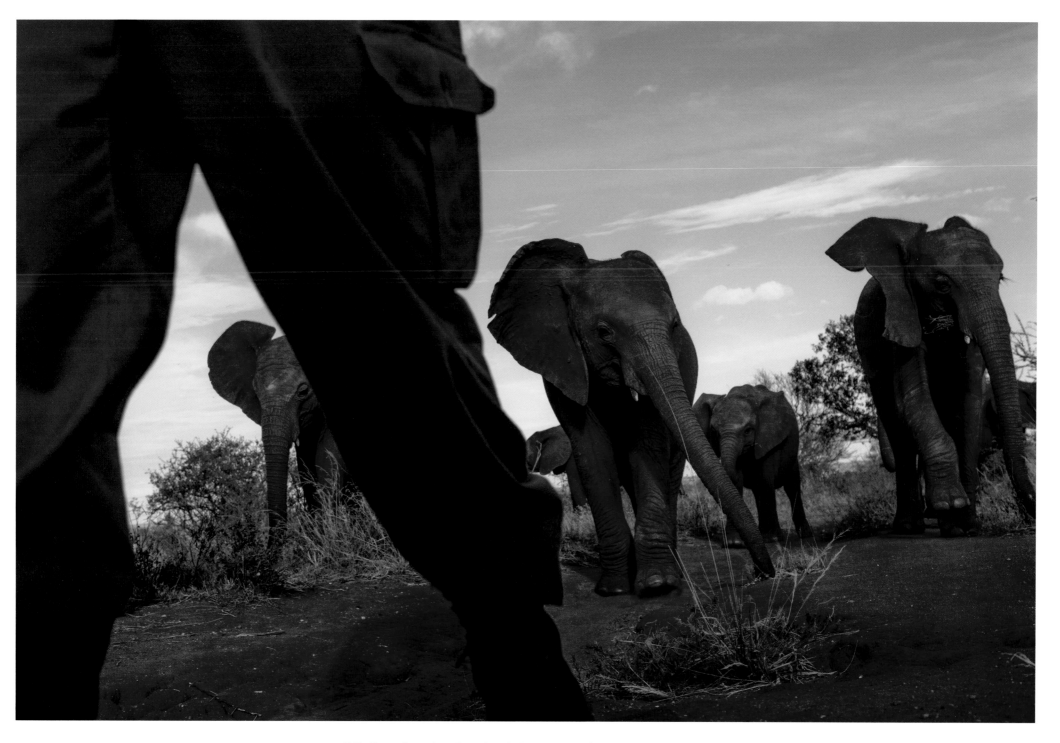

At the Tsavo release sites, the orphans begin the process of independence and spend the day walking and foraging, weaning gradually from their milk formula. 175

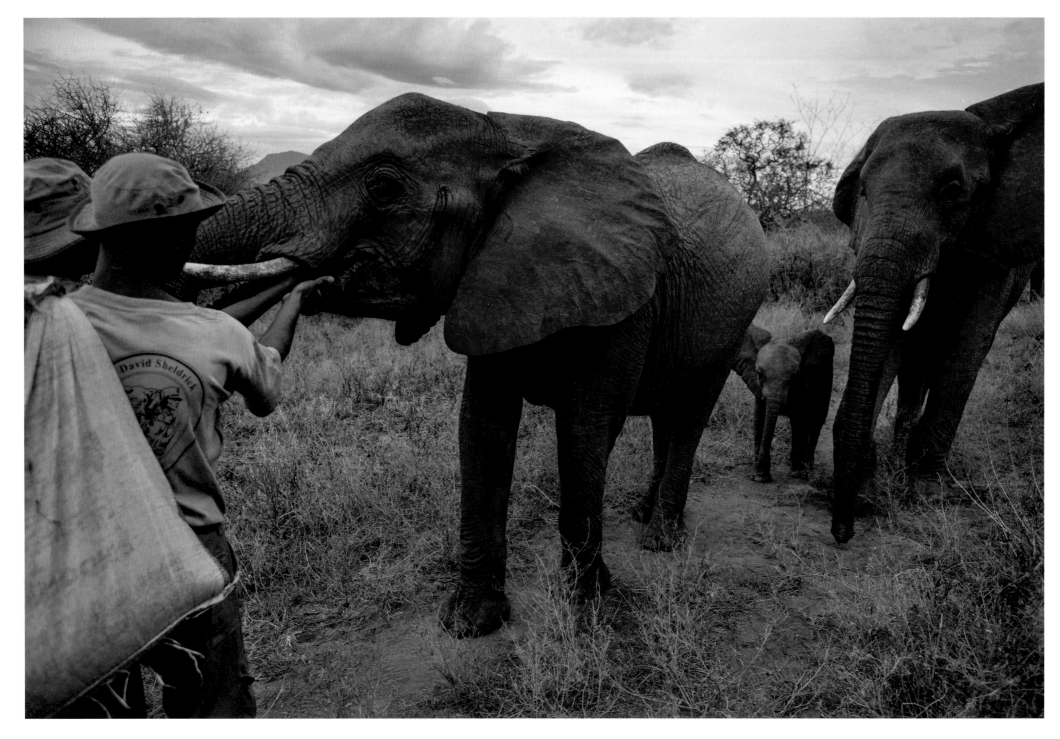

176 Seventeen-year-old Emily, the matriarch of a family of independent orphans, visits the Voi stockade with her wild-born infant, to have a poacher's poisoned arrow removed from her flank.

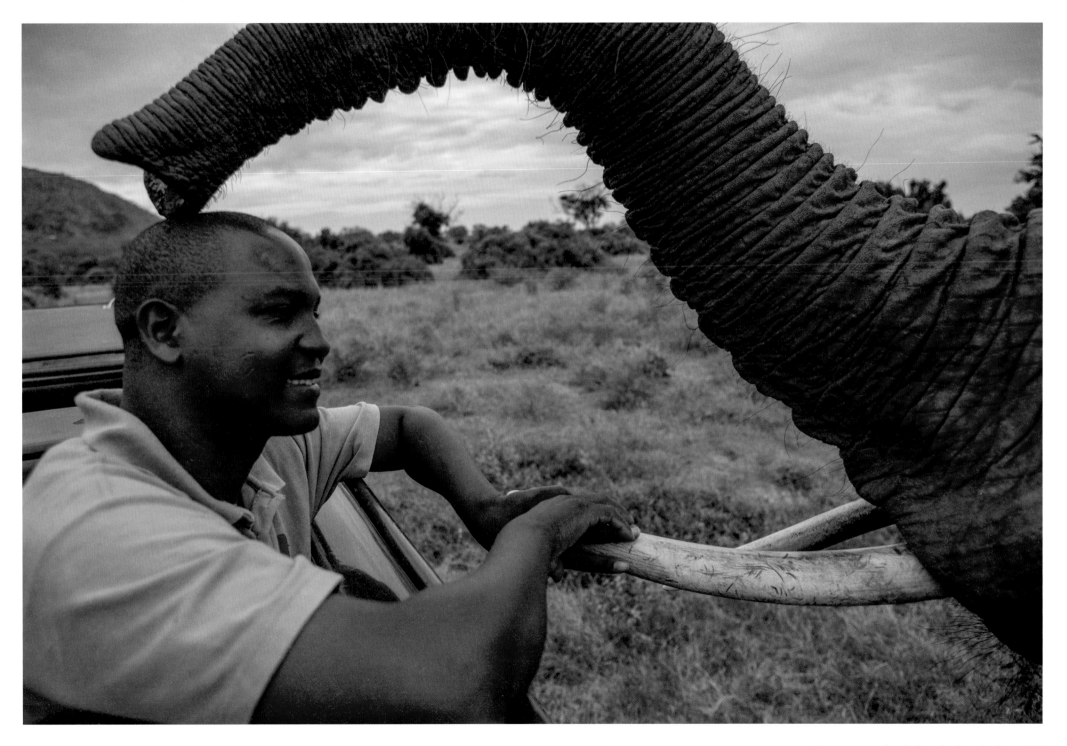

The day after the arrow is removed, Emily lovingly greets head keeper Joseph Sauni, who helped to raise her.

Mysteriously . . . the ex-orphans who are now living wild anticipate ahead of time the arrival of new nursery elephants. How they know this defies human interpretation, but it happens far too often to be chance. Mobile phone signals are poor in Tsavo's remote north, and there have been occasions when even the Ithumba keepers have been unaware that the new elephants are on their way, yet the independent ex-orphans are the "giveaway," turning up unexpectedly to wait at the stockade compound for the new arrivals. We can only assume that telepathy is at work, and, even more astoundingly, that such telepathy can only be between the ex-orphans and the Nairobi keepers, since there have been instances when new transferees are not known by those now living wild.

The reunions that take place are always joyful, involving trumpeting, the intertwining of trunks, urinating and rumbling, with the newcomers always welcomed with a great outpouring of love.

—*Daphne Sheldrick,* Love, Life, and Elephants: An African Love Story, *2012*

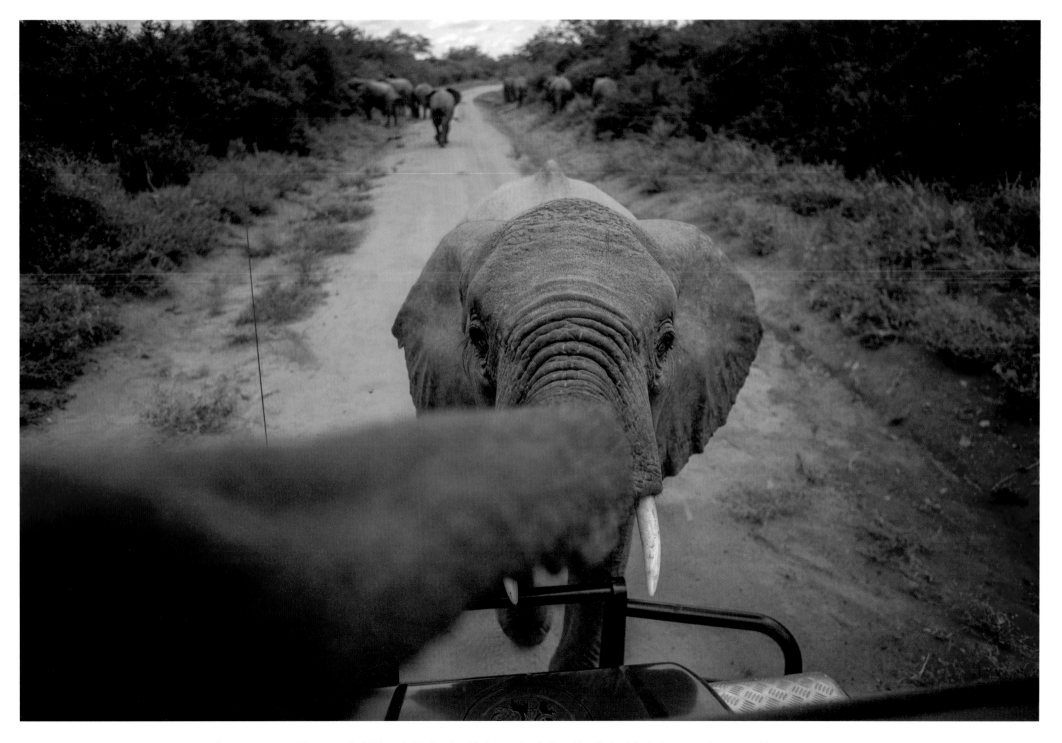

This elephant, Wendi, was found as an hours-old newborn in 2002, probably abandoned by her mother. At Tsavo East National Park, she now leads a group of fourteen orphans that have been independent since 2009. 179

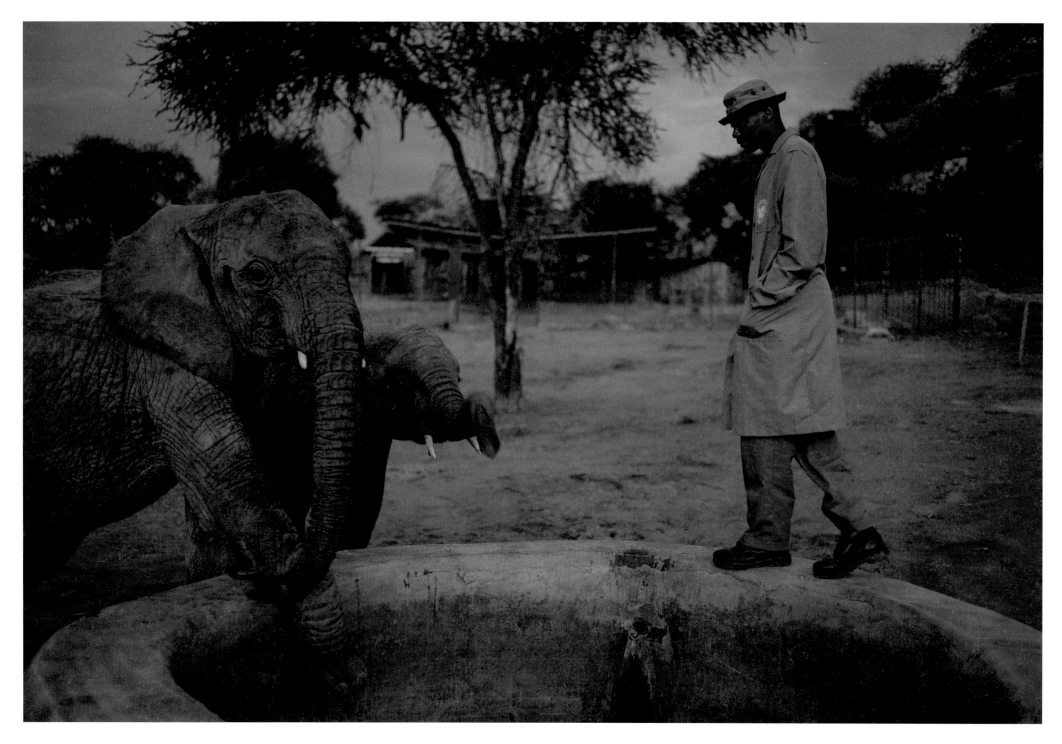

180 Benjamin Kyalo is the head keeper responsible for opening the Ithumba Rehabilitation Center in northern Tsavo. Here he supervises orphans drinking at a man-made water hole.

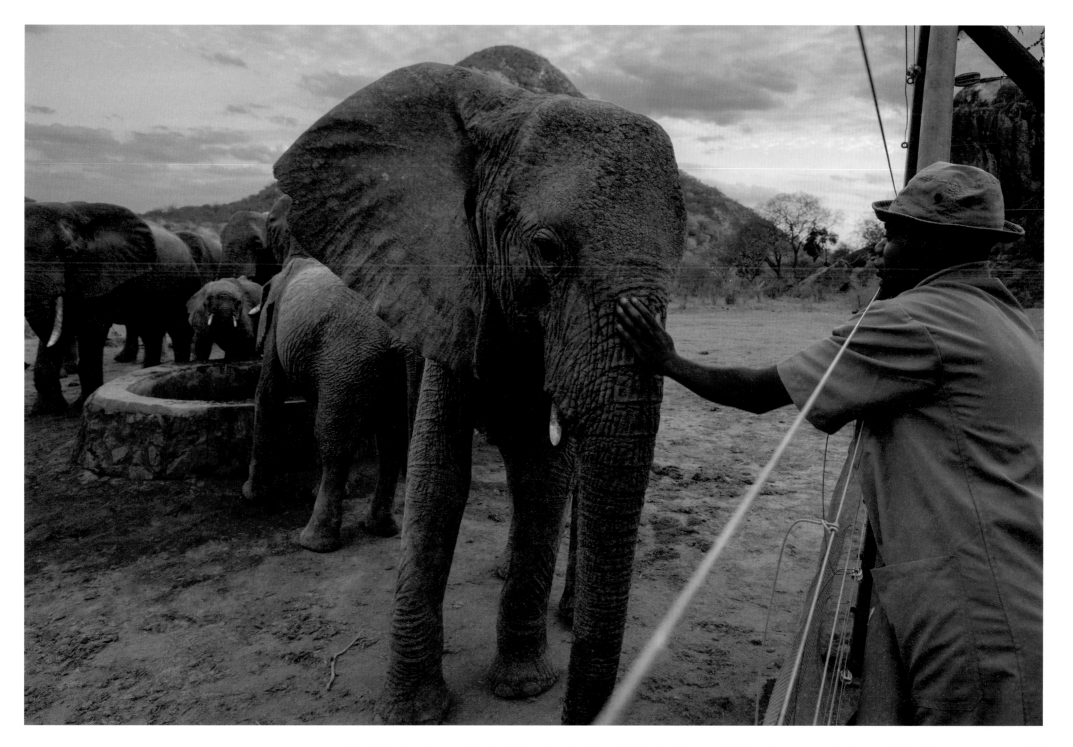

The introduction of orphans into Ithumba has drawn back the wild elephants; they come to drink precious water and to interact with the independent orphans. 181

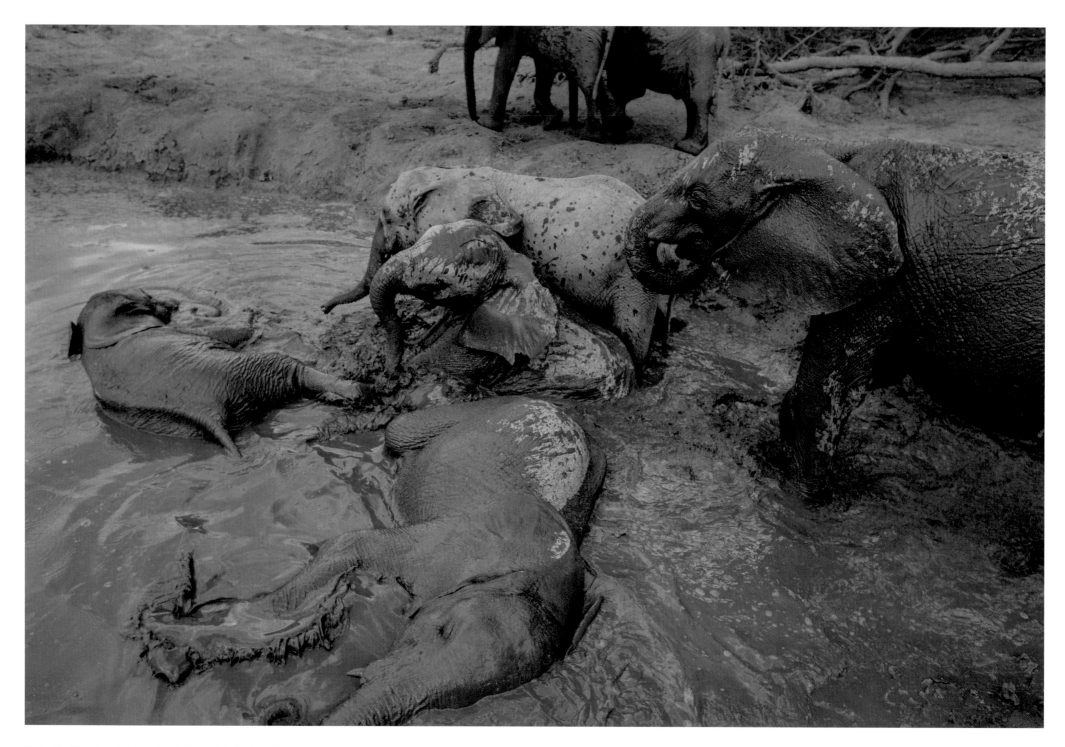

182 The Ithumba midday mud bath is a social playtime, where young orphans like these often mingle with wild elephants.

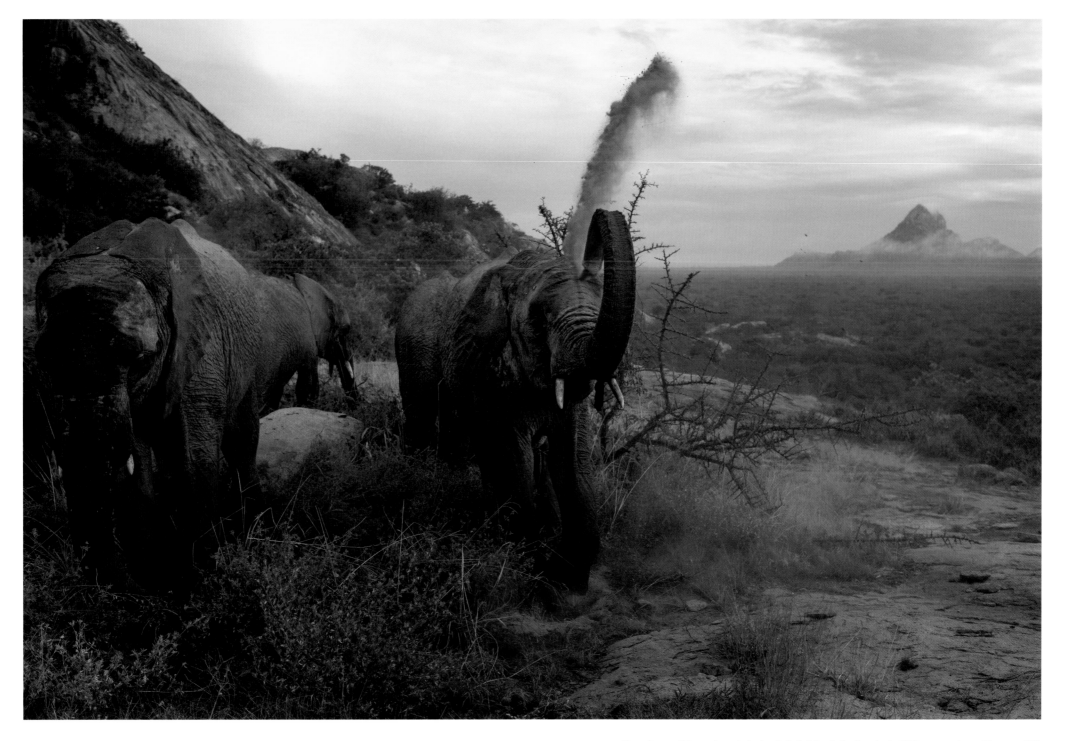

The release of the orphaned elephants is helping to heal and rebuild the ecosystem of Tsavo. 183

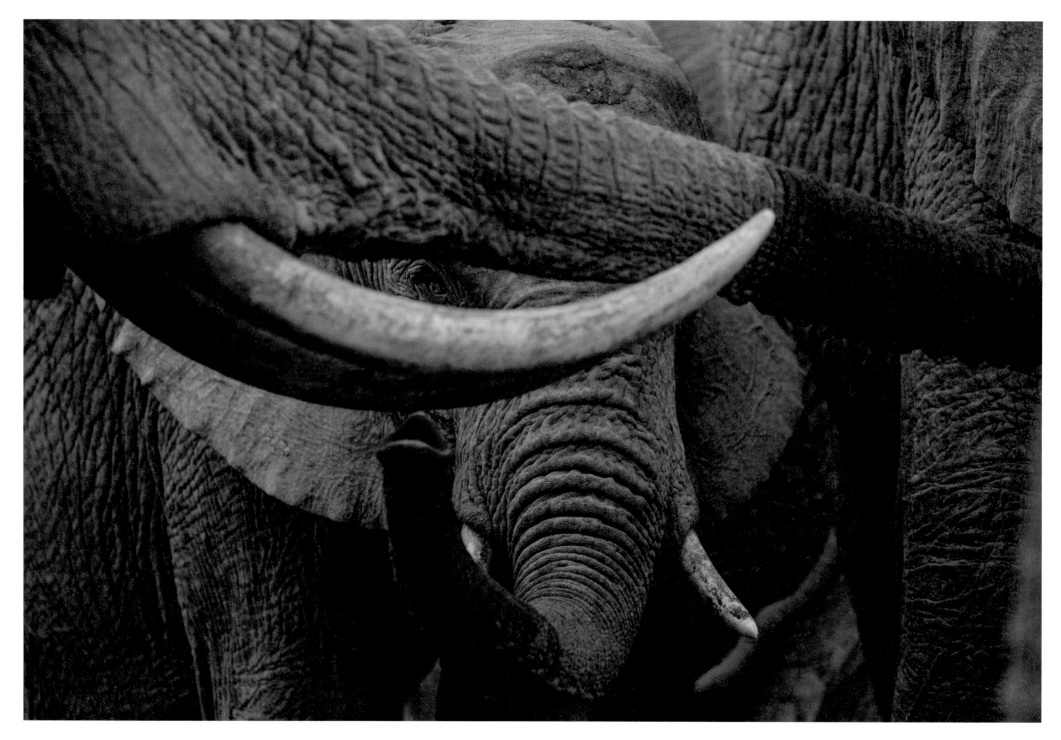

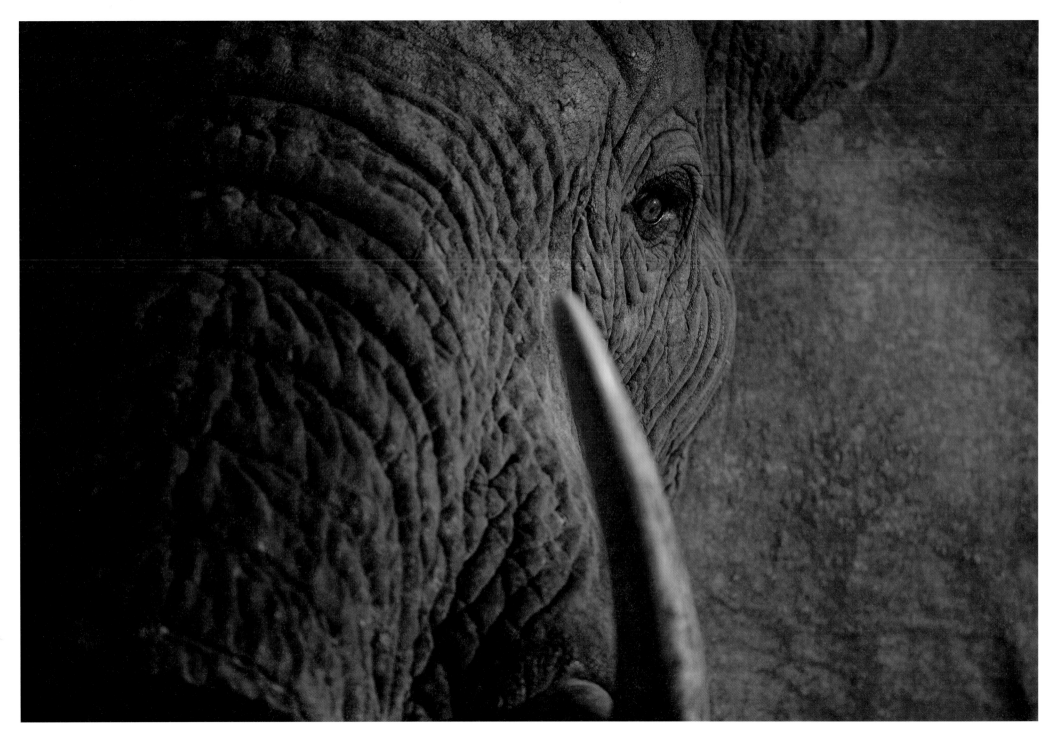

And while I still have much to learn, this much I know: animals are indeed more ancient, more complex and in many ways more sophisticated than us. They are more perfect because they remain within Nature's fearful symmetry just as Nature intended. They should be respected and revered, and perhaps none more so than the elephant, the world's most emotionally human land mammal.

—*Daphne Sheldrick,* Love, Life, and Elephants: An African Love Story, *2012*

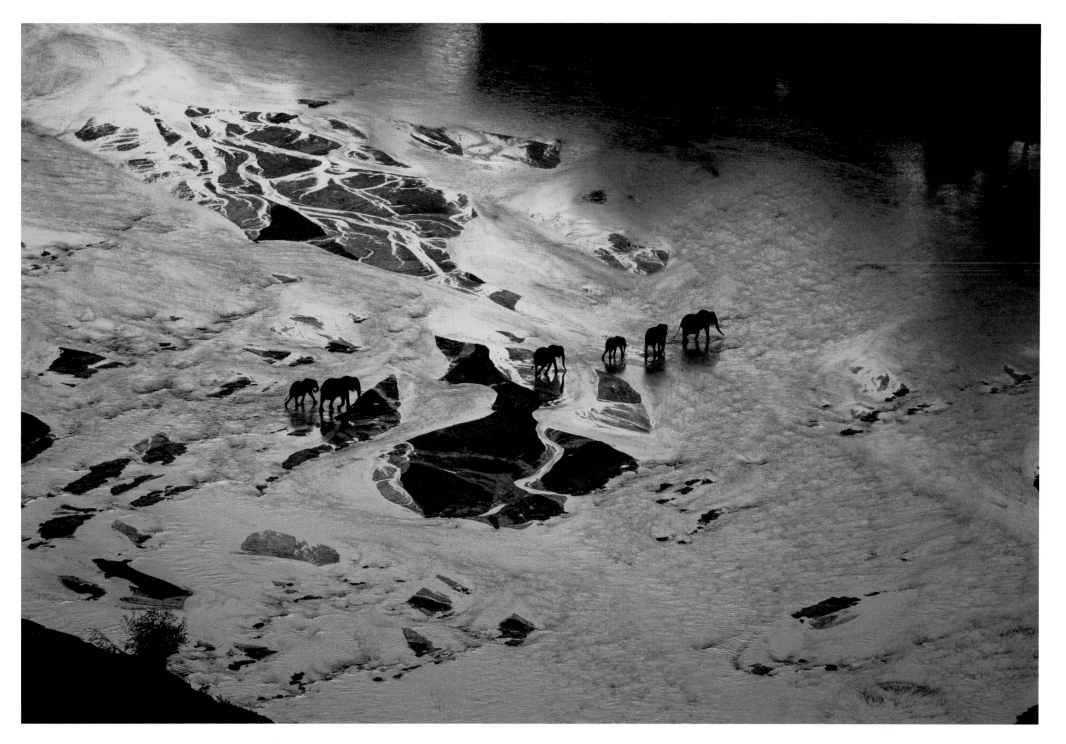

A wild family crosses the Galana River that divides Tsavo National Park. One of the largest parks in Africa, Tsavo is a critical last stand habitat for wild elephants to walk the earth. 187

ELEPHANT POACHING

Killing African elephants for their ivory is devastating a species that's already losing ground to a growing human population. Estimates of poaching come from examining elephant carcasses at monitored sites (map). In 2011 poaching hit the highest levels in a decade, with the greatest impact in the central Africa region (charts below).

IVORY SEIZURES

Most of the world's countries agreed to ban international trade in ivory in 1989. Yet demand has grown in Asia, driven by new wealth in China. The illegal ivory that is seized represents only a fraction of what gets through—and the number of large seizures has risen, evidence of organized smuggling syndicates.

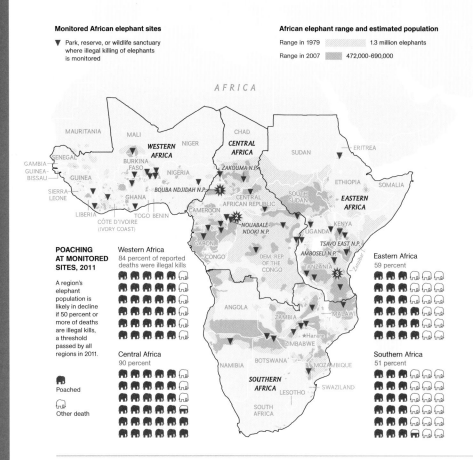

Monitored African elephant sites

▼ Park, reserve, or wildlife sanctuary where illegal killing of elephants is monitored

African elephant range and estimated population

Range in 1979 — 1.3 million elephants
Range in 2007 — 472,000-690,000

POACHING AT MONITORED SITES, 2011

A region's elephant population is likely in decline if 50 percent or more of deaths are illegal kills, a threshold passed by all regions in 2011.

🐘 Poached
🐘 Other death

Western Africa
84 percent of reported deaths were illegal kills

Central Africa
90 percent

Eastern Africa
59 percent

Southern Africa
51 percent

LARGE-SCALE POACHING

✳ Cameroon, early 2012
Organized raiders on horseback from Chad and Sudan killed more than 300 elephants in Bouba Ndjidah National Park.

✳ Congo, 2006-2011
Nearly 5,000 elephants died in lands outside Nouabalé-Ndoki National Park; new logging roads make the area more accessible.

✳ Tanzania, 2012
Poachers are using poison so gunshots won't attract park wardens. Tanzania is a main shipping point for illegal ivory to Asia.

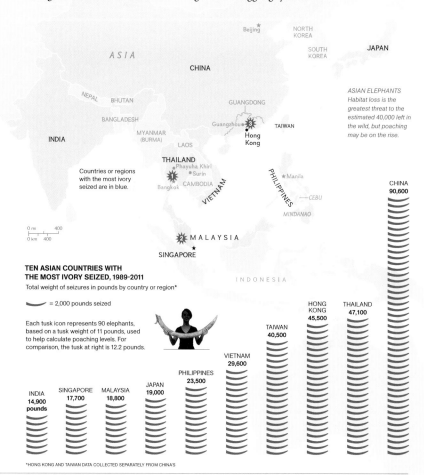

ASIAN ELEPHANTS Habitat loss is the greatest threat to the estimated 40,000 left in the wild, but poaching may be on the rise.

Countries or regions with the most ivory seized are in blue.

TEN ASIAN COUNTRIES WITH THE MOST IVORY SEIZED, 1989-2011

Total weight of seizures in pounds by country or region*

〜 = 2,000 pounds seized

Each tusk icon represents 90 elephants, based on a tusk weight of 11 pounds, used to help calculate poaching levels. For comparison, the tusk at right is 12.2 pounds.

INDIA 14,900 pounds
SINGAPORE 17,700
MALAYSIA 18,800
JAPAN 19,000
PHILIPPINES 23,500
VIETNAM 29,600
TAIWAN 40,500
HONG KONG 45,500
THAILAND 47,100
CHINA 90,600

*HONG KONG AND TAIWAN DATA COLLECTED SEPARATELY FROM CHINA'S

SMUGGLING TACTICS

✳ Bangkok, Thailand, 2011
An x-ray scan found 247 large tusks, valued by authorities at $3 million, in a shipping container of frozen mackerel from Kenya.

✳ Malaysia, 2011
Shipping containers of recycled plastic from Tanzania also held nearly 700 tusks destined for China via Malaysia.

✳ Guangdong Province, China, 2009
A rented Chinese fishing boat returned from the Philippines with 770 whole and partial tusks packed in five wooden crates.

NGM STAFF. AFRICAN ELEPHANT DATA: CITES MIKE PROGRAMME; IAIN DOUGLAS-HAMILTON, SAVE THE ELEPHANTS; DIANE SKINNER, AFRICAN ELEPHANT SPECIALIST GROUP, IUCN.

IVORY SEIZURE DATA: TOM MILLIKEN, ETIS TRAFFIC. TUSK: SMITHSONIAN NATIONAL MUSEUM OF NATURAL HISTORY, COLLECTED 1909

HOW TO HELP

AFRICAN PARKS NETWORK www.african-parks.org

If we are to realize the vision of long-term habitat and wildlife protection, conservation organizations must be in a position to assume greater responsibility in the countries where they operate. This is achieved by forging relationships with all levels of government—partnerships from which everyone benefits, including local communities, wildlife, and protected areas. This is the philosophy of African Parks, as seen in Zakouma National Park—an area that has been devastated by poachers. Together with the Chadian government, African Parks is working to turn the fate of elephants around. This iconic species can be protected, but it requires all of us to reexamine the status quo and look for solutions.

AMBOSELI TRUST FOR ELEPHANTS www.elephanttrust.org

The Amboseli Trust for Elephants works for the conservation and welfare of Africa's elephants through scientific research, training, community outreach, public awareness, and advocacy. Since 1972, the efforts of Cynthia Moss and her research team at Amboseli have led to deeper understanding of these intelligent and complex animals.

DAVID SHELDRICK WILDLIFE TRUST www.sheldrickwildlifetrust.org

The David Sheldrick Wildlife Trust, under the direction of Daphne Sheldrick, embraces measures that complement the conservation and protection of wildlife. These include the rescue and hand-rearing of orphaned elephant calves, along with other species—so that they can ultimately experience a wild life—in addition to antipoaching efforts, safeguarding the natural environment, enhancing community awareness, addressing animal welfare issues, and providing veterinary assistance to animals in need.

ELEPHANT LISTENING PROJECT www.birds.cornell.edu/brp/elephant

Combining technologies of sound recording, thermal imaging, and direct observation, the Elephant Listening Project helps us to understand forest elephants as individuals and to discover how their complex societies function. The Dzanga Bai elephants, and Andrea Turkalo's in-depth knowledge of their behavior, provide the foundation for this work. By listening to the voices of Africa's forest elephants, we can learn about their lives and search for ways to secure a future for them and the forests they roam.

ELEPHANTVOICES www.elephantvoices.org

ElephantVoices, founded by Joyce Poole, works to further the understanding of the wisdom and complexity of elephants, and ensure a future for them through conservation, research, and the sharing of knowledge. It provides a comprehensive source of information about elephants and their behavior, including unique educational databases of their acoustic and gestural communication. The ElephantVoices project in the Maasai Mara engages people in conservation via Web technology, Facebook, and online databases: the Mara Elephant Who's Who and Whereabouts.

SAVE THE ELEPHANTS www.savetheelephants.org

Save the Elephants, led by Iain Douglas-Hamilton, aims to secure a future for elephants in a rapidly changing world. Pioneers in cutting-edge science, STE conducts research that provides vital insights into elephant behavior, intelligence, and long-distance movement. Given the current crisis, STE has now marshaled its resources to combat elephant poaching, prevent ivory trafficking at all levels, and bring to the attention of consumers the catastrophic impact of their ivory purchases.

TARANGIRE ELEPHANT PROJECT www.wcstanzania.org/tarangire.htm

Charles and Lara Foley have studied the elephants of Tarangire Park in Tanzania for twenty years, following the lives of more than eight hundred individual animals. The Tarangire elephants leave the park during the wet season, making them vulnerable to ivory poachers. To counter this growing threat, the project has established a network of Masai village game scouts who conduct daily patrols of elephant dispersal areas; it also provides support to the Tanzania wildlife authorities that allows them to respond rapidly to poaching threats.

WILDAID www.wildaid.org

WildAid is working in China to raise awareness of the elephant-poaching crisis in Africa, in order to reduce demand for ivory. In a campaign led by former NBA star Yao Ming, WildAid uses public-service announcements, video shorts, and billboards to reach hundreds of millions of people—through over $150 million a year of donated media space. The organization's previous campaign for sharks is credited with helping to reduce consumption of shark-fin soup by 50 to 70 percent, helping to maintain a balance of marine life.

WILDLIFE CONSERVATION SOCIETY www.wcs.org

With elephants across Africa facing unprecedented slaughter for their tusks, the Wildlife Conservation Society works in many of the largest and most at-risk populations to stop the killing by partnering with communities and governments to bolster antipoaching efforts. At the same time, they are working to stop the trafficking of ivory from Africa to Asia by boat and plane, and to stem the demand for ivory through social-networking in China.

This book is dedicated to Darlene Anderson, my patron, adviser, and confidante.
She is a true friend to my family and a vital supporter of all the things we are hoping to protect
and conserve with images and with the noise we make. —M.N.

Earth to Sky: Among Africa's Elephants, A Species in Crisis
has been made possible through the generous support of:

National Geographic Society

Darlene and Jeffrey Anderson

Edith S. McBean

Ron and Christie Ulrich, African Parks Foundation

Donna and Garry Weber

ACKNOWLEDGMENTS

My thanks go to the book team: Melissa, Yo, Diana, Kristi, Bonnie, and Matt. You will see their full names on the book's copyright page, but I'll keep it personal here because we are truly a team; together we have worked to translate a vision to the page.

At home and in the studio, I give my love and gratitude, as always, to my soul mate, Reba Peck, my partner in this work from the beginning. Jenna Pirog has been working with me since 2006's "Ivory Wars" project—first at *National Geographic* and now at Look3 and as my studio manager. Chloe Delaney is the smart dynamo who, with little guidance but a wonderfully quick mind, read every book I threw at her and found the quotes that dovetail with these images so perfectly.

At *National Geographic*, I thank my good friend and the magazine's editor-in-chief, Chris Johns, who knows and cares as much for Africa and elephants as I do, and who readily supported each story proposal I brought in. Virtually all my work at NGM has been created under the nurturing eyes and heart of my editor, Kathy Moran. I am indebted to *National Geographic* for fostering the creation of all the projects in this book.

In the field I have worked with the assistance of Nathan Williamson since 2004—first he operated the camera traps, today he is a talented videographer—it has been my good fortune to have him by my side all these years.

For their invaluable help with the specific projects in this book, my very deep thanks go to a number of collaborators. "In the Forest": J. Michael Fay, Richard Ruggiero, Steve Blake, Lee White, and Sophiano Etouck. "Ivory Wars": Luis Arranz, Nuria Ortega, Jean Marc Froment, Ladis N'dahiliwe, and Djako Tamsia. "Family Ties": all the Douglas-Hamiltons—Iain, Oria, Saba, and the inspiration, Mara, known as "Dudu"—as well as Daniel Lentipo and David Daballen. And "Orphans": Rob Carr-Hartley, Daphne and Angela Sheldrick, and the elephant keepers: Mishak Nzimbi, Bejamin Kyalo, Joseph Sauni, Edwin Lusichi, Amos Lekalau, Amos Leleruk, and Hassan Adan.

Finally, this book would not exist without the generosity of a group of supporters who understand the vital importance of the survival of African elephants. My profound gratitude goes to the National Geographic Missions Programs, Darlene and Jeff Anderson, Edith McBean, Christie and Ron Ulrich, and Donna and Garry Weber. Your belief in this project is inspiring.

Earth to Sky
Among Africa's Elephants, A Species in Crisis
by Michael Nichols

Publisher: Lesley A. Martin
Editor: Melissa Harris
Book Design: Yolanda Cuomo, NYC
Associate Designer: Kristi Norgaard
Assistant Designer: Bonnie Briant
Senior Editor: Diana C. Stoll
Production: Matthew Harvey
Senior Text Editor: Susan Ciccotti
Managing Editor: Amelia Lang
Assistant Editor: Paula Kupfer
Work Scholars: Luke Chase, Alison Karasyk, Elli Trier

Text excerpts: Pages 4, 20, 26: courtesy Peter Matthiessen;
p. 16: © Estate of Carl E. Akeley; pp. 24, 30, 32, 98: courtesy Iain and
Oria Douglas-Hamilton; pp. 36, 76: courtesy J. Michael Fay; pp. 40,
52, 90, 102, 128: courtesy Cynthia Moss; pp. 44, 124, 132, 166: courtesy
Diego Gary and Leila Chellabi; pp. 58, 78: courtesy Bryan Christy;
pp. 64, 114, 144, 162: courtesy Charles Siebert; p. 72: courtesy
National Geographic magazine; p. 74: courtesy Luis Arranz;
p. 94: courtesy David Quammen; p. 106: © Simon and Schuster, 1958,
and courtesy Diego Gary and Leila Chellabi; p. 116: courtesy
Alex Shoumatoff; pp. 120, 158: © Joyce H. Poole; pp. 140, 148,
152, 170, 178, 186: courtesy and © Dame Daphne Sheldrick;
p. 154: courtesy G. A. Bradshaw, Allan N. Schore, Janine L. Brown,
Joyce H. Poole, Cynthia J. Moss; Page 188: Courtesy Virginia W. Mason,
Brad Scriber, and John Tomanio, *National Geographic* magazine staff

First edition
Printed by Graphicom in Italy
10 9 8 7 6 5 4 3 2 1

Library of Congress Control Number: 2013937774
ISBN 978-1-59711-243-7

Aperture Foundation books are distributed in the U.S. and Canada by:
ARTBOOK/D.A.P.
155 Sixth Avenue, 2nd floor
New York, N.Y. 10013
Phone: (212) 627-1999
Fax: (212) 627-9484
E-mail: orders@dapinc.com
www.artbook.com

Aperture Foundation books are distributed worldwide,
excluding the United States and Canada, by:
Thames & Hudson Ltd.
181A High Holborn
London WC1V 7QX
United Kingdom
Phone: + 44 20 7845 5000
Fax: + 44 20 7845 5055
E-mail: sales@thameshudson.co.uk
www.thamesandhudson.com

aperture

Aperture Foundation
547 West 27th Street, 4th Floor
New York, N.Y. 10001
www.aperture.org

Aperture, a not-for-profit foundation, connects the photo community
and its audiences with the most inspiring work, the sharpest ideas,
and with each other—in print, in person, and online.